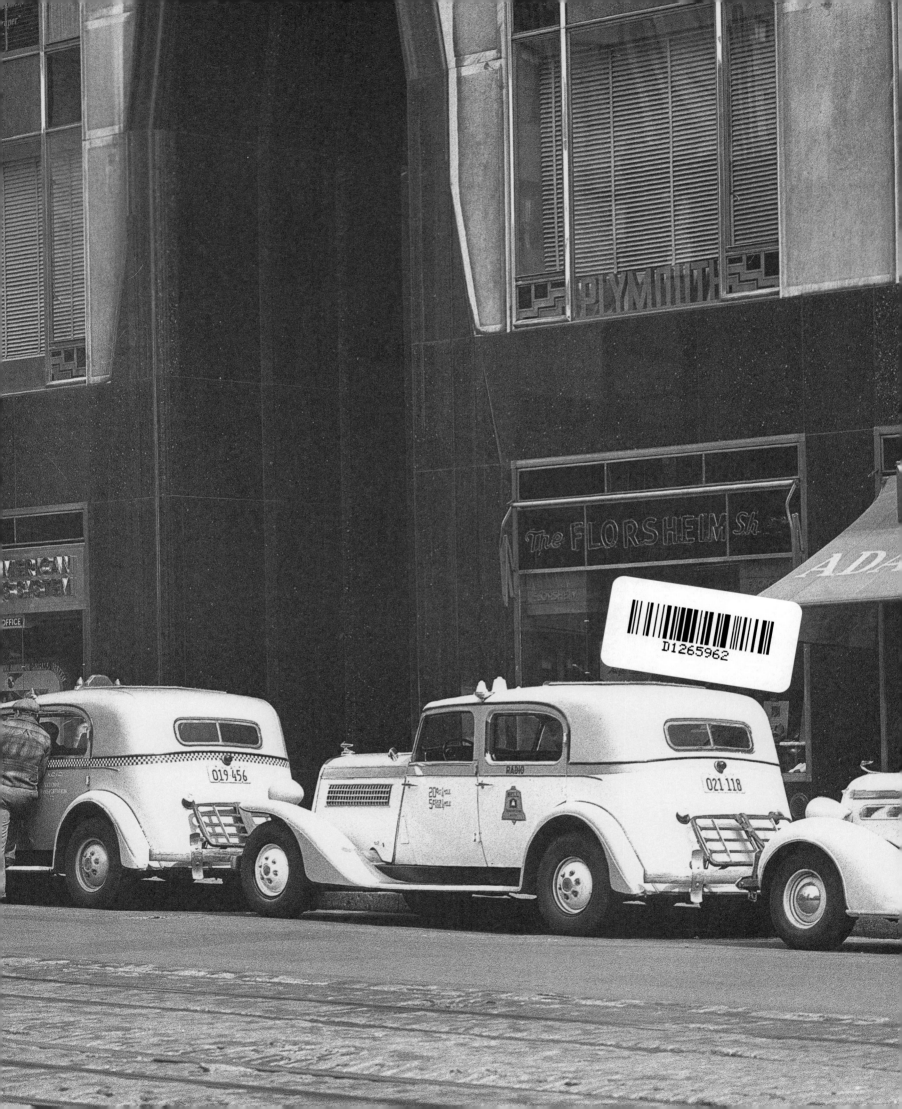

THE CHRYSLER BUILDING

CREATING A NEW YORK ICON, DAY BY DAY

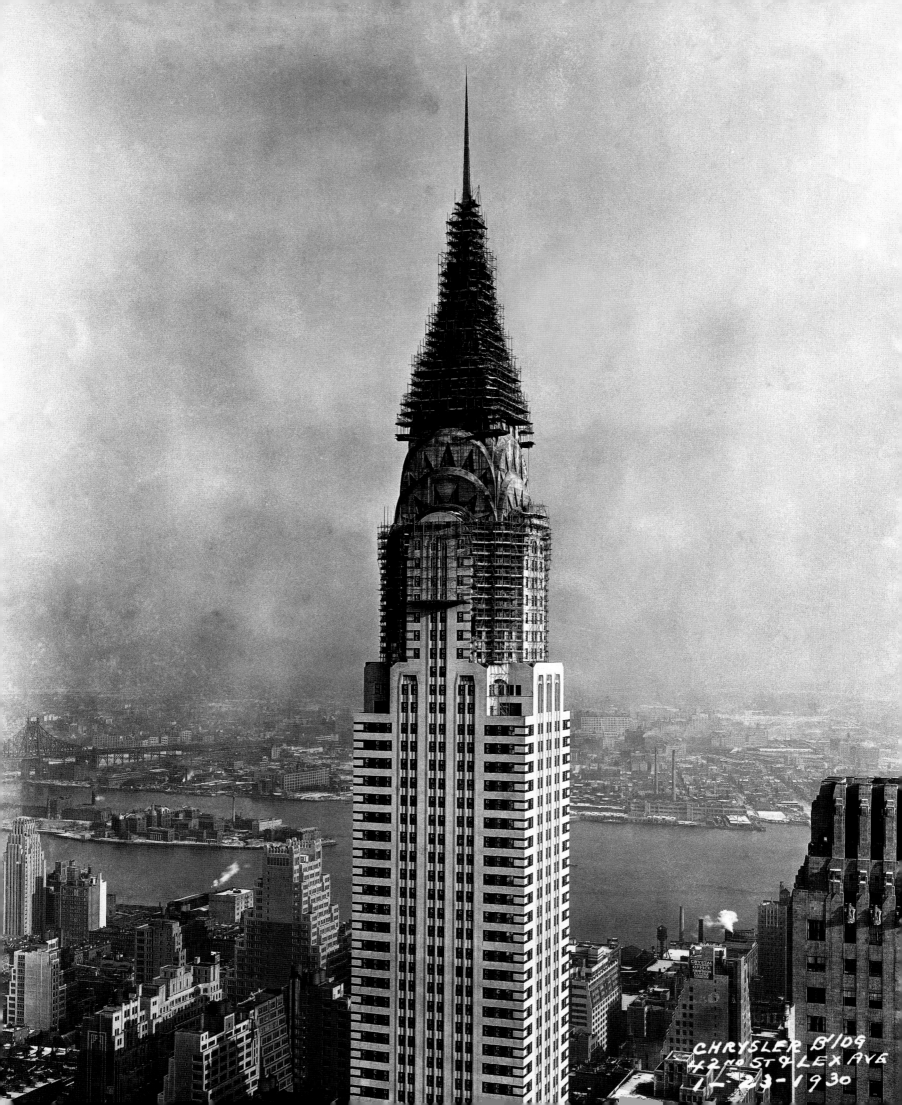

CHRYSLER B'LDG
42ND ST & LEX AVE
1-23-1930

THE CHRYSLER BUILDING
CREATING A NEW YORK ICON, DAY BY DAY

David Stravitz

Introduction by Christopher Gray

Princeton Architectural Press *New York*

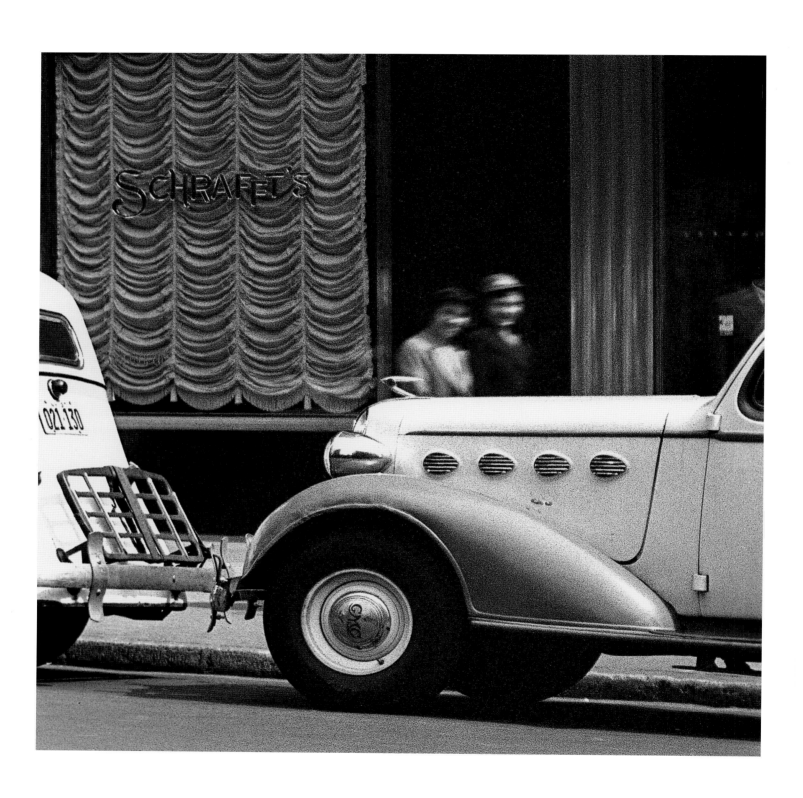

To Amy and Alison

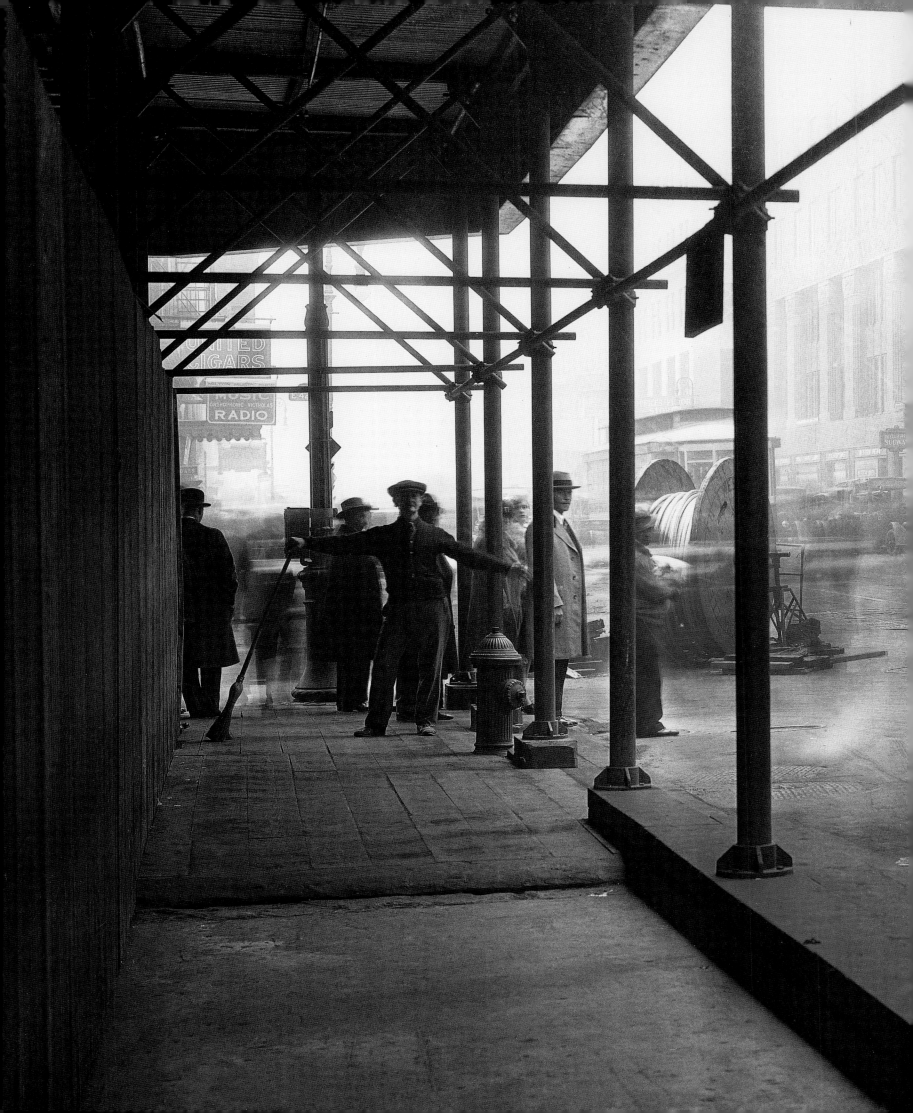

MORE THAN TWENTY years ago, I found myself in the right place at the right time.

While working as a product designer creating a photographic system, I got hooked on photography. I began working with a 35 mm camera and then moved on to medium- and large-format equipment as my hobby became a passion. I joined the New York Photographic Historical Society and began networking with a group of photo enthusiasts. In 1979 a friend of mine introduced me to an elderly photographer who was closing up shop and selling off his equipment. I took down his address and a few days later appeared at his studio door.

The photographer's place was like a dungeon. In the dim light of a 40-watt bulb hanging from the ceiling, I could see that every surface was completely corroded from thirty-plus years of developing film. I examined the gentleman's equipment and decided to purchase a number of things: two wooden cameras from the early 1920s (a 5 by 7 and an 8 by 10 with red leather bellows), a couple of brass-barreled studio lenses from the turn of the century, and a tripod. This was quite a thrilling experience, but what happened next was even more exciting: I was about to stumble upon the treasure of a lifetime.

Tucked away in a corner of the studio, almost entirely in shadow, were stacks of boxes about as high as my knee. "What's in those boxes?" I asked my host. "Nothing you would be interested in," he replied, "just a bunch of old 8 by 10 negatives that I'm going to convert to silver in about a week." I told him that I collected images as well as cameras and asked if I could take a look. "Go right ahead," he said, "but I don't see what interest they would be to you." I slid the boxes directly under the light and began to open one after another.

I couldn't believe my eyes. There, unfolding before me, were the streets of New York in the late 1920s and 1930s: the buildings, businesses, theaters, and restaurants; the advertising signage; the skyline; the people; the hustle and bustle of New York City, recorded and preserved in minute detail. There were over five hundred 8 by 10 negatives in all. Some were made on Kodak safety film, but others were of highly inflammable silver nitrate, and many had begun to reticulate. Needless to say, to my host's surprise and delight I bought the whole lot.

My brief review of the negatives had not revealed the full scope of what I had uncovered. I would come to learn that more than one hundred and fifty negatives contained in this collection documented the day-by-day construction of the world's greatest art deco skyscraper, the Chrysler Building—from the excavation of its site at the northeast corner of 42nd Street and Lexington Avenue, to the erection of its tower, to the crowing of its magnificent spire. Taken primarilly

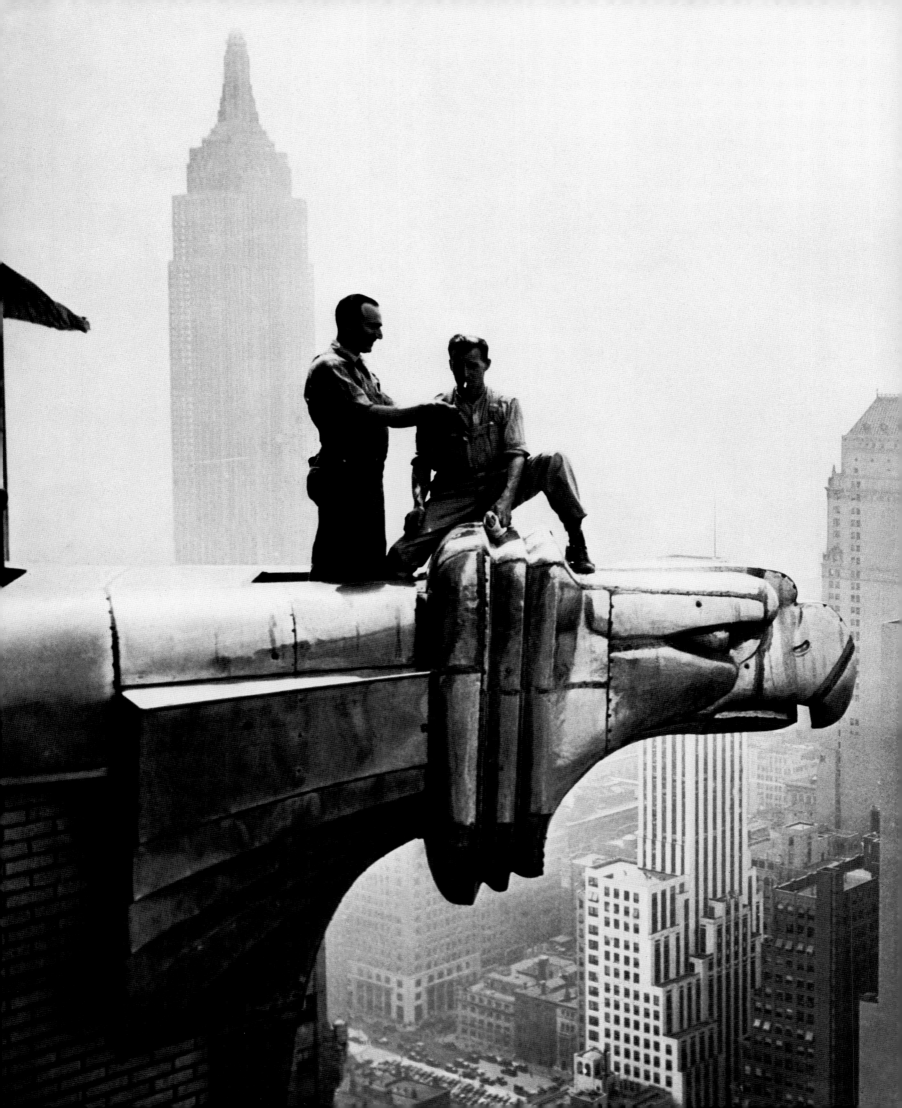

by the commercial and industrial photographers Peyser & Patzig, the views taken from ground level as well as from the building as it climbed skyward capture both the street life and the expansion of New York between 1926 and 1937 and make the period come alive.

I became obsessed with these spectacular images. I spent days poring over their intimate details, peering into the world that they capture. Many of the negatives are inscribed with their original dates; I placed them in chronological order and attempted to fill in the gaps with the undated images. I became mesmerized by the stories the photographs tell. An image from October 23, 1929—the day before Black Thursday—shows the Chrysler Building (at that time, the tallest in the world) nearing completion. Photographs from just one week later show that after the stock market crashed construction continued merrily along, as if unaffected by the nation's financial collapse.

Over one hundred of these incredible images of the Chrysler Building are reproduced in this book, at large scale and in remarkable detail. In preparing the negatives for publication, Matthew Stravitz and Thomas Oh offered their help and computer expertise, for which I am truly grateful. A very special thanks goes to Christopher Gray for his wisdom and encouragement throughout this project. I would also like to thank Nancy Eklund Later for her enthusiasm and direction in preparing this book. Most importantly, thanks goes to my wife Amy for her tireless support in helping me throughout many phases of this project, and to my daughter Alison for her honest critiques.

The images presented here reveal that New York was then—as it is today—the world's greatest city, and the Chrysler Building, among its prized possessions. I offer this photographic retrospective to the reader, to look at and enjoy for both its architectural and historical interest. I hope you will find its contents as engaging as I have over the last two decades.

DAVID STRAVITZ

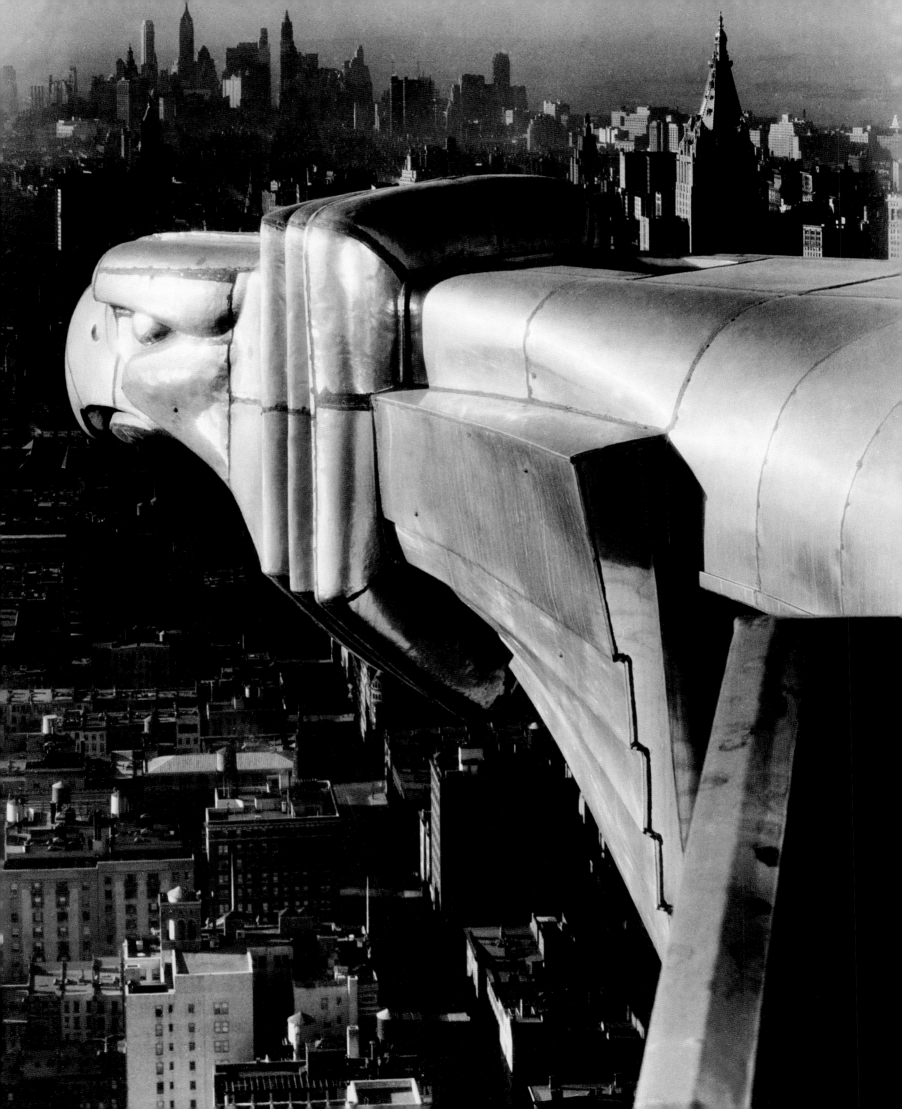

WE WEREN'T JUST THROWING AWAY our buildings in the mid-twentieth century, we were throwing away our history. Huge runs of nineteenth-century newspapers—pulped. Collections of architectural drawings of some of our most famous landmarks—junked. And architectural photographs! The vast gaps in numbering of surviving negatives created by the major architectural photographers of New York City buildings—the Wurts Brothers, for example, or Irving Underhill—suggest that less than 5 percent of those collections survive.

But that's the way it was done then, and why not? If we were ready to throw out our architectural monuments in the years around the demolition of Pennsylvania Station, why in the world would we want to bother with their birth certificates?

Architectural photographers were the Ansel Adamses of our modern cities, making large photographs with 8 by 10 and 11 by 14 negatives of our architectural Yosemites, usually working on commission for the architects or materials suppliers of the buildings they photographed. That most of the works of these photographers have been scrapped is a tragedy for the field of architectural preservation.

A firm for which only a small fraction of work survives was founded in the early 1920s by Alfred E. Peyser and August L. Patzig. Little is known about the photographers. Their name appears only occasionally in architectural journals of the period, and sporadic listings in directory sources do not reveal much about their specialty.

David Stravitz's heroic tale of stumbling across and then saving the astonishing series of photographs documenting the construction of the Chrysler Building—most of which were taken by Peyser & Patzig—is breathtaking for how close we came to losing it; they were only days away from being salvaged for their silver content. Probably Peyser and Patzig themselves would not have seen this as any great tragedy. Almost all the photographers who made these types of images saw them in commercial terms, not artistic ones, and once their immediate commercial value had passed, they seemed like supercargo.

Like William H. Jackson's photographs of the wonders of the American West, which often captured a stray burro or a lone prospector to one side, the Peyser & Patzig series of the Chrysler Building documents the warp and woof of both the building and the city around it:

A man stands on 42nd and Madison, casting a shadow into the street. The man is stationary, but the sun-shadow is in motion. We have only a milli-slice of it.

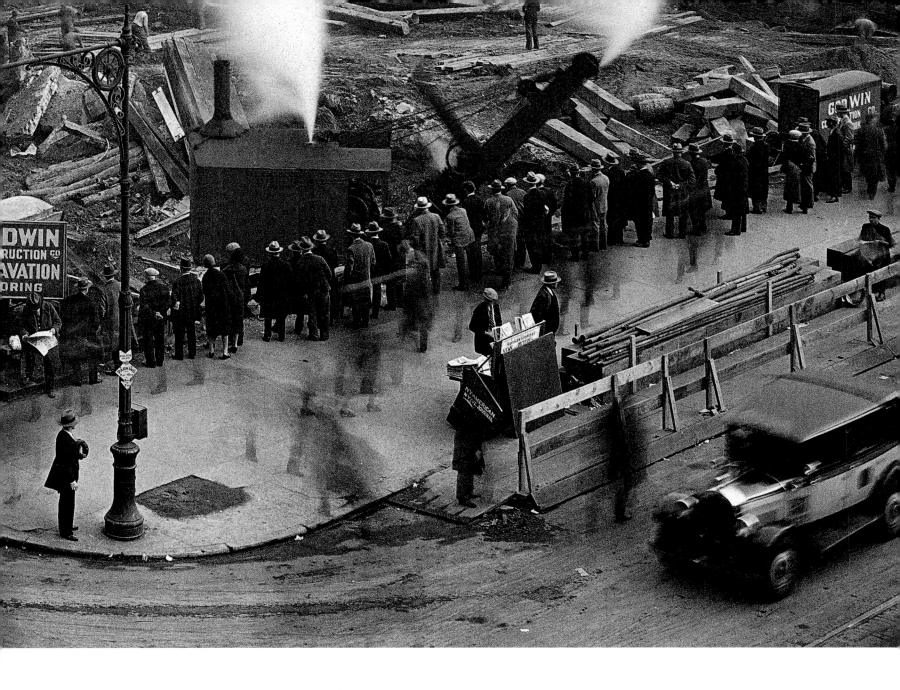

In November of 1929, an 1880s palimpsest on a lot-line wall on 42nd Street,
suddenly exposed by demolition for the Chrysler Building, is just as suddenly
snapped up by Rival Shoes for their painted billboard, even though they know
it will disappear within a year.

In the same picture, over one hundred people look down into the growing pit
dug by a Mike Mulligan steam shovel, each of them stopping for a minute or
two in the middle of some more important errand.

Each picture like this traps the breathing, pushing human rush of New
York like the amber engulfing an ancient insect, for us to study at our own leisure.
Peyser and Patzig probably did not intend to send messages from beyond
the grave. Rather, they were almost certainly hired by the general contractor, Fred T.

Ley, to document the progress on the Chrysler Building, upon which contractors' payments were usually based. Most other large buildings had such documentation, but typically it was tossed out along with specifications, blueprints, architectural models, and other documents, which were, after all, only a means to an end.

The genesis of one of the most striking buildings of the twentieth century began in 1911, when the Brooklyn developer and politician William H. Reynolds leased the east side of Lexington Avenue between 42nd and 43rd streets. In 1903 Reynolds had built the fantastical Dreamland Park, a sensational amusement center in Coney Island, which had visionary attractions like "Trip to the Moon" and "Fire and Flames." Photographs from July of 1928 show a building on the site with ads for Lido Beach, a waterfront development with which Reynolds was also connected.

Reynolds had worked with the architect William Van Alen as early as 1921, and in 1928 asked him to design an 808-foot skyscraper with an illuminated glass dome for the 42nd Street site. But later in the year, Reynolds sold the skyscraper project to Walter P. Chrysler, the automaker. The *New York Times* said the sale price was about $2 million. Chrysler inherited Van Alen's design but gave it a twist midway through construction.

The tale of the 185-foot high "surprise spire" of Chrysler's building is now fairly well known. The story goes that the spire was hidden inside the building until the last possible moment and revealed as Van Alen's sweet revenge against H. Craig Severance, his erstwhile partner. Severance had just finished what he thought was the world's tallest building, at 40 Wall Street. It is clear that the spire was erected inside the building (a huge, central air shaft is still in place), but the element of surprise in the story is somewhat less credible. Just how many hundreds of construction workers can be brought in on a "secret" like that before it becomes public knowledge?

The spire, hoisted in place in just 90 minutes, sometime in October or November of 1929, was not the front page news you would expect. Indeed, a search through the dailies for the relevant period has so far yielded no significant article announcing its installation at all, even though the resulting building—at 1,046 feet, 4 3/4 inches high—was the tallest in the world. Perhaps it was the architectural—and social—optimism of the time that such records were not even considered fit to print, since they were being broken all the time. This was a disposable fame, even if more than fifteen minutes' worth.

The Chrysler Building itself attracted attention, although mostly negative. In an entry in the 1930 *New International Yearbook*, Talbot Hamlin called it "frivolous," and Lewis Mumford, writing in *The New Republic*, witheringly awarded it one of the "Booby Prizes for 1930" for its *retardataire* styling; an "admirable period reproduction" of mid-1920s modernism, he said.

But the Beaux Arts architect Kenneth Murchison defended the Chrysler Building, in part because of his admiration for Van Alen, who had also studied at the Ecole des Beaux-Arts but whose work remained free from historicism. (Murchison called him "the only student who returned from Paris without a box full of books.") In a 1930 article in the *American Architect*, Murchison noted the divided opinion about the skyscraper: "A few think it positively ugly; others consider it a great feat, a masterpiece, *a tour de force*." Murchison was in the latter camp, appreciating its brash newness. "It teems with the spirit of modernism," he said. He also found admirable a dozen or more of the building's technical details, like the shallow window reveals, let in just a few inches from the face of the building and giving it a taut skin, in comparison to the deep, medieval-style window reveals of the Chanin Building, diagonally across the 42nd Street and Lexington Avenue intersection.

Although the Chrysler Building, with its automobile hubcabs and extensive use of stainless steel, presents like a Machine Age product, Peyser and Patzig's photographs show it close up for what it truly is: a huge handcraft of individually laid bricks and what must be a mile or more of metal joints, hand-soldered and hand-crimped like an enormous piece of jewelry. Despite its mechanistic character, the Chrysler Building is closer in basic character to the load-bearing buildings of the late-nineteenth century than the seamless International Style buildings that came within just another decade.

At first glance also, the private Cloud Club, on the 66th, 67th, and 68th floors, was the apotheosis of Chrysler Building modernism, with wild, abstract tilework and astronomically styled light fixtures. Members like the financier E. F. Hutton, publisher Condé Nast, and Pan Am founder Juan Trippe paid dues of $300 a year to eat lunch at a greater altitude than ever before. But the club, which partly survives, also had a Tudor-style lounge and an "Old English" bar and grill—a peculiar contrast for such a self-consciously modern design. Seating eighty in the main dining room, it opened in July 1930, a month after Van Alen sued Chrysler for his fee and put a mechanic's lien on the automaker's dream project.

As the newness of Van Alen's building wore off, people began to consider the Chrysler Building embarrassingly ambitious. It was indeed antithetical to the sober, cool International Style modernism that reigned from World War II to the ascendancy of the preservation movement in the 1970s. Guidebooks of the 1950s and 1960s barely mention it. But more recently architectural taste has lightened up—like freedom of opinion in the former Soviet bloc—and today the Chrysler Building is one of the top tourist destinations of New York. Who is there now who doesn't admire Van Alen's frivolity?

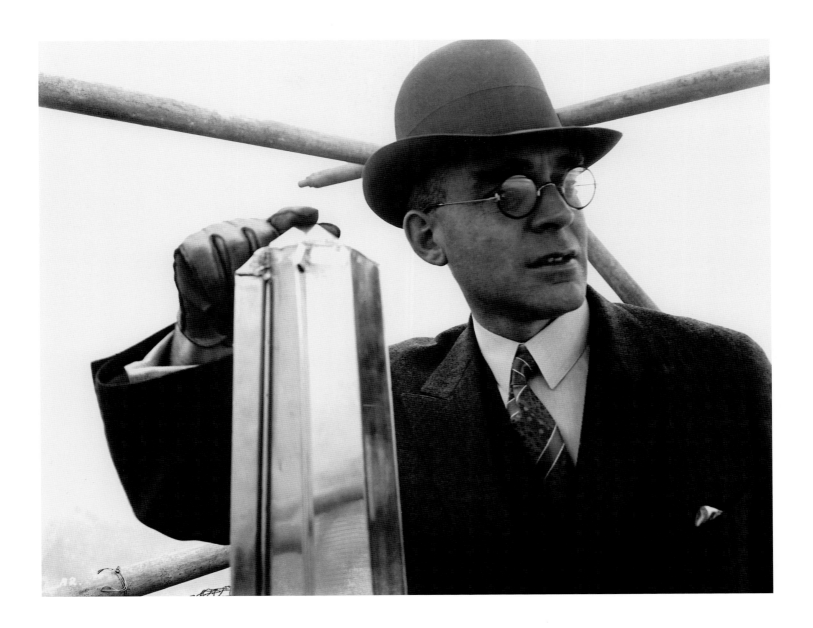

This change in heart has mirrored the economic resuscitation of the building, which weathered foreclosure proceedings in 1975. At that time, the high-end office building market revolved around large, open floor plates for giant corporations; the Chrysler Building's office floors have no more than 15 clear feet in any direction. But as small start-ups, which do not require giant, open floors, have elbowed their way to the front of the real estate table, such niche buildings have been brought partway back from economic obscurity.

David Stravitz's fortuitous reclamation of this photographic collection constitutes another chapter of rescue in the history of the Chrysler Building. With a level of documentation rivaled by few other collections, it almost cinematically brings to life the creation of what remains New York's most spectacular structure.

CHRISTOPHER GRAY

PLATES

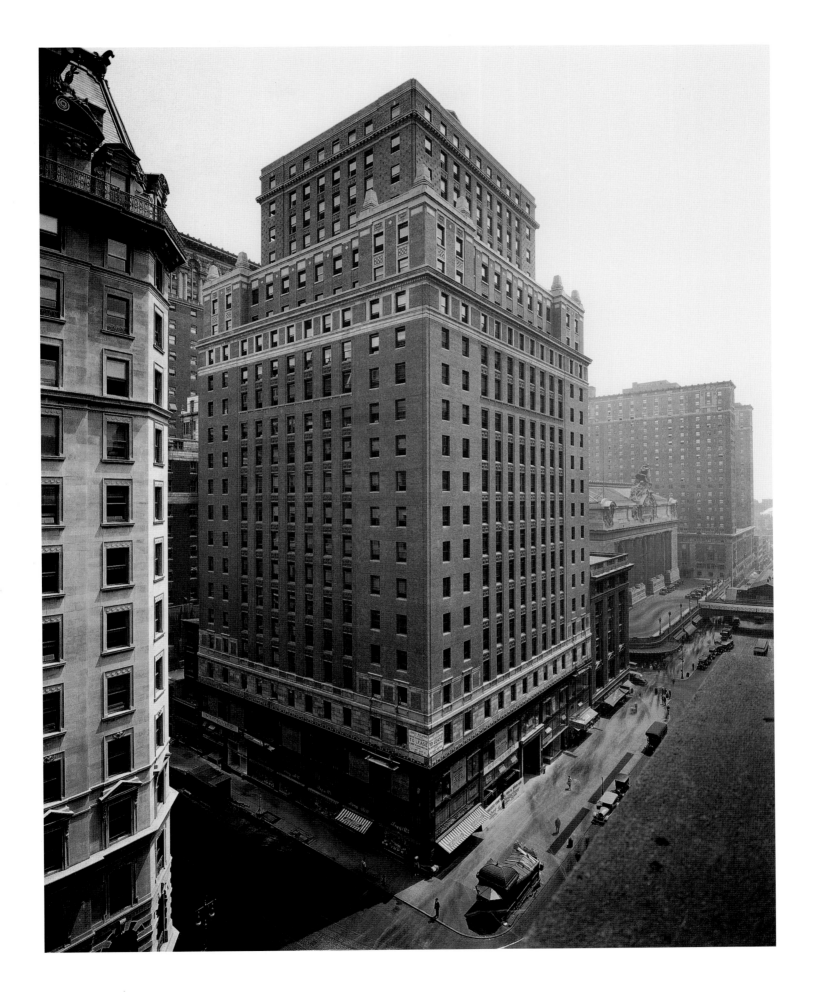

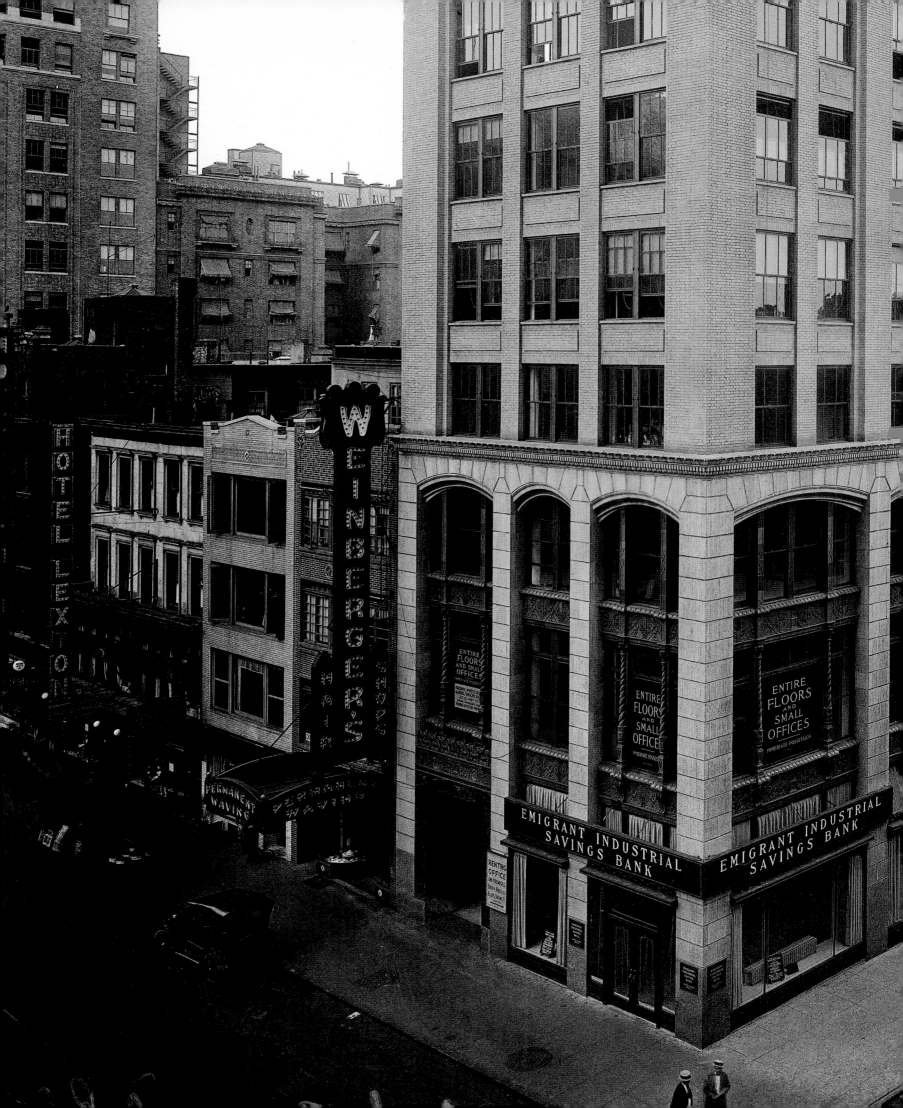

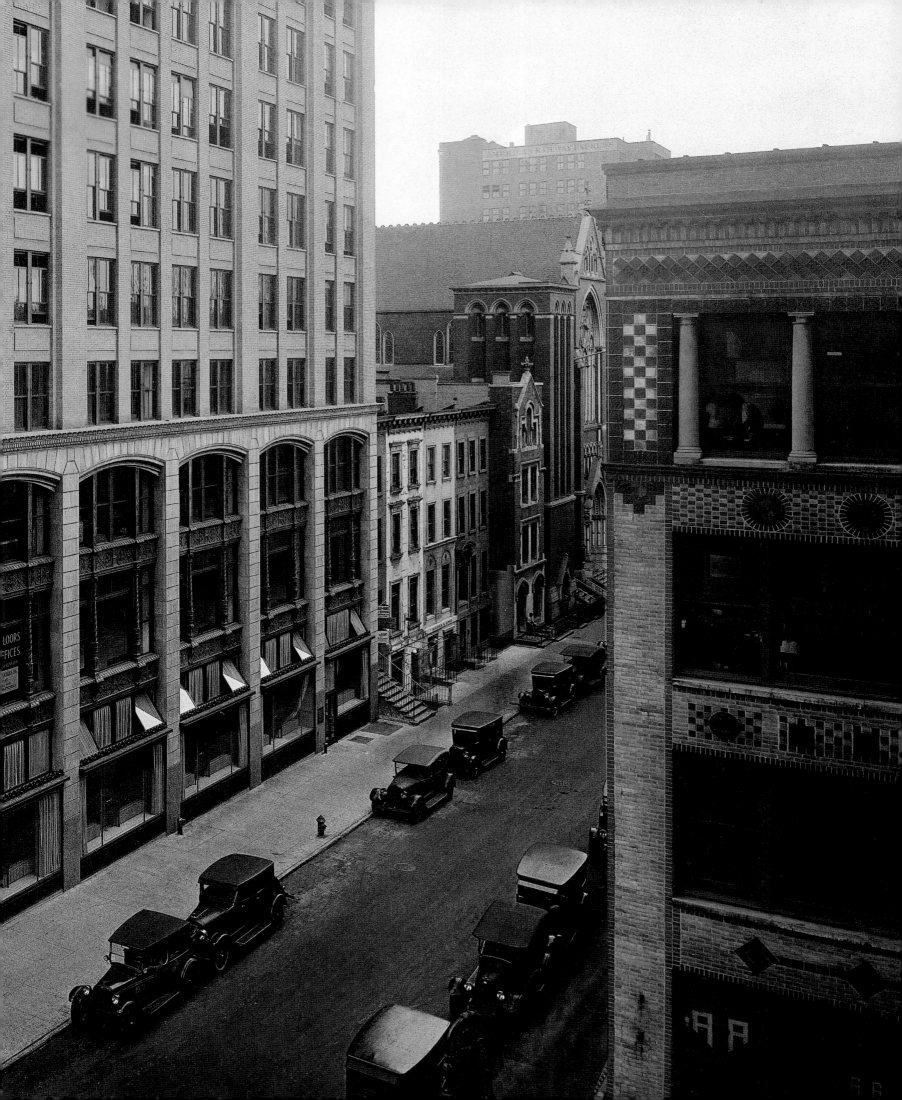

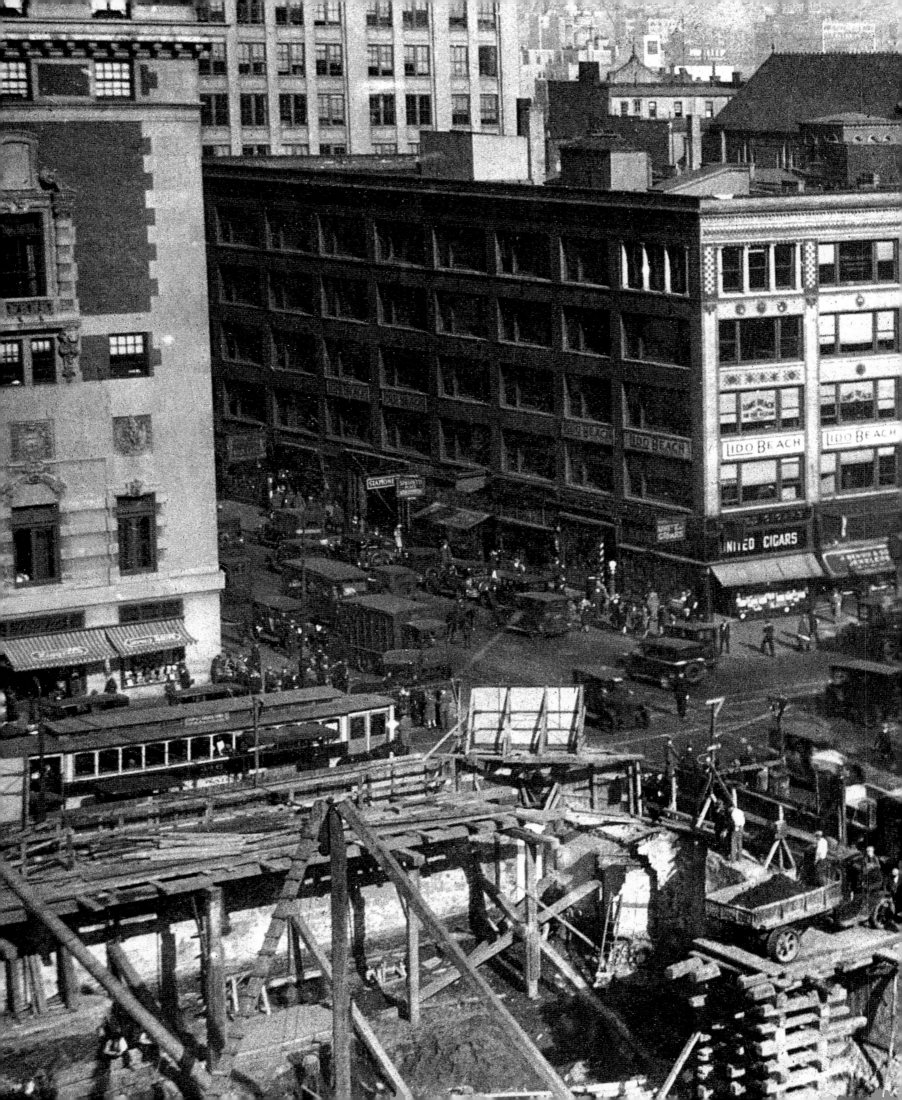

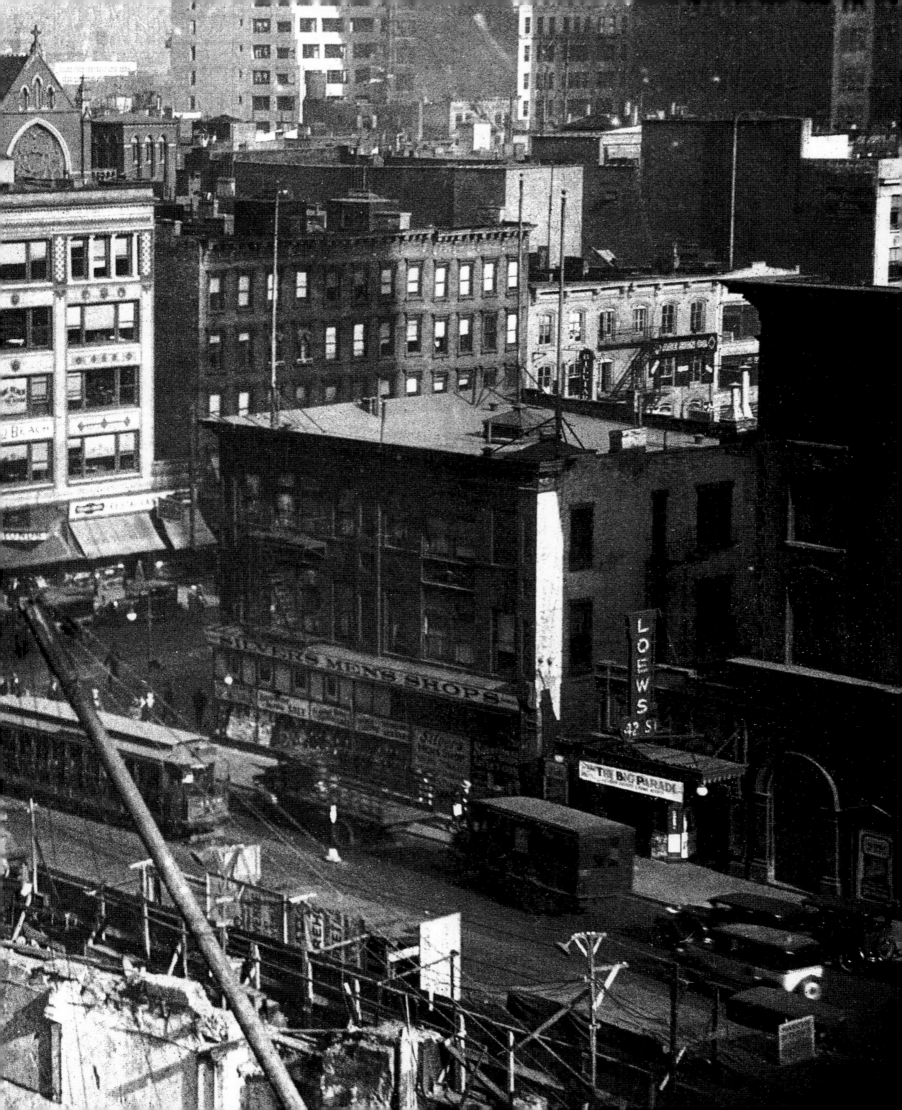

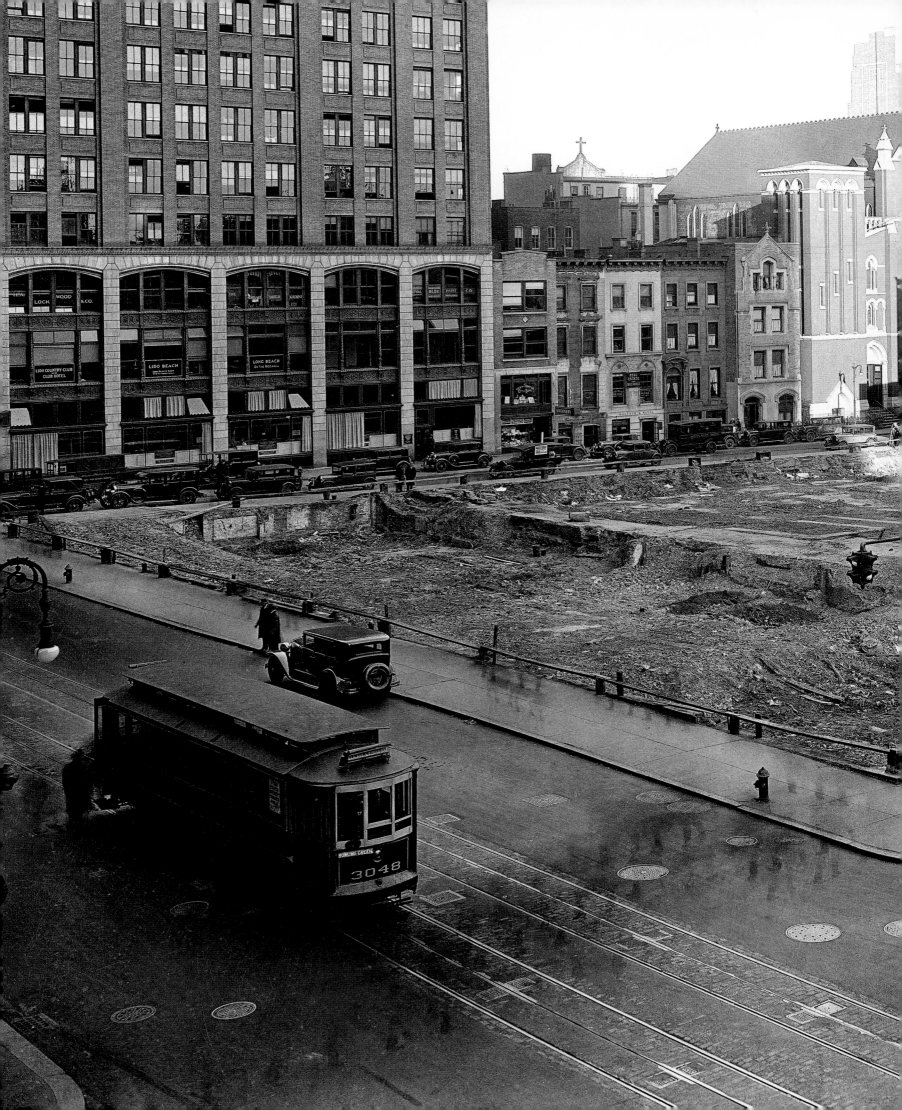

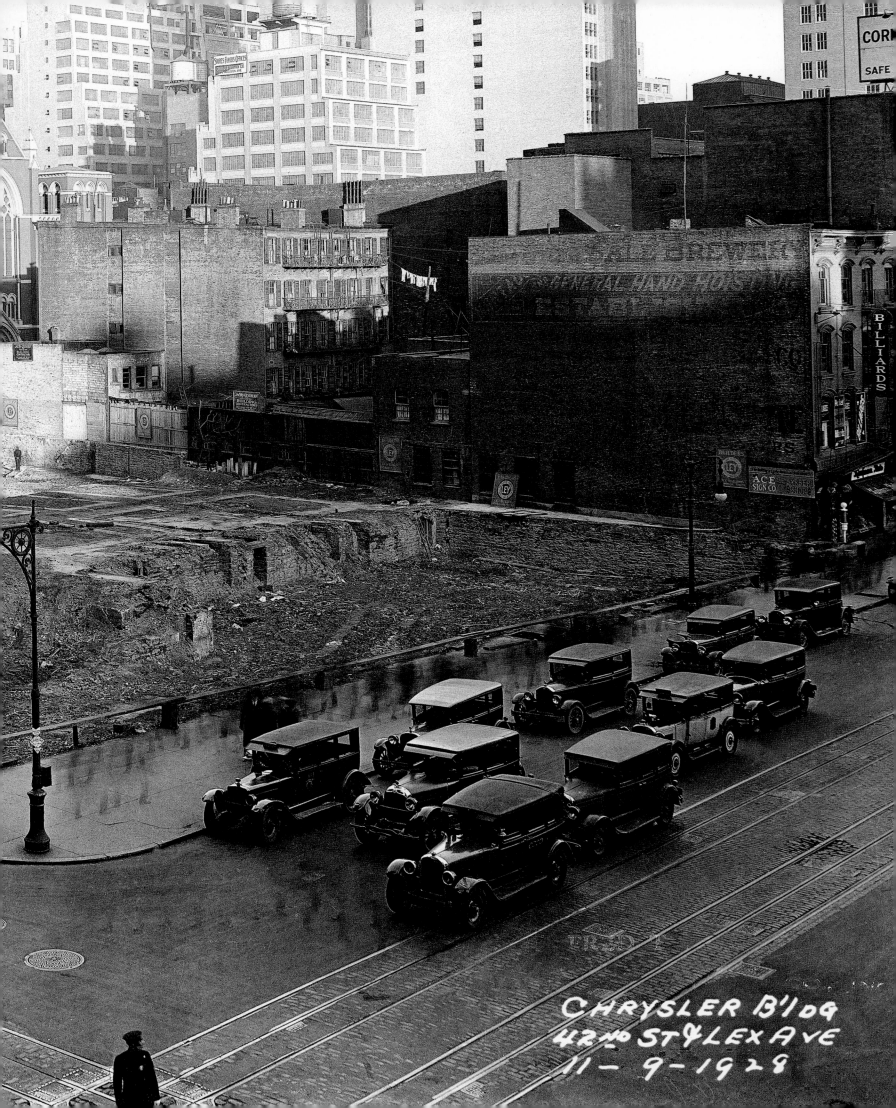

ALE BREWING
GENERAL HAND HOIST

BILLIARDS

ACE
SIGN CO.

CHRYSLER B'LDG
42ND ST & LEX AVE
11-9-1929

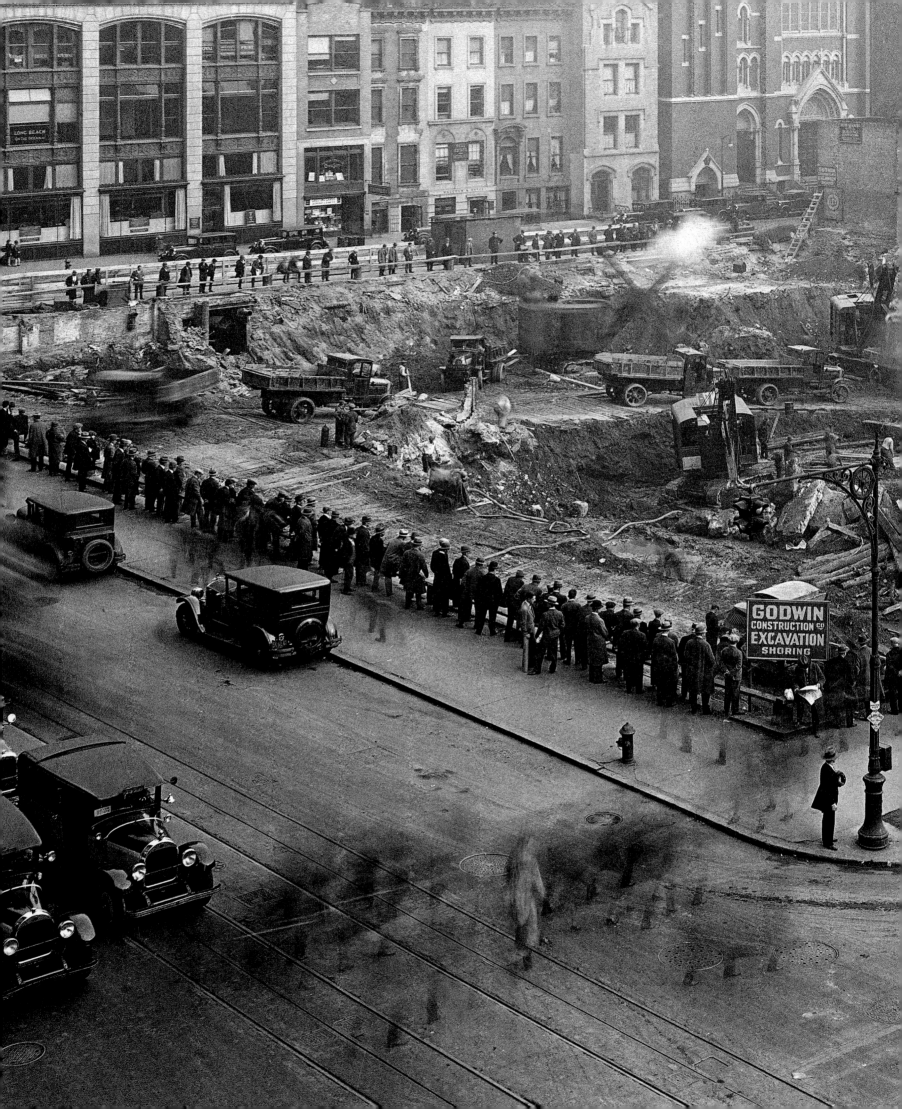

A LOOK IN THE WINDOWS
WILL SHOW YOU WHY !
— THE PRICE COUNTS. OF COURSE.
BUT THAT IS NOT THE ONLY REASON MEN BUY
RIVAL SHOES AT $5.
THE NEAREST OF THE 30 RIVAL STORES
IS RIGHT HERE 147 EAST 42ND STREET

CHRYSLER B'LDG
11 - 17 - 1928

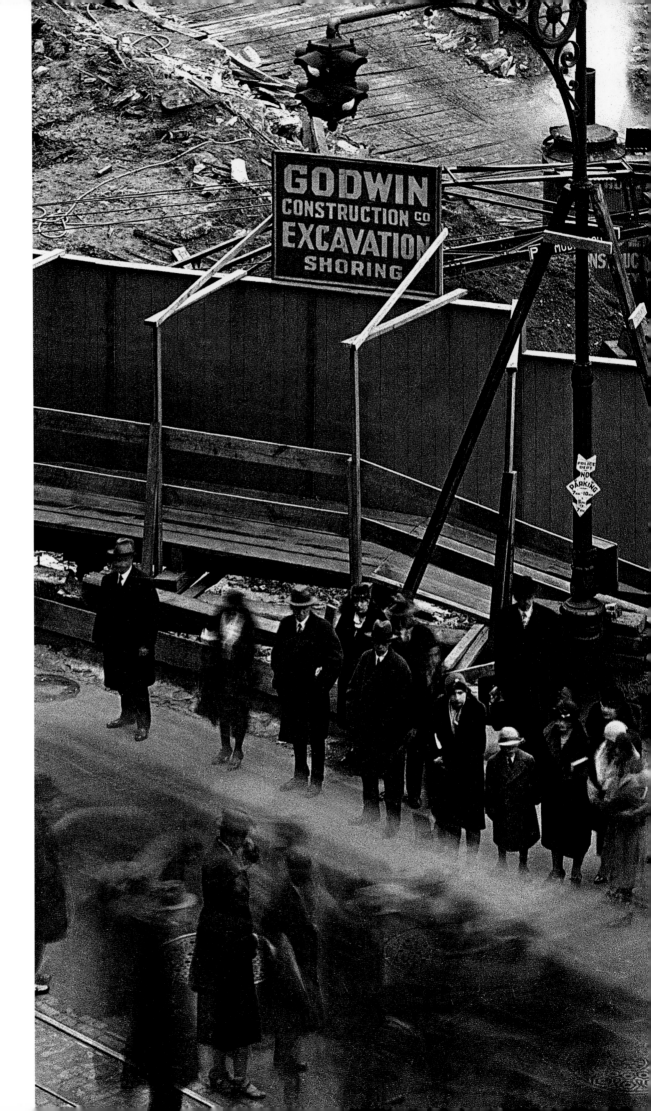

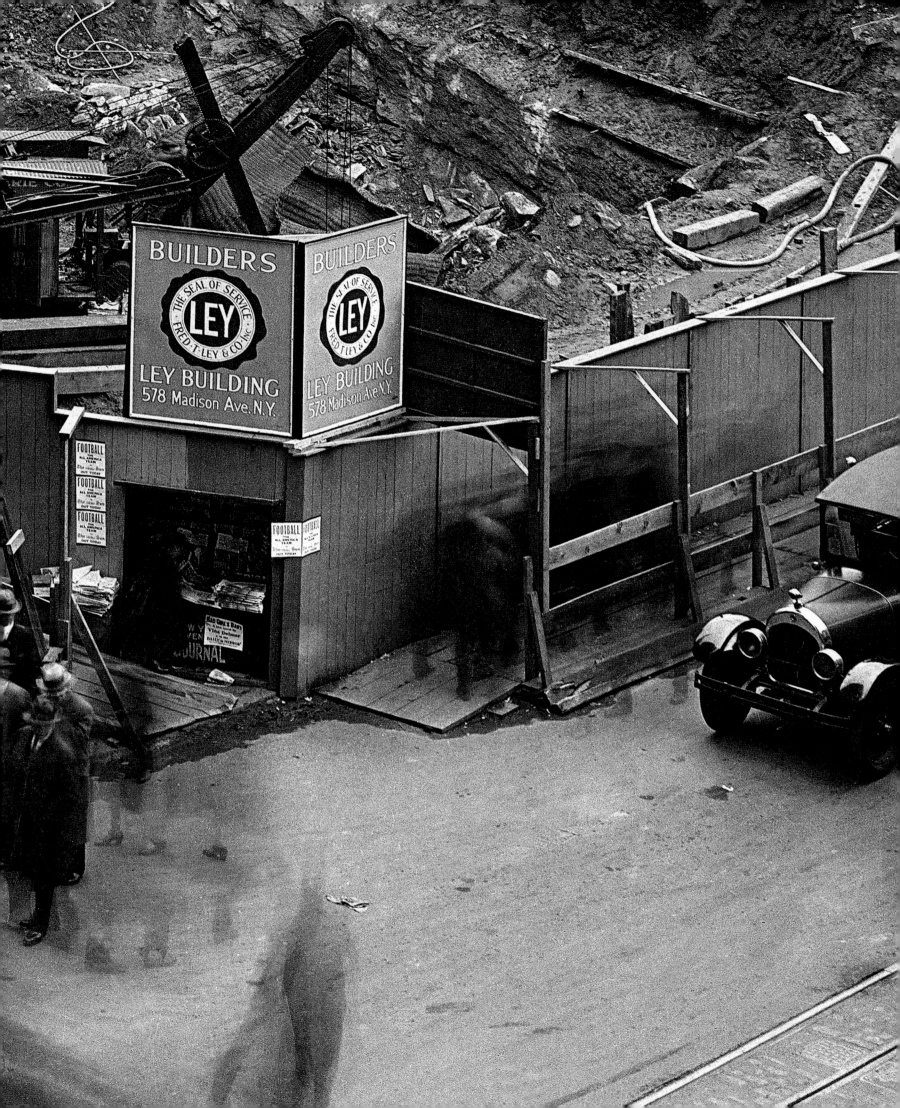

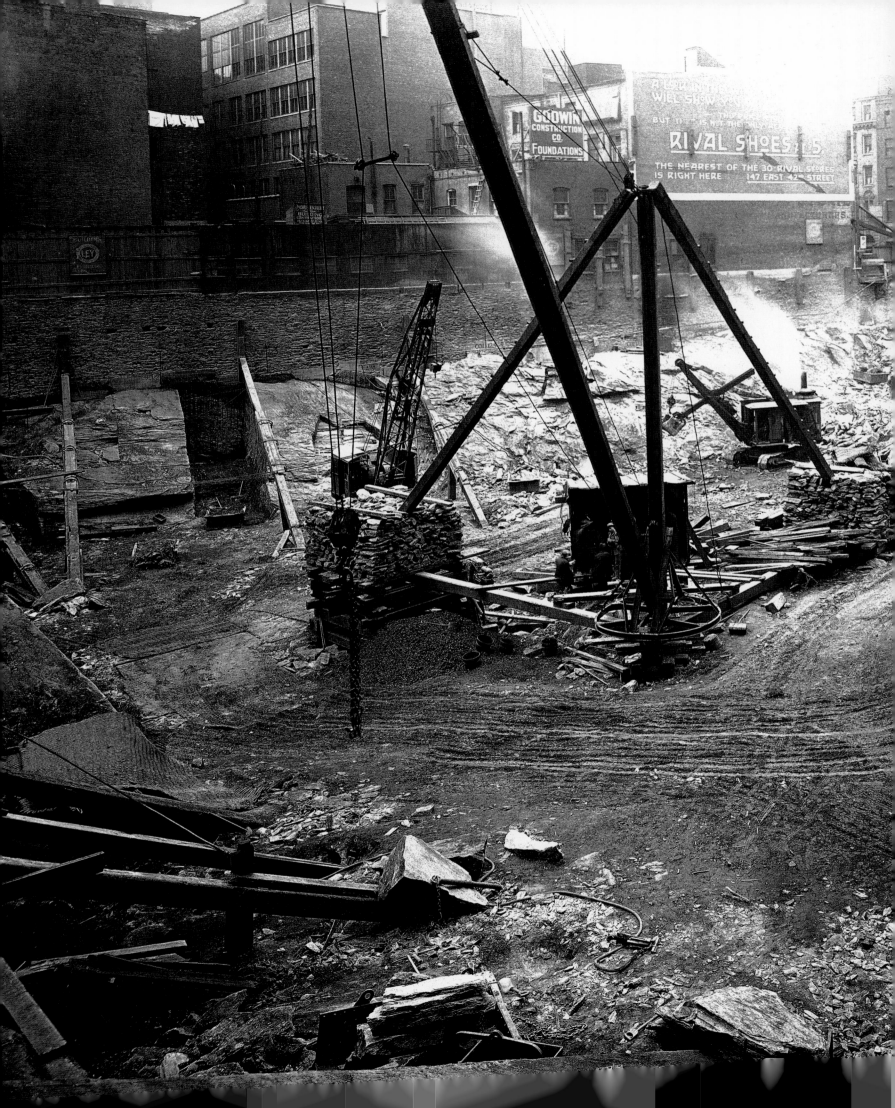

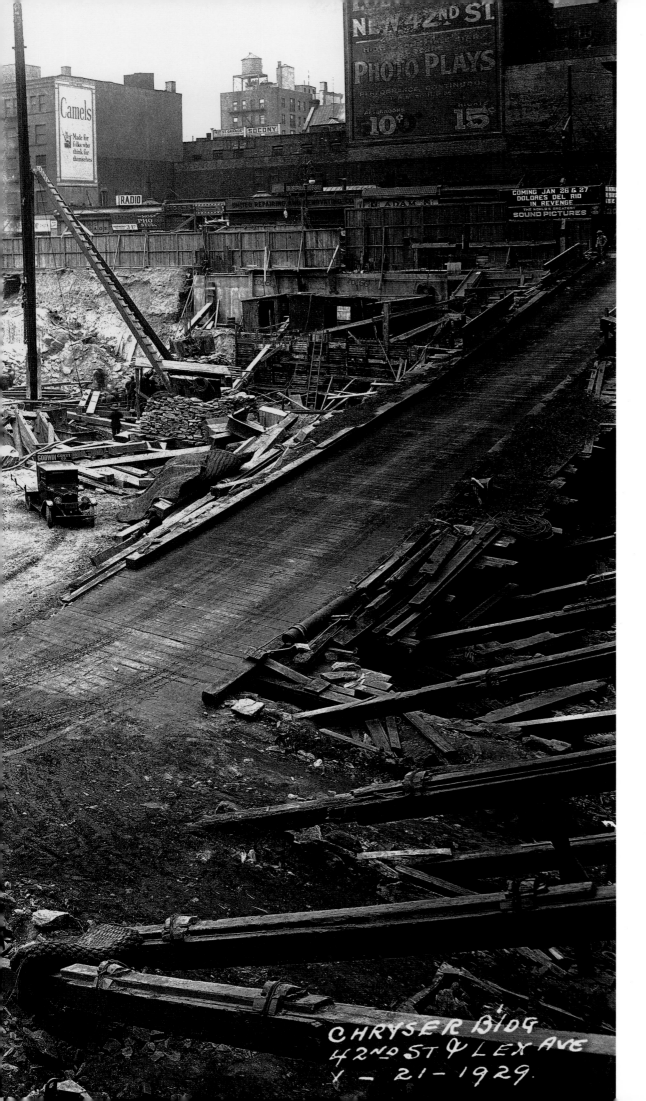

CHRYSER BLDG
42ND ST & LEX AVE
1 - 21 - 1929.

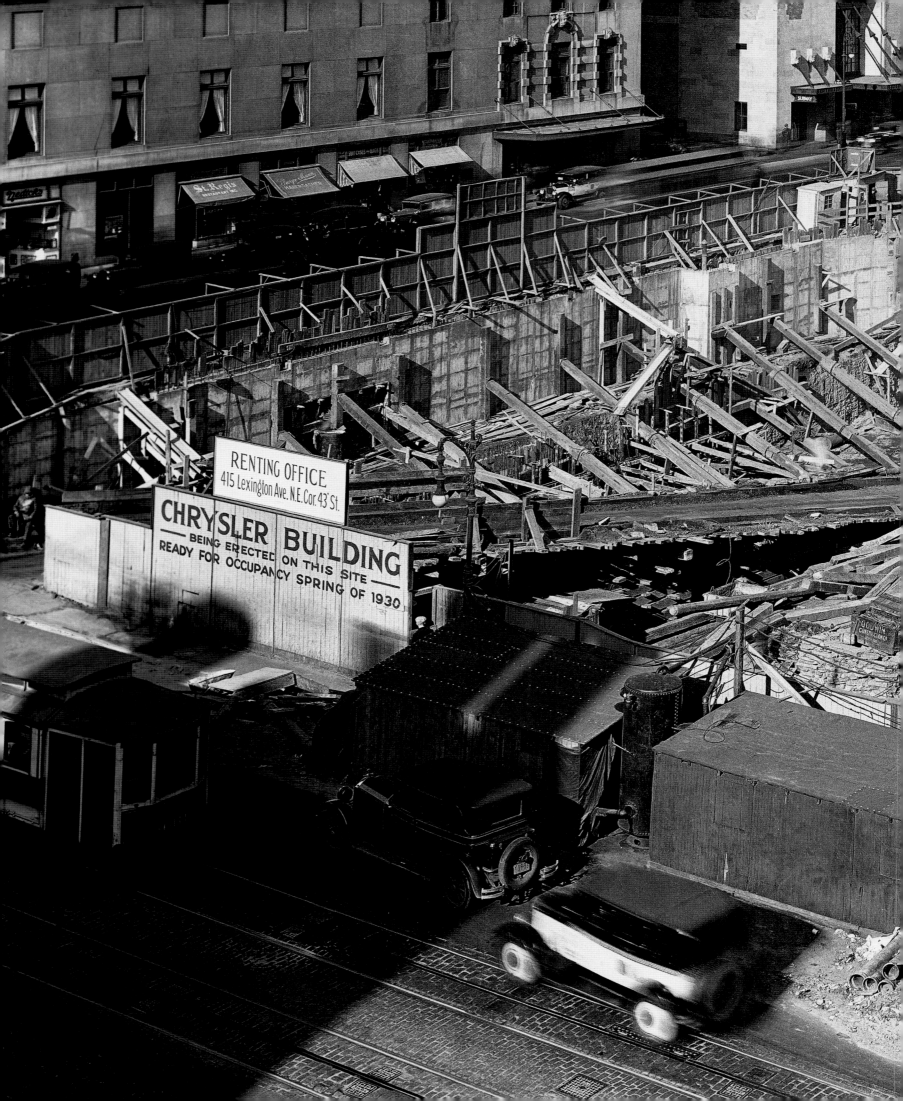

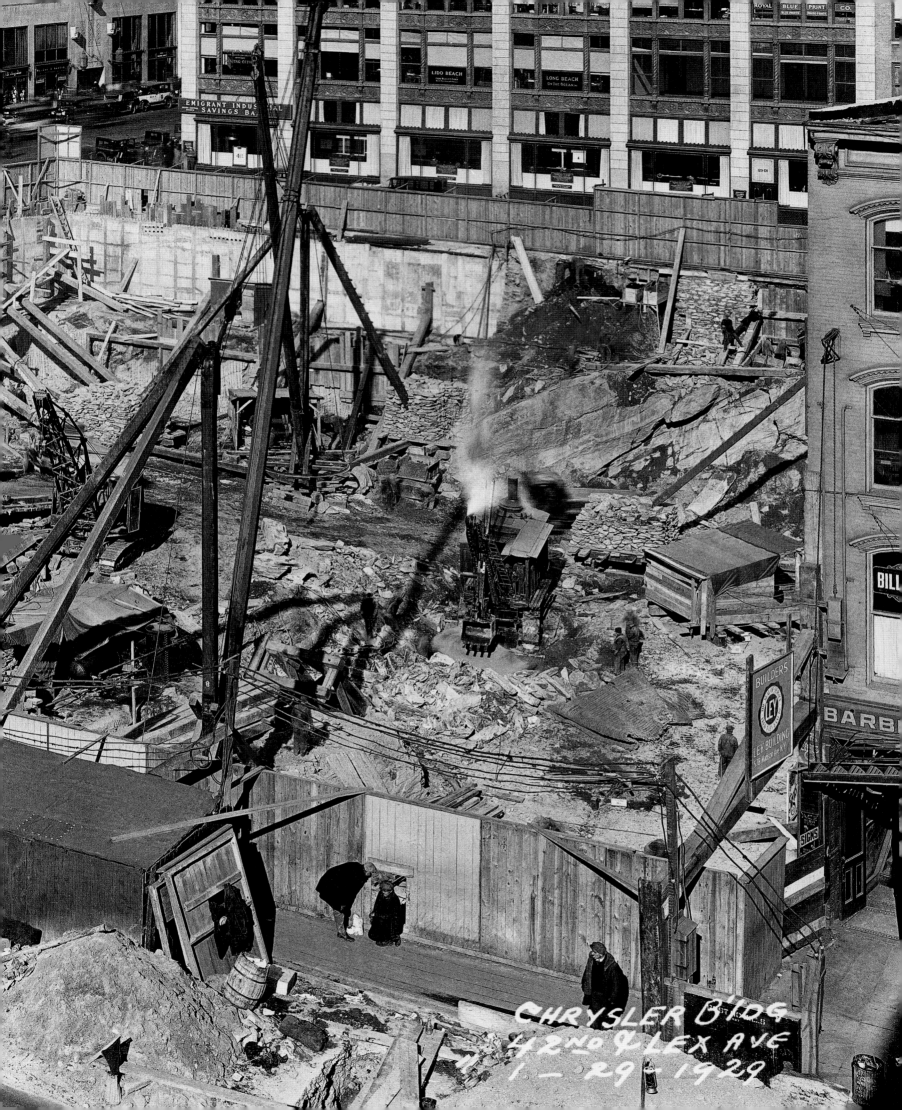

CHRYSLER B'DG
42ND & LEX AVE
1 — 29 — 1929

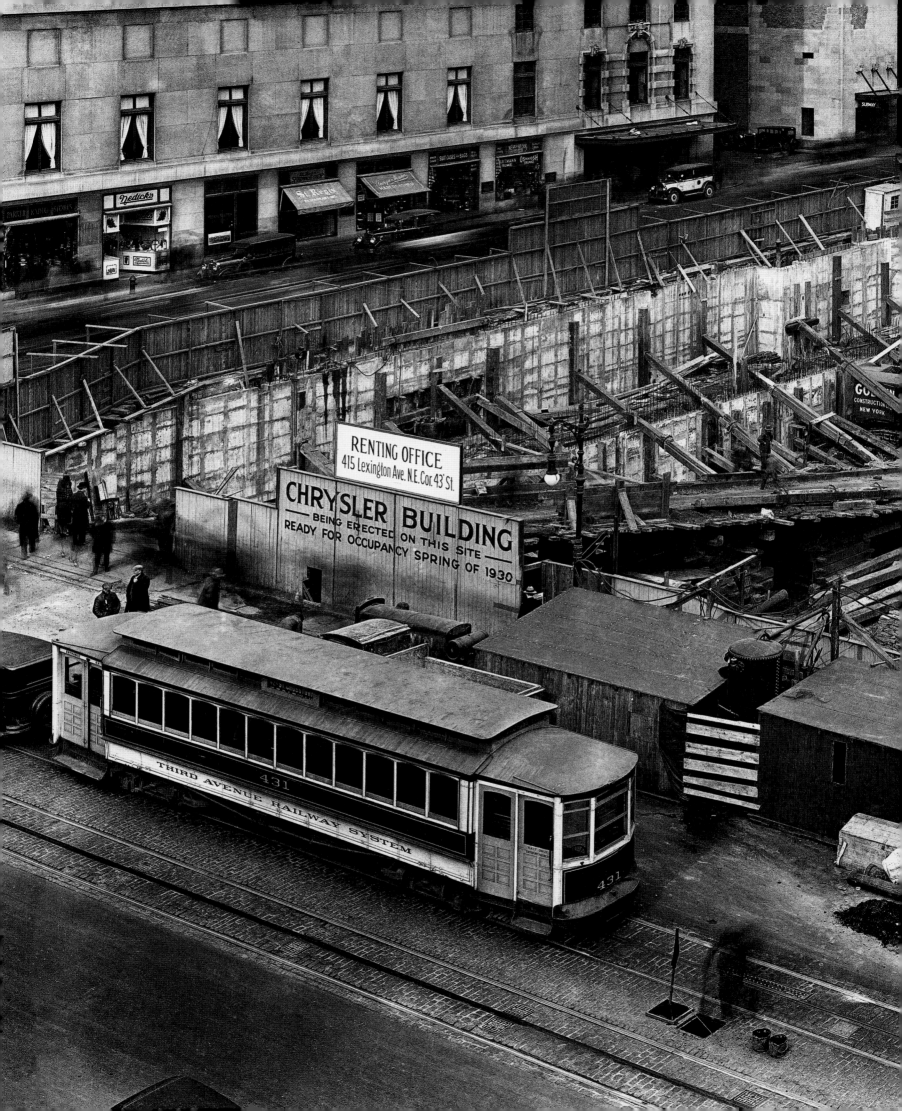

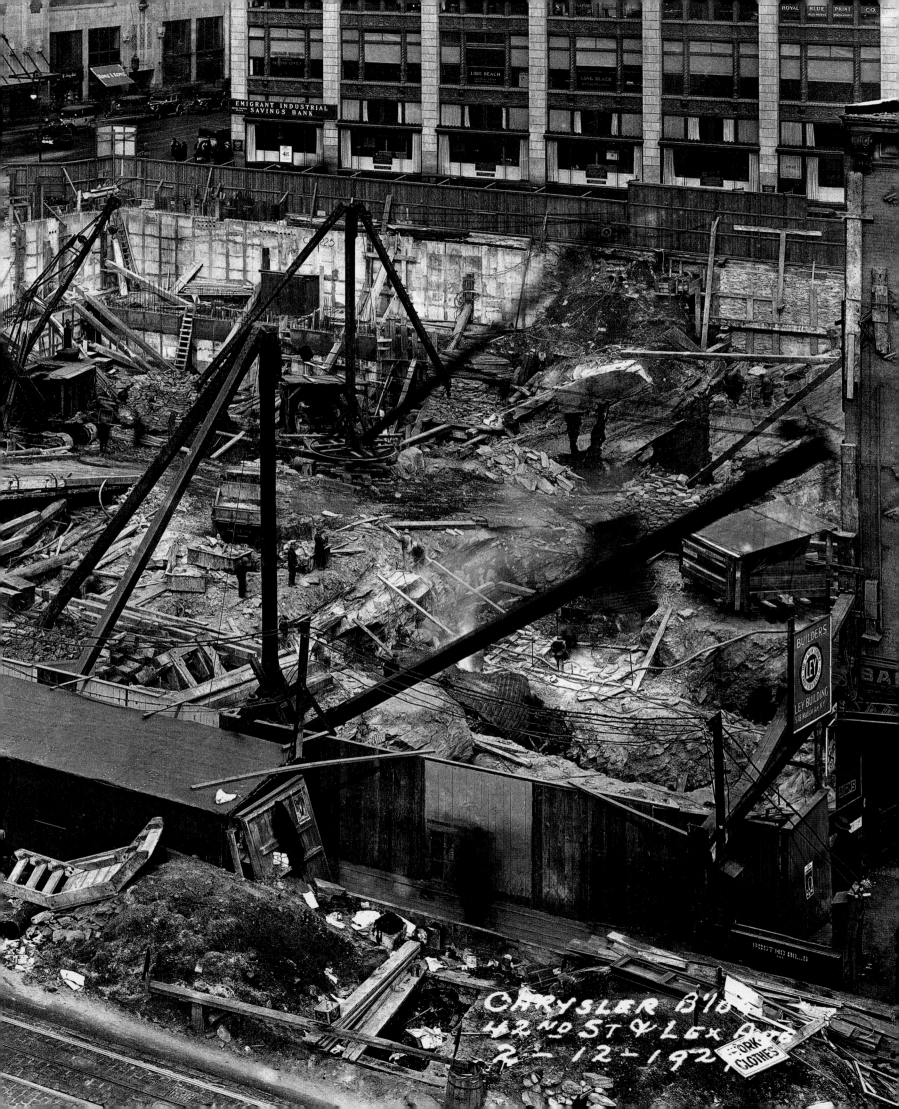

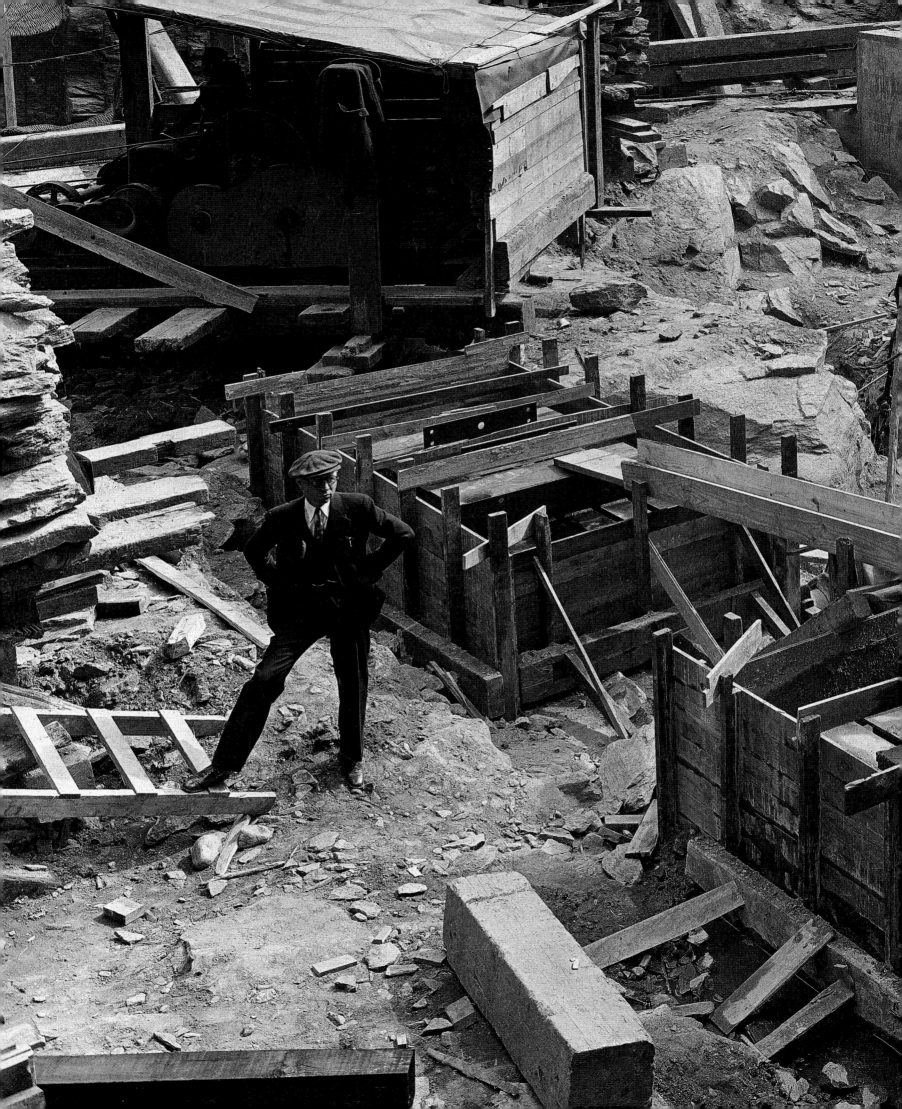

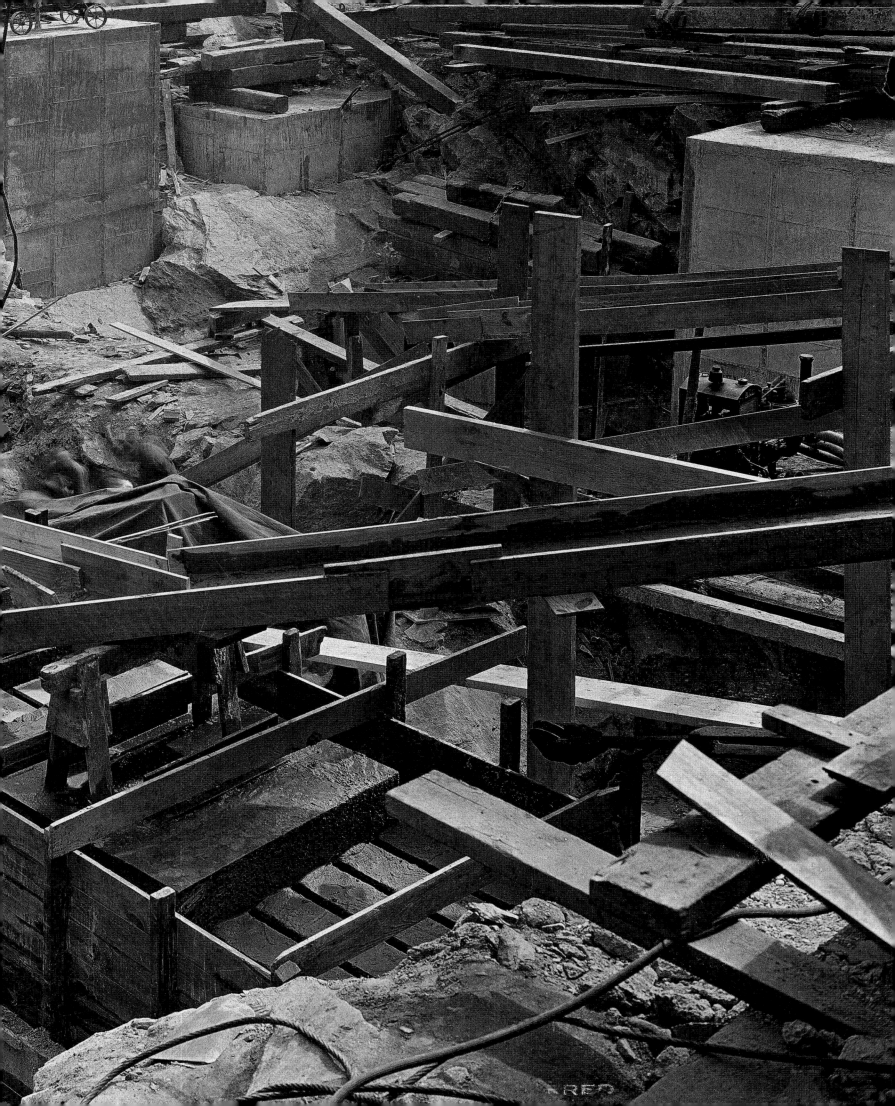

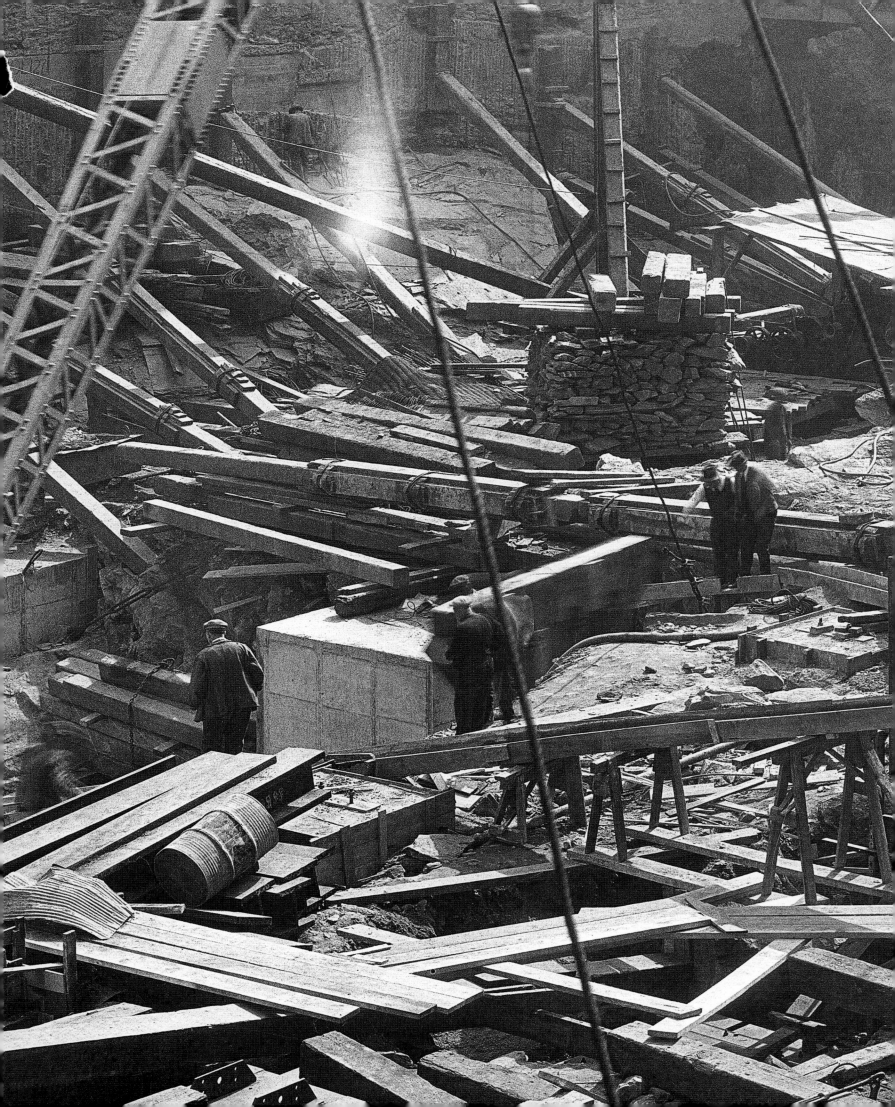

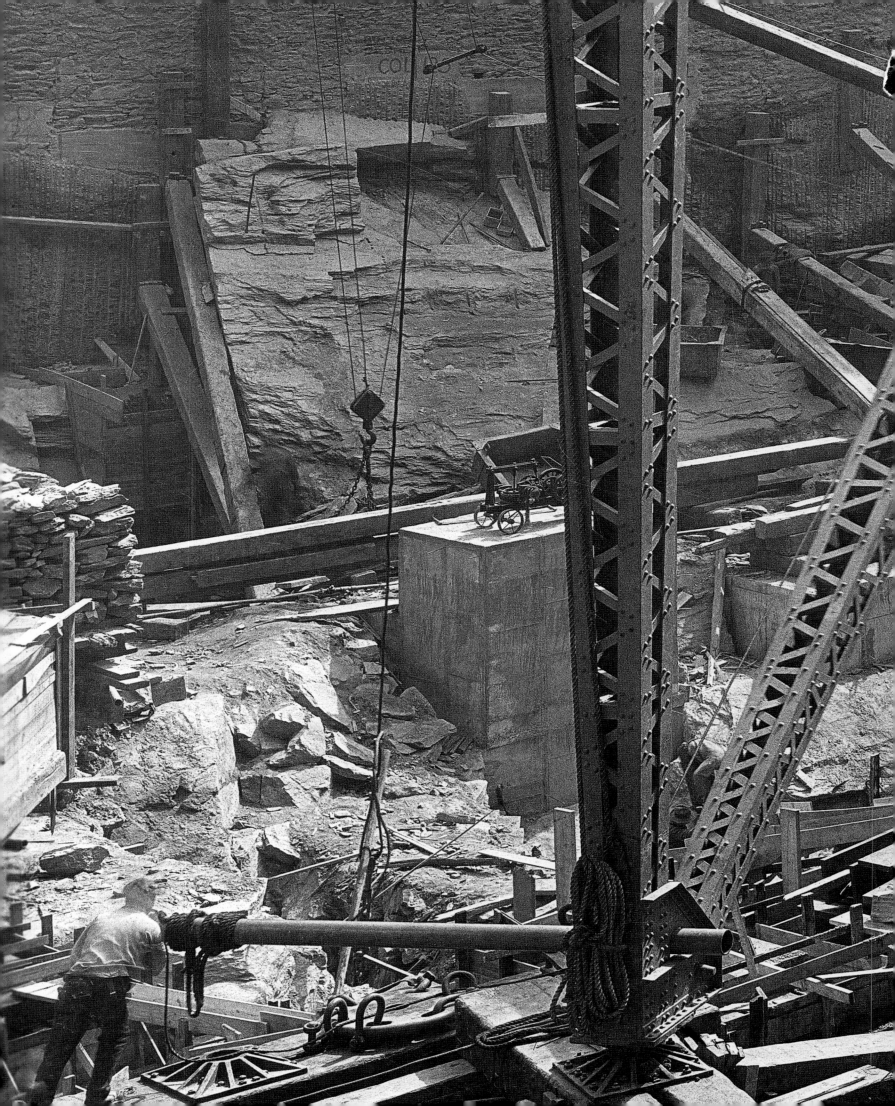

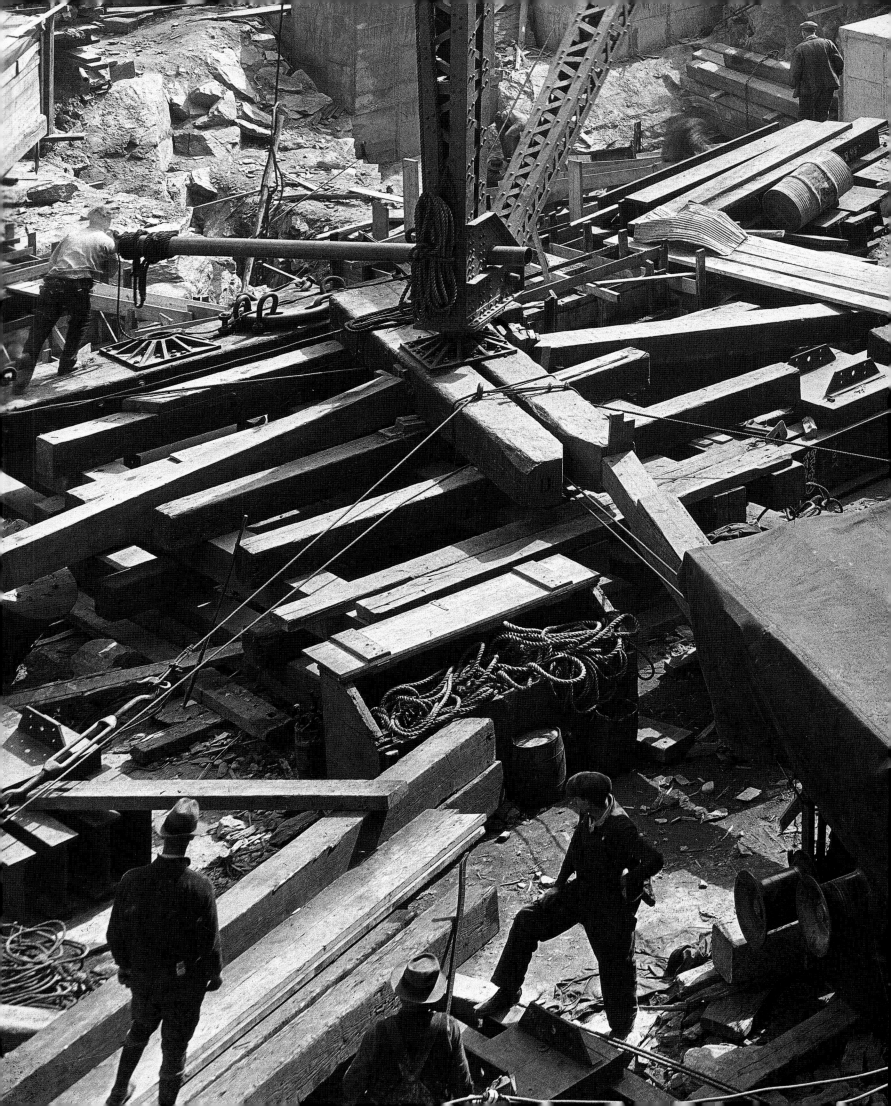

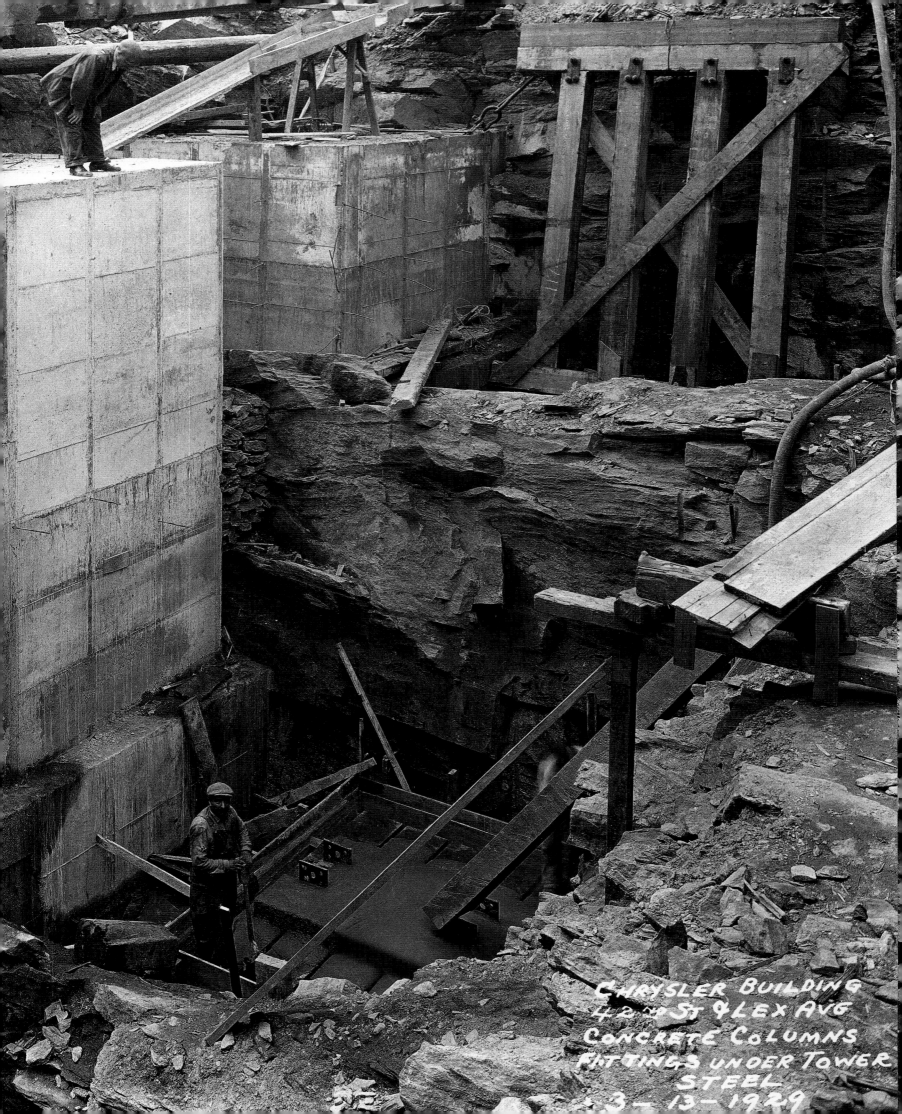

CHRYSLER BUILDING
42ND ST & LEX AVE
CONCRETE COLUMNS
FITTINGS UNDER TOWER
STEEL
3-13-1929

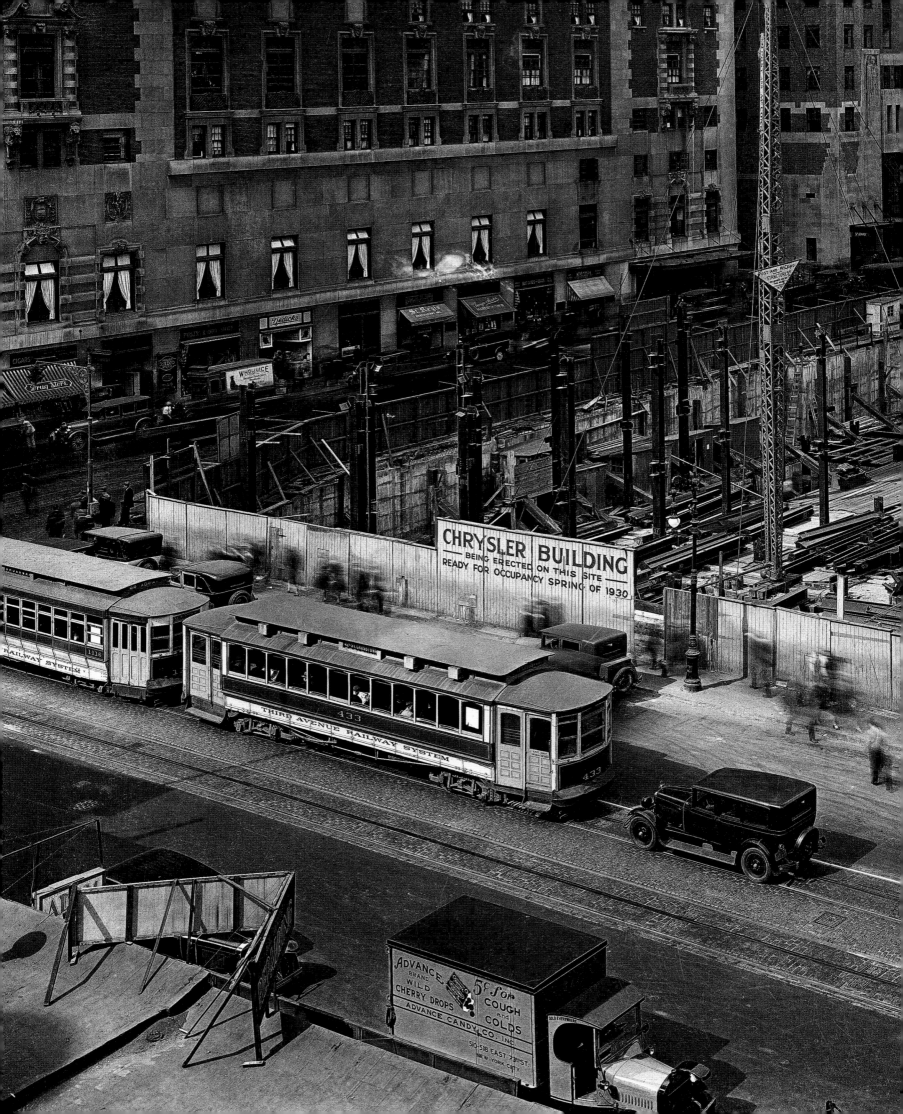

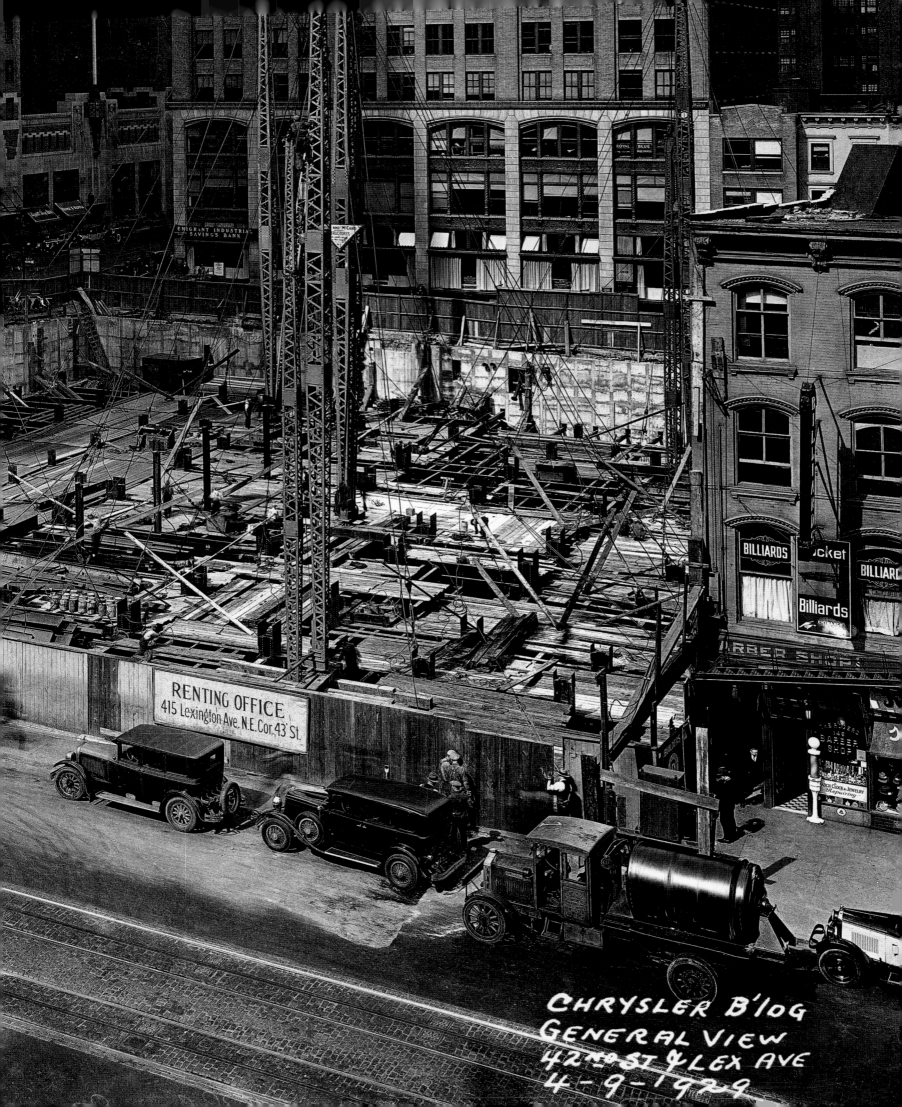

RENTING OFFICE
415 Lexington Ave. N.E. Cor. 43' St.

BILLIARDS

Billiards

CHRYSLER B'LDG
GENERAL VIEW
42ND ST & LEX AVE
4-9-1929

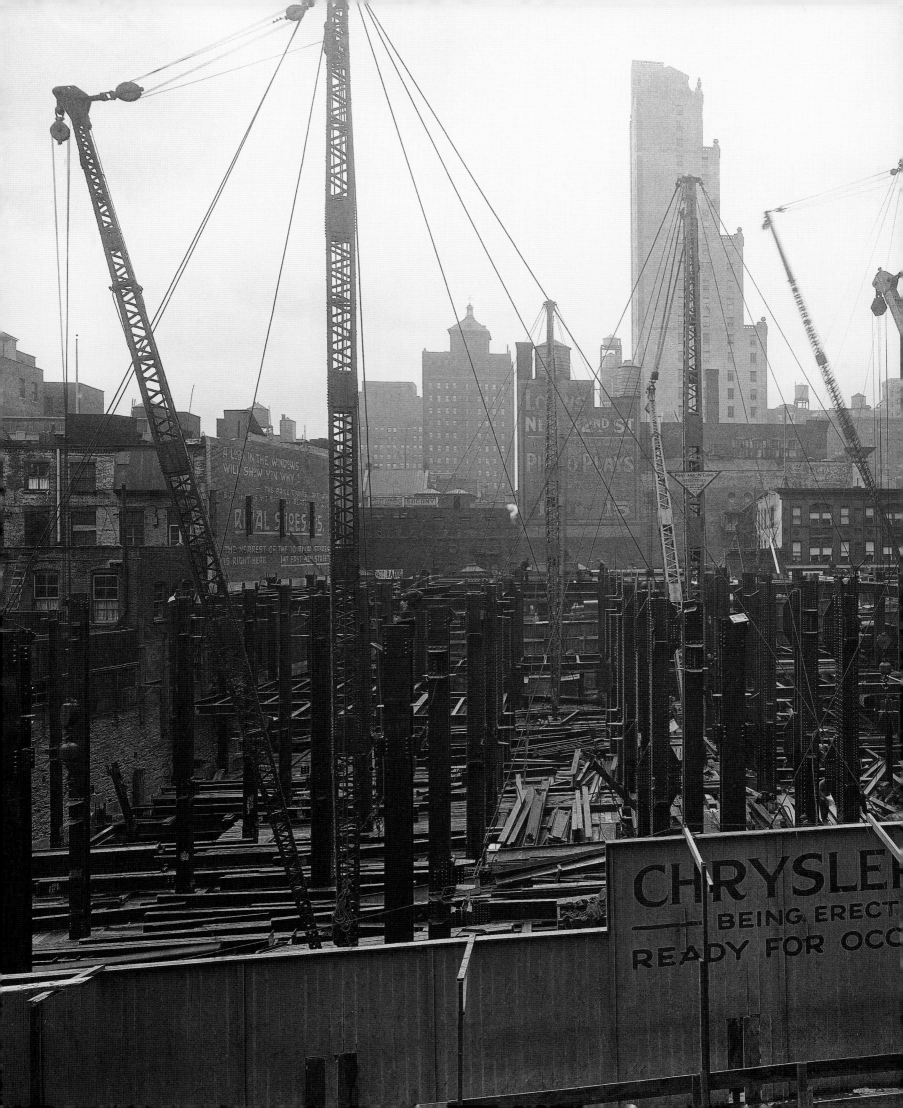

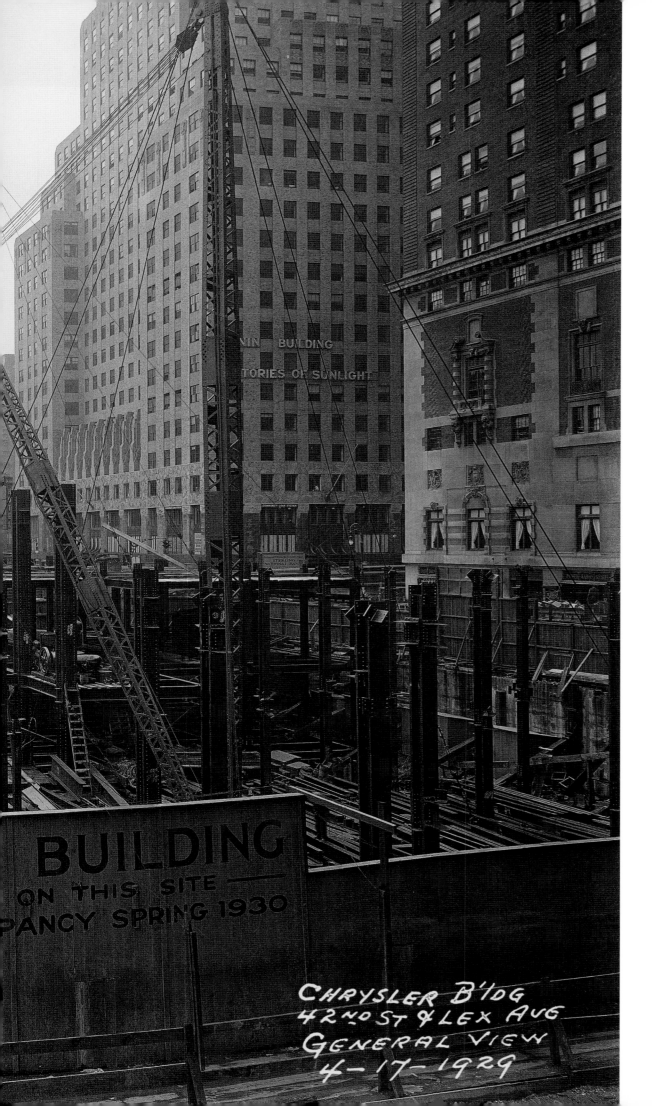

BUILDING
ON THIS SITE
PANCY SPRING 1930

CHRYSLER B'LDG
42ND ST & LEX AVE
GENERAL VIEW
4-17-1929

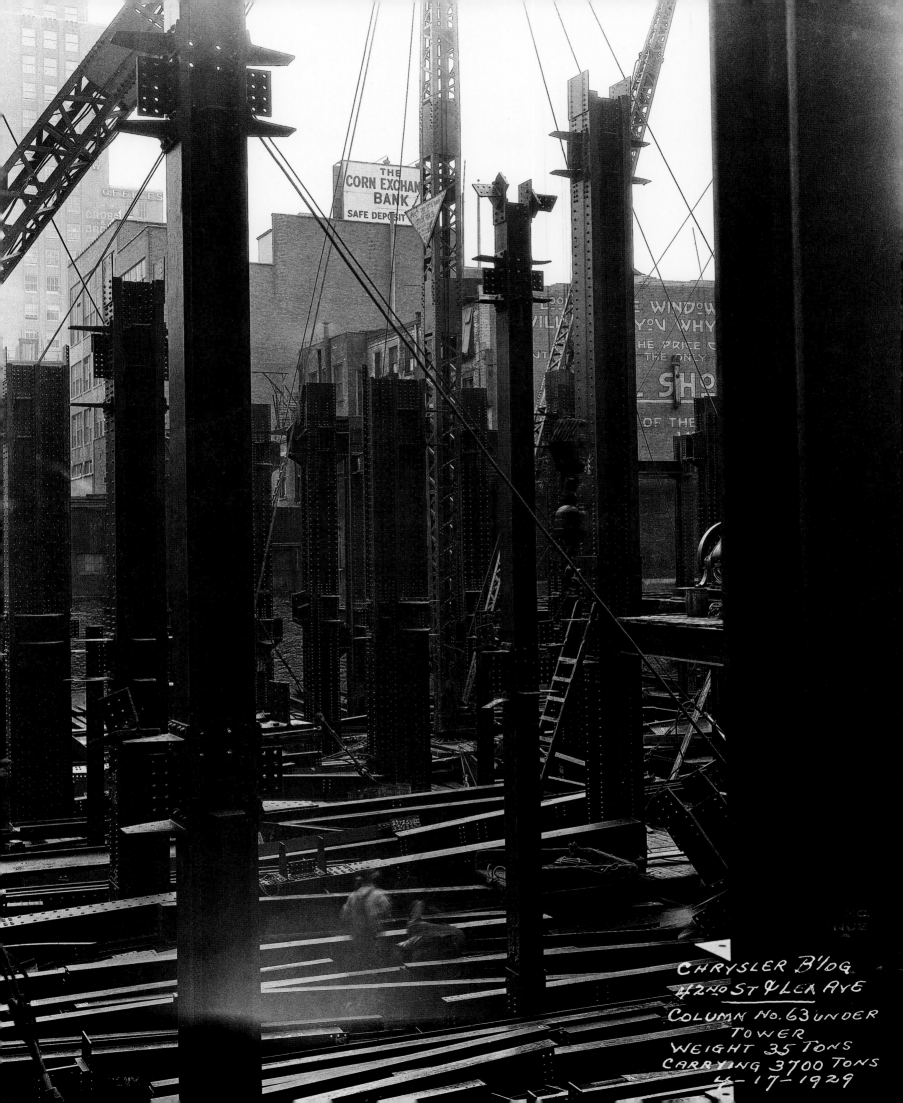

THE
CORN EXCHANGE
BANK

SAFE DEPOSIT

CHRYSLER B'LDG
42ND ST & LEX AVE

COLUMN No. 63 UNDER
TOWER
WEIGHT 35 TONS
CARRYING 3700 TONS
4-17-1929

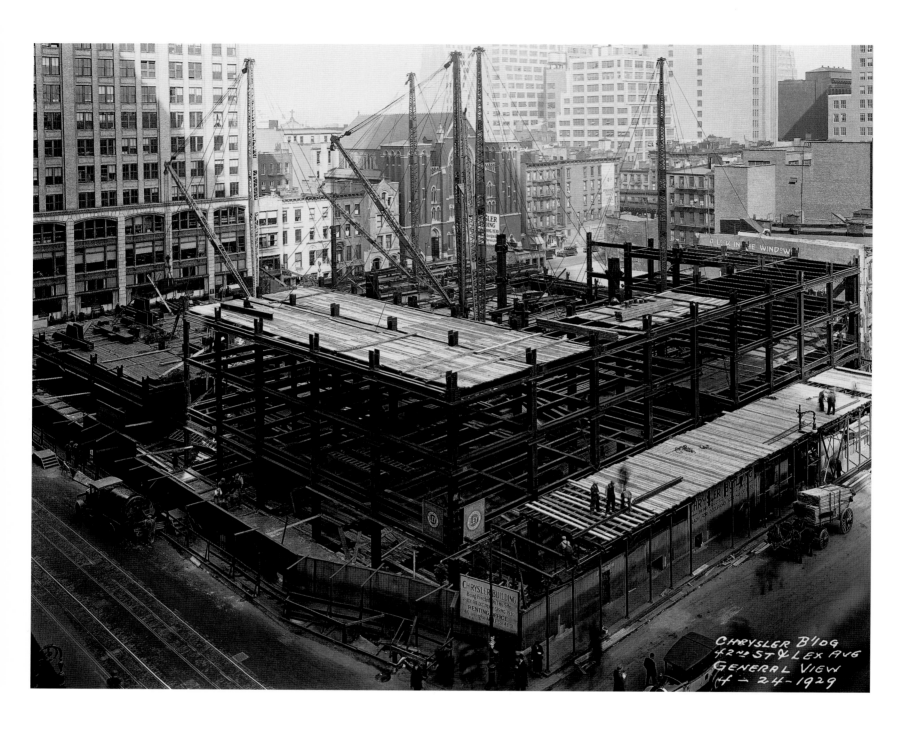

CHRYSLER BLDG
42ND ST & LEX AVE
GENERAL VIEW
4-24-1929

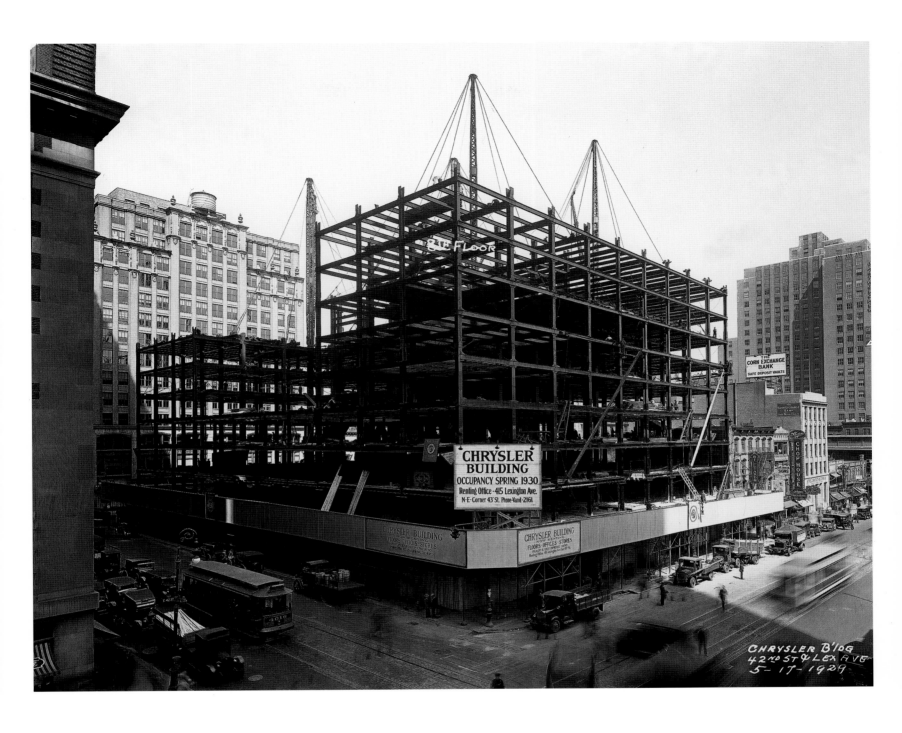

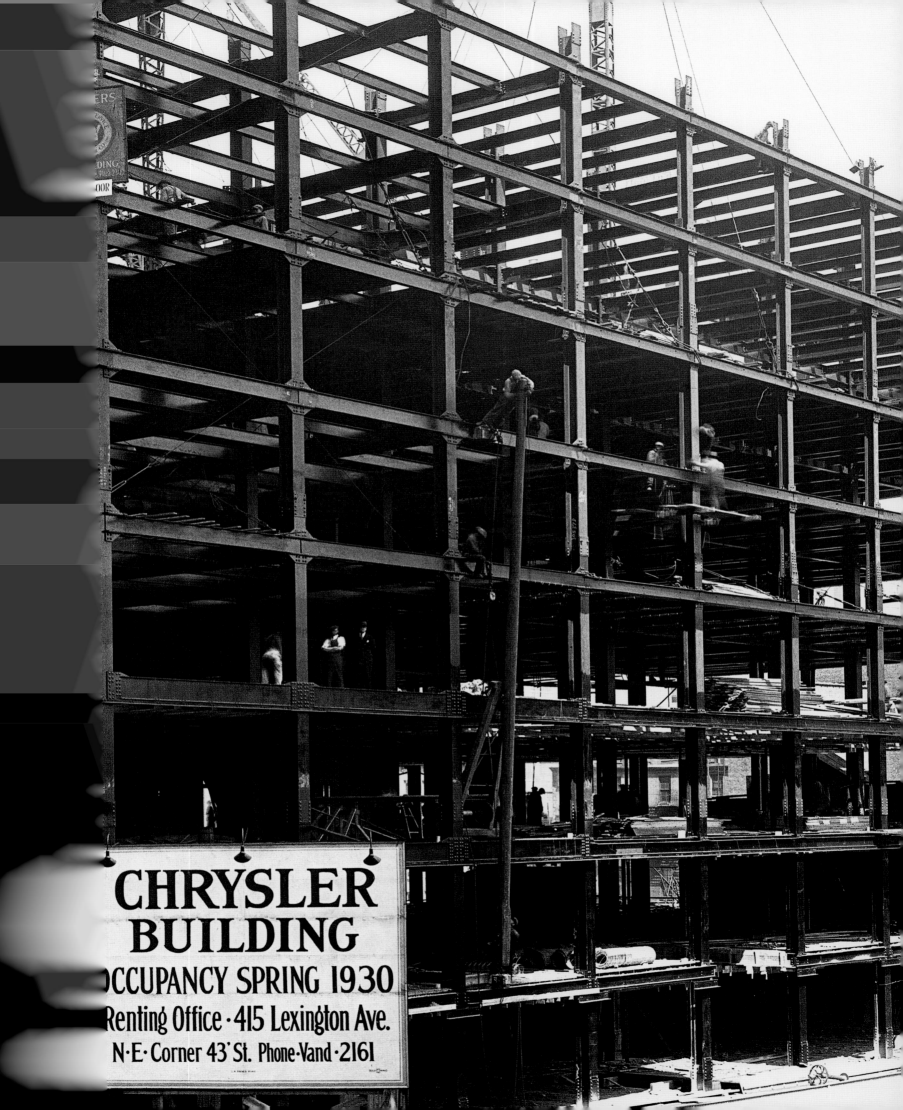

CHRYSLER
BUILDING

OCCUPANCY SPRING 1930

Renting Office · 415 Lexington Ave.

N·E· Corner 43' St. Phone·Vand·2161

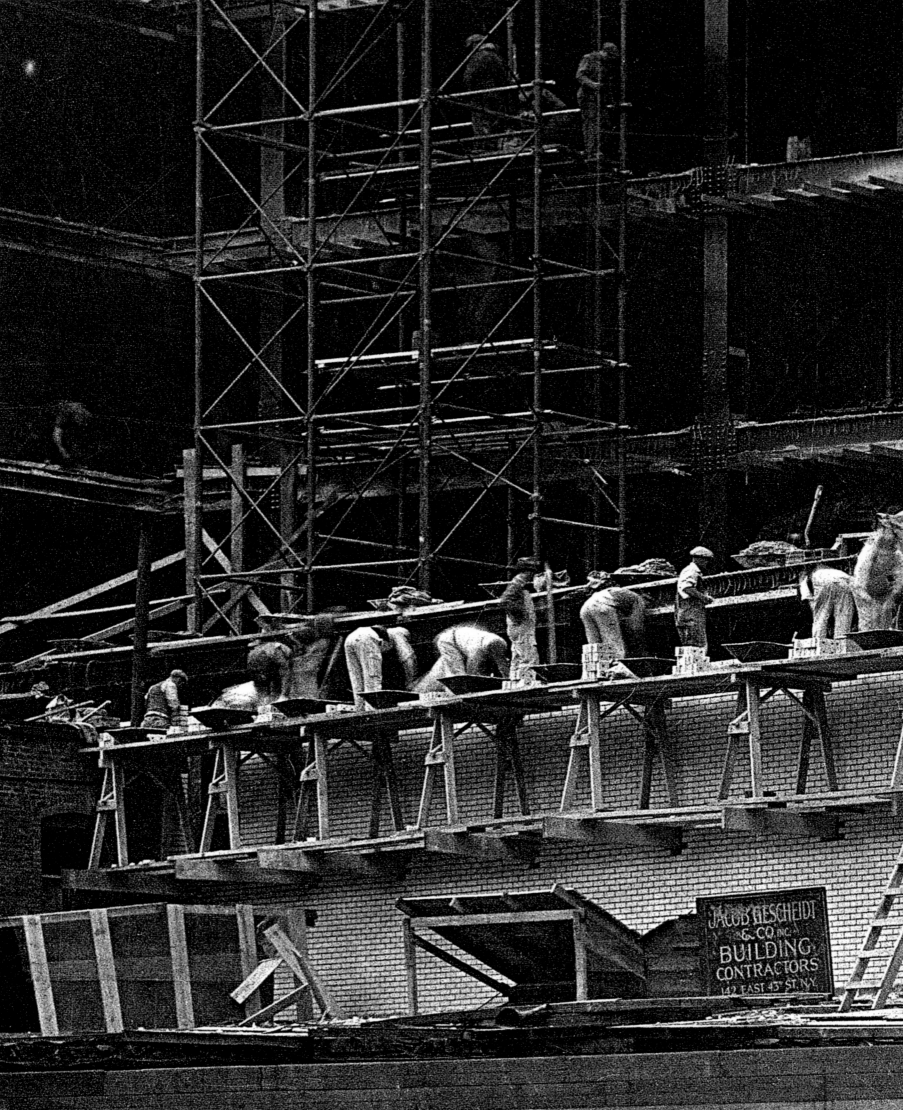

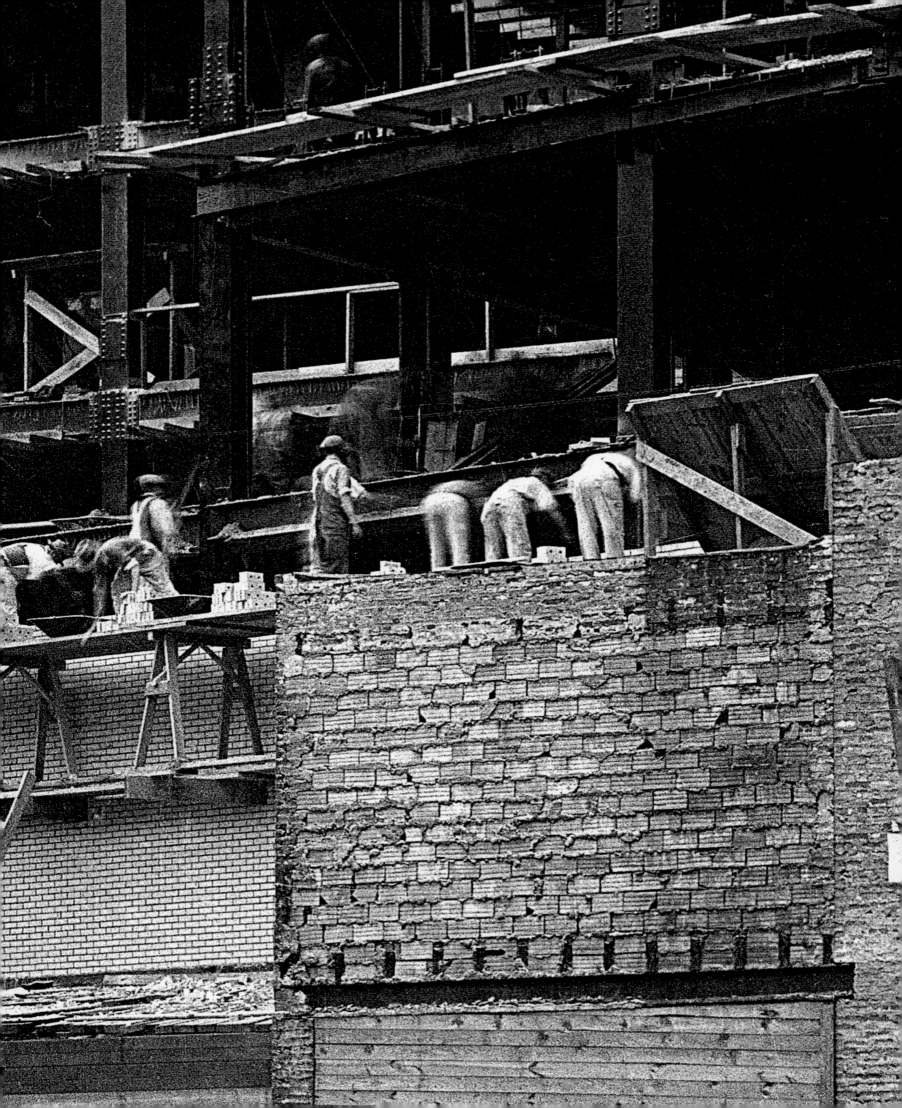

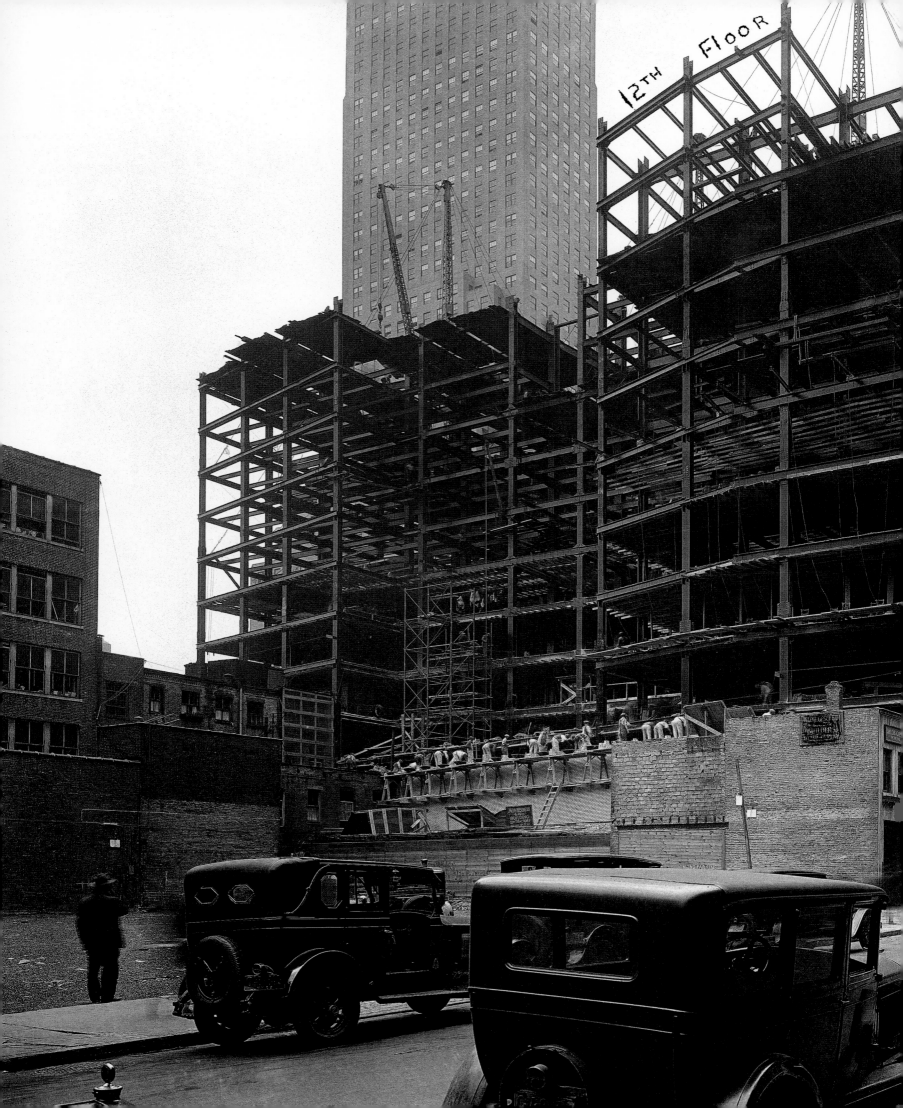

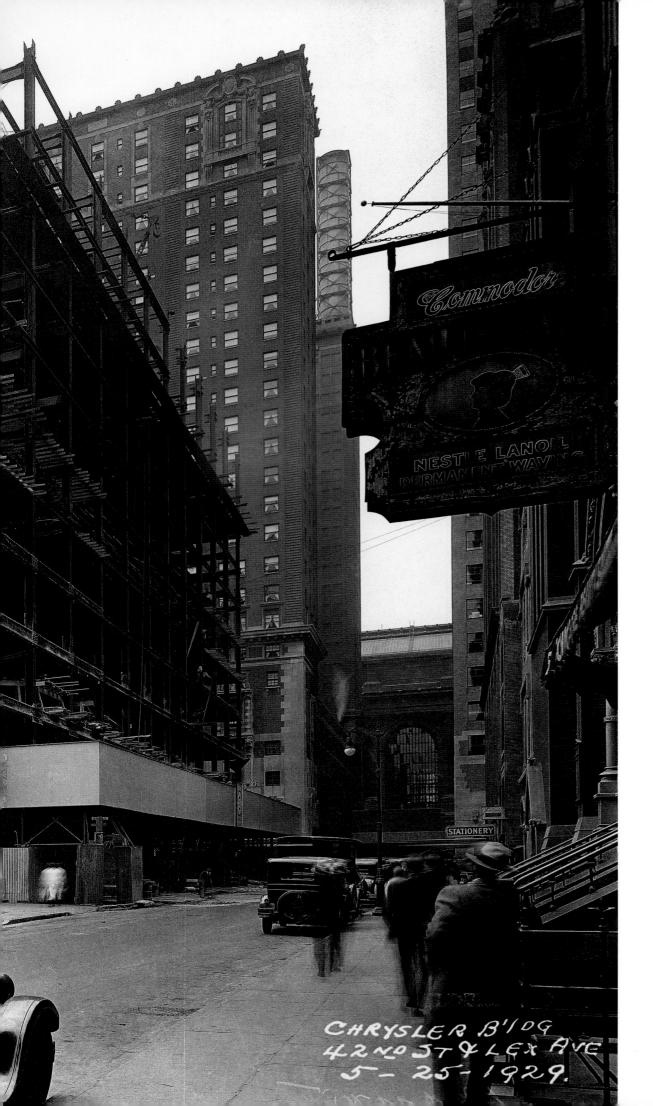

Commodore

NESTLE LANOIL
PERMANENT WAVING

STATIONERY

CHRYSLER B'LDG
42ND ST & LEX AVE
5-25-1929.

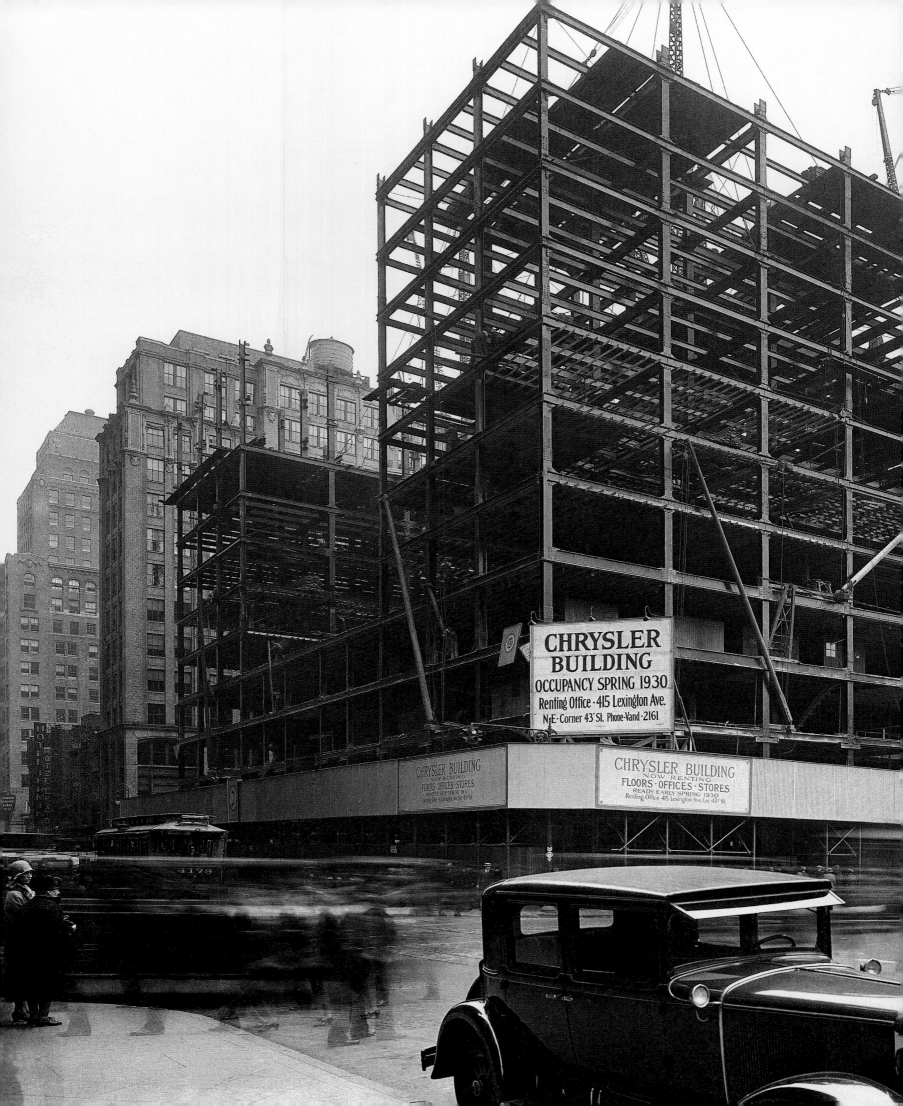

CHRYSLER
BUILDING

OCCUPANCY SPRING 1930

Renting Office · 415 Lexington Ave.

N·E· Corner 43rd St. Phone·Vand·2161

CHRYSLER BUILDING
NOW RENTING
FLOORS · OFFICES · STORES
READY EARLY SPRING 1930
Renting Office 415 Lexington Ave. Cor. 43rd St.

CHRYSLER BUILDING
NOW RENTING
FLOORS · OFFICES · STORES
READY EARLY SPRING 1930
Renting Office 415 Lexington Ave. Cor. 43rd St.

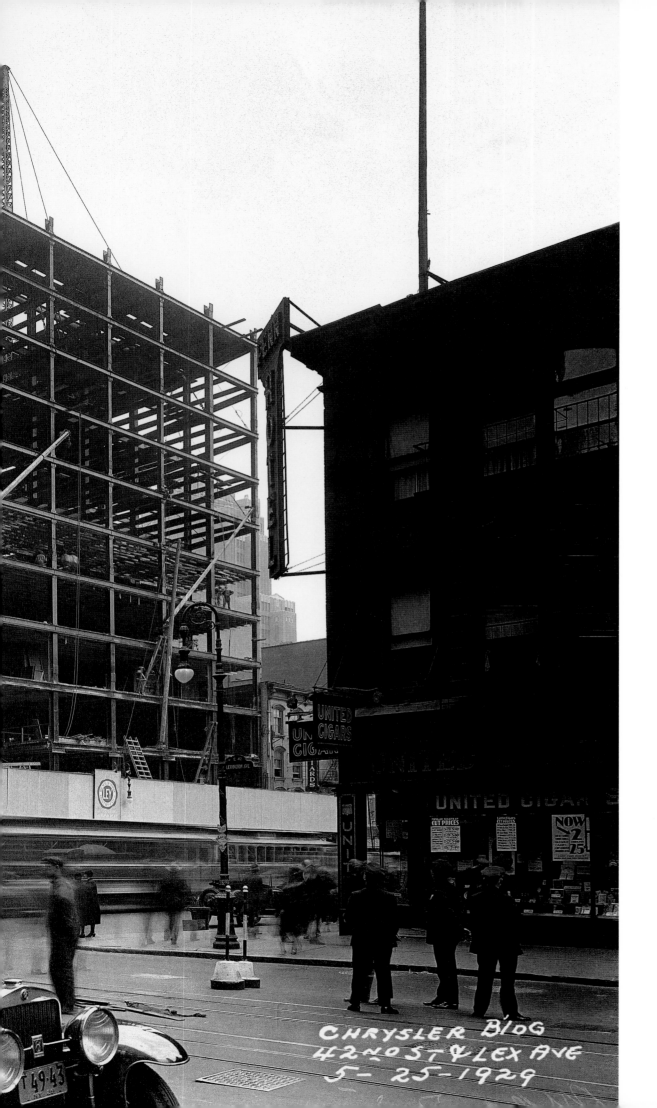

CHRYSLER BLDG
42ND ST & LEX AVE
5-25-1929

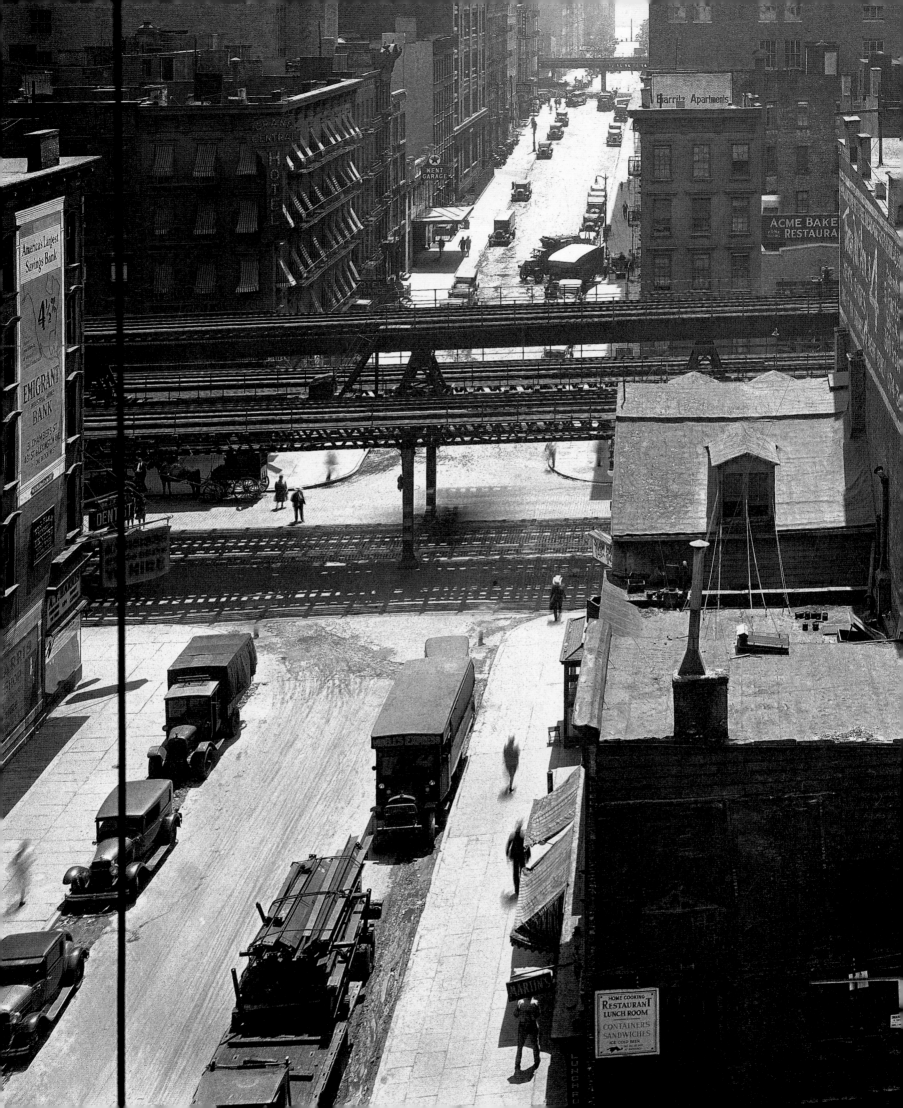

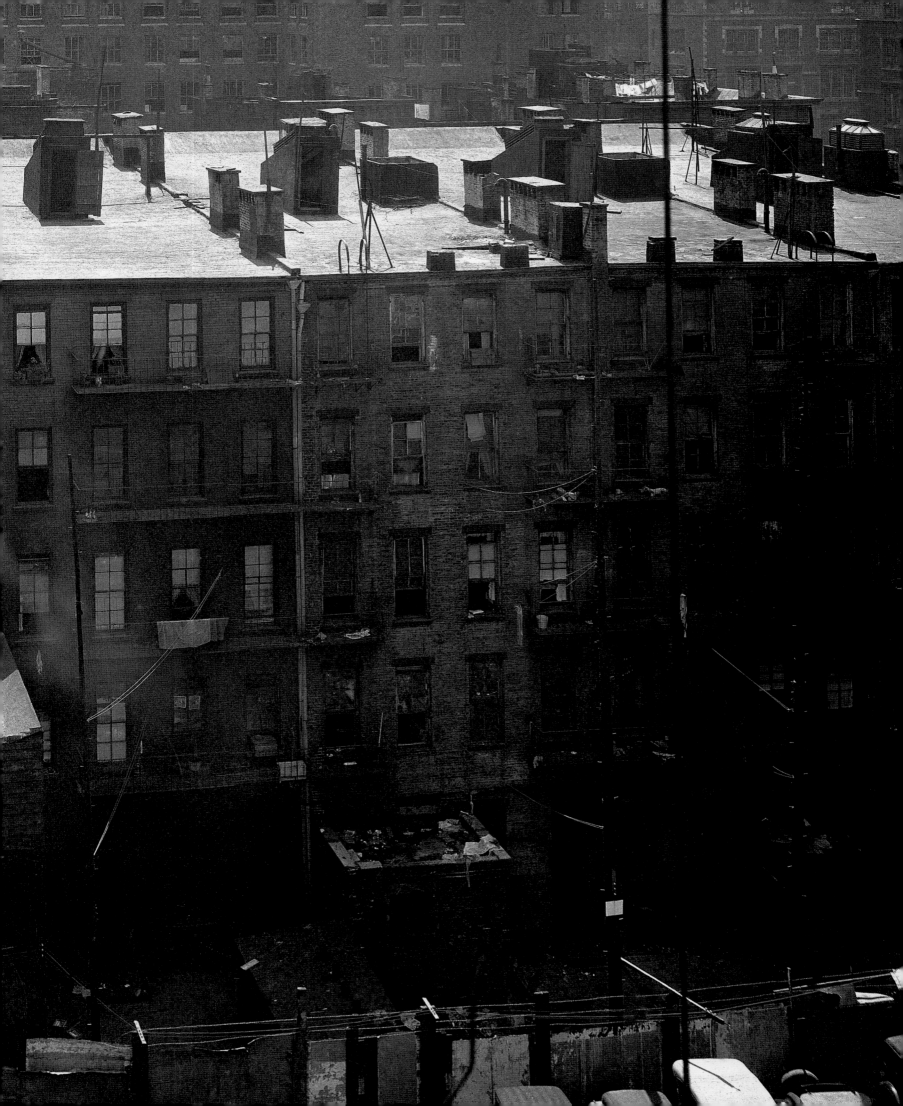

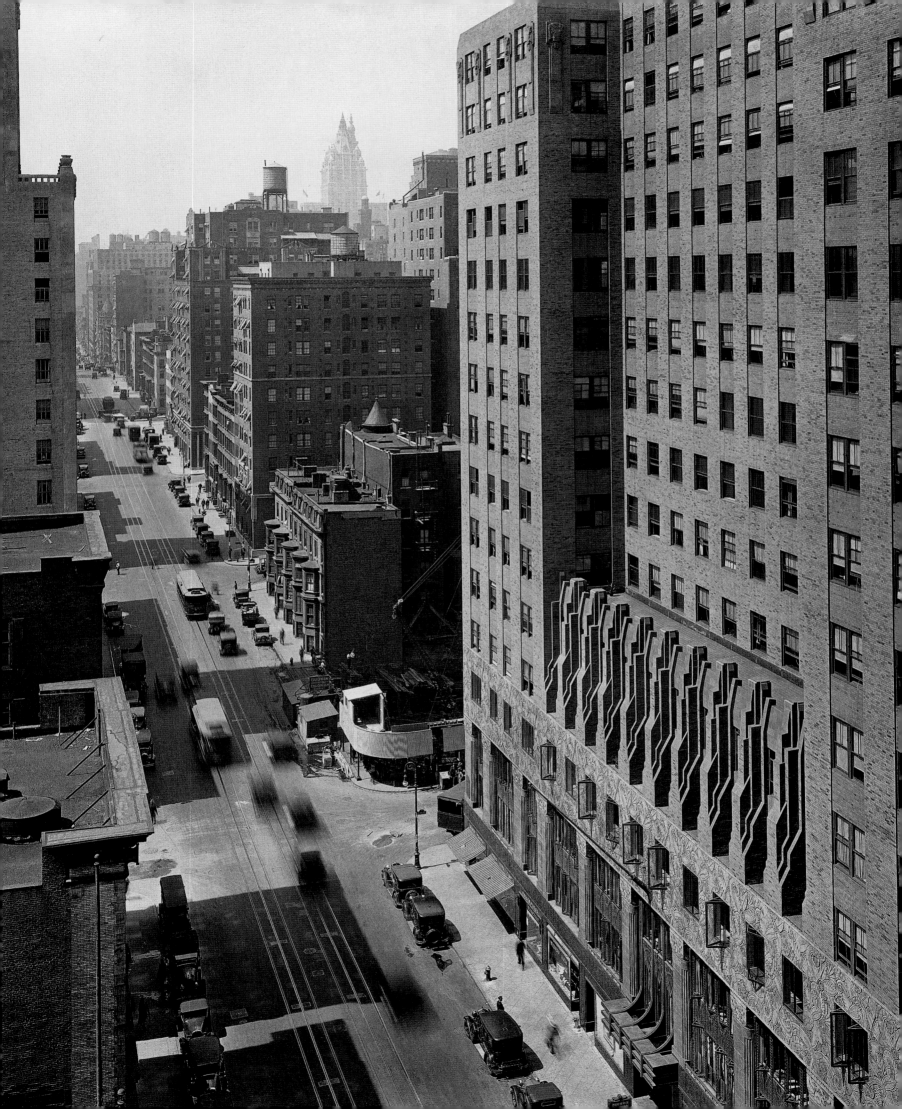

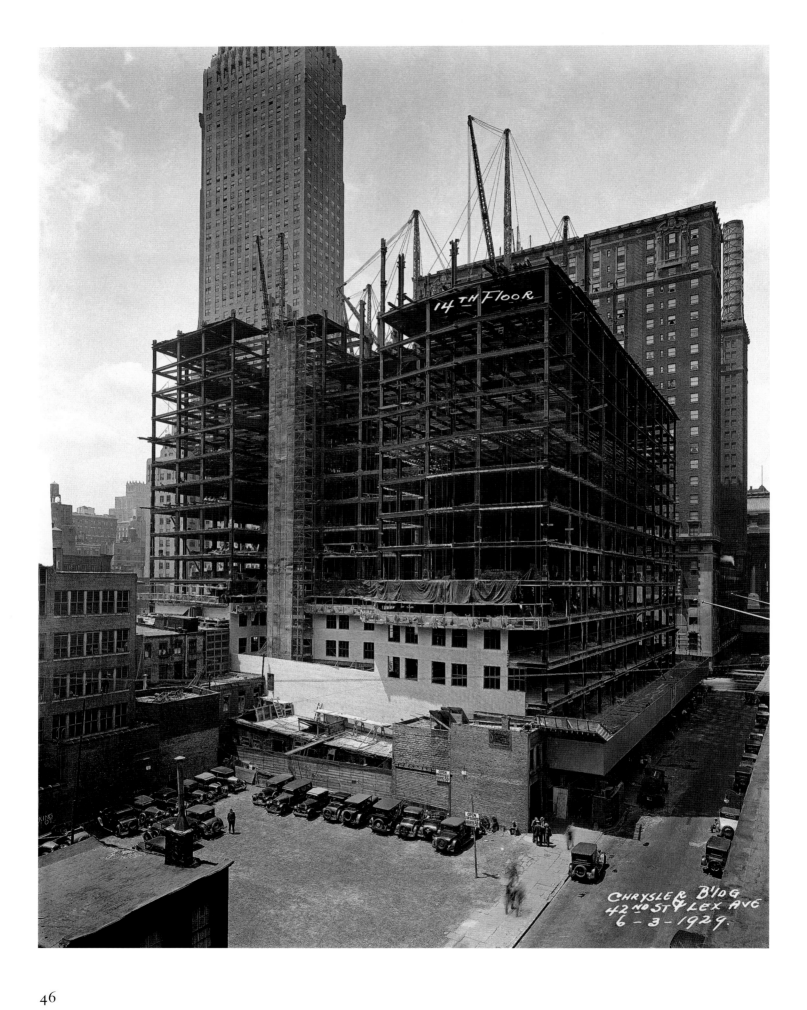

46

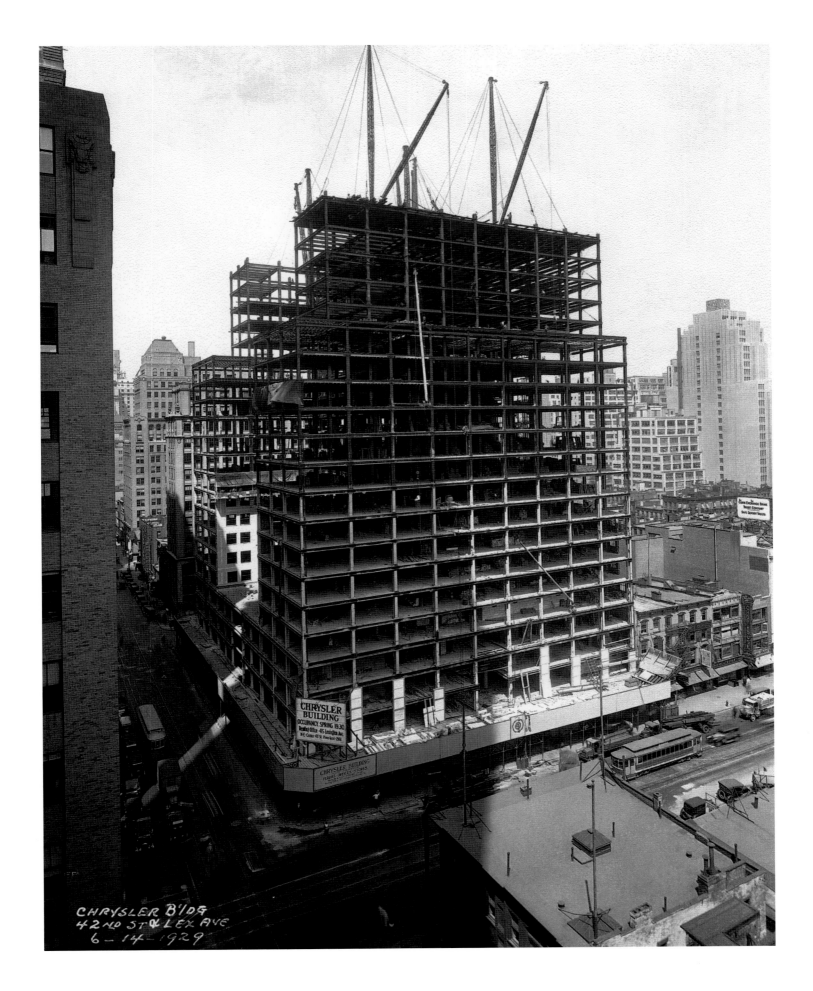

CHRYSLER BLDG
42ND ST & LEX AVE
6-14-1929

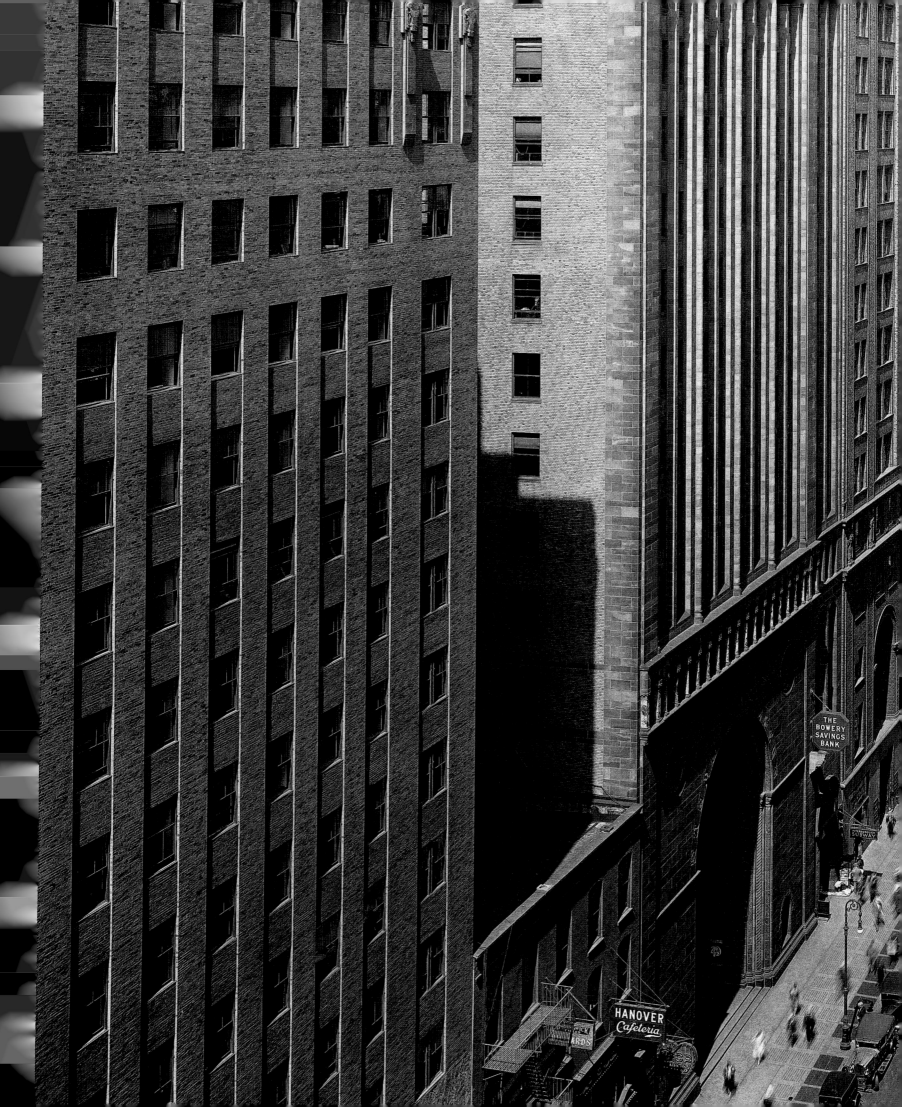

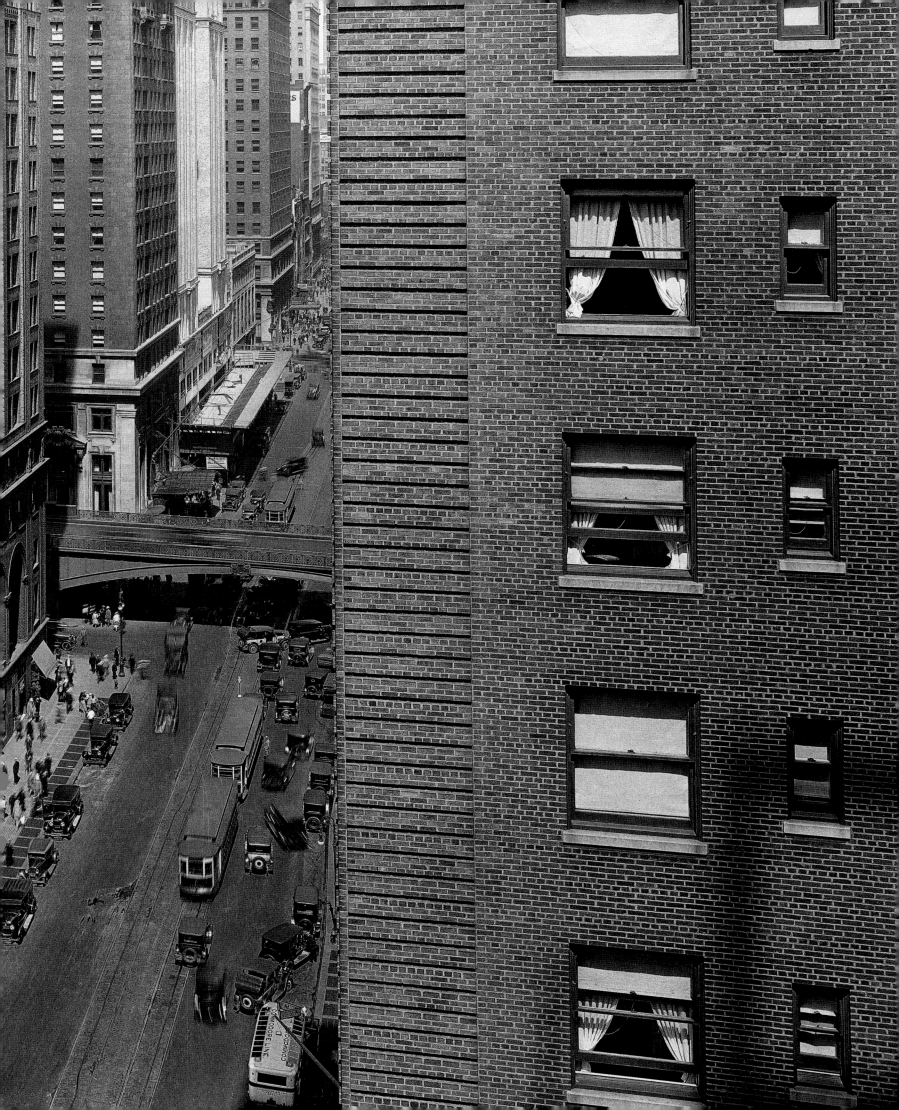

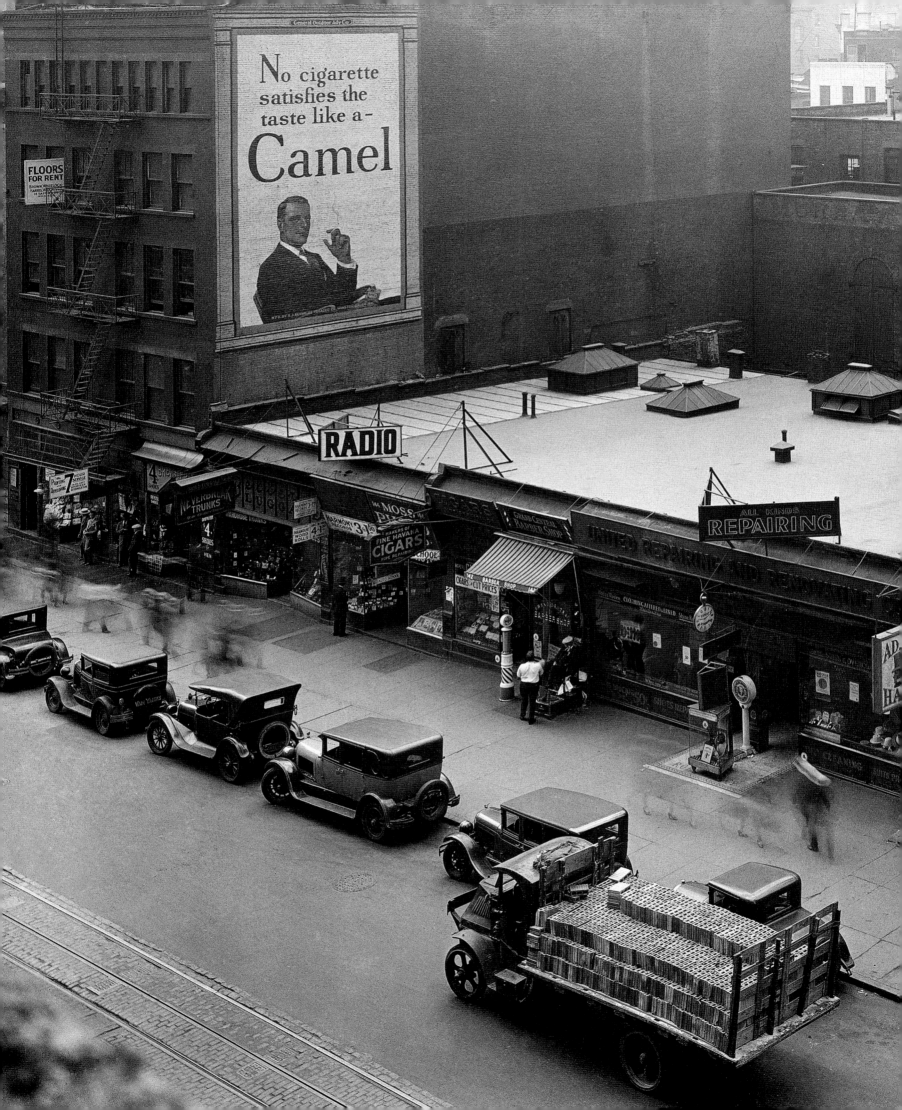

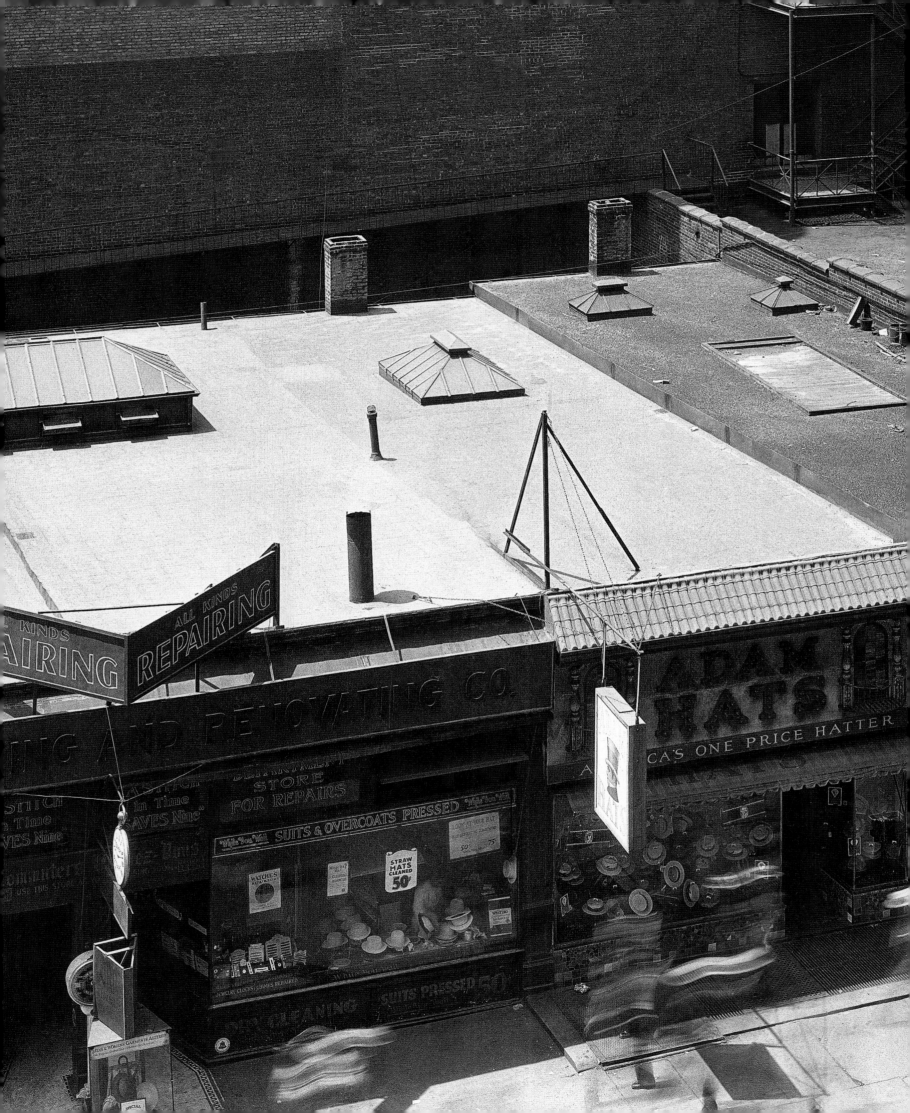

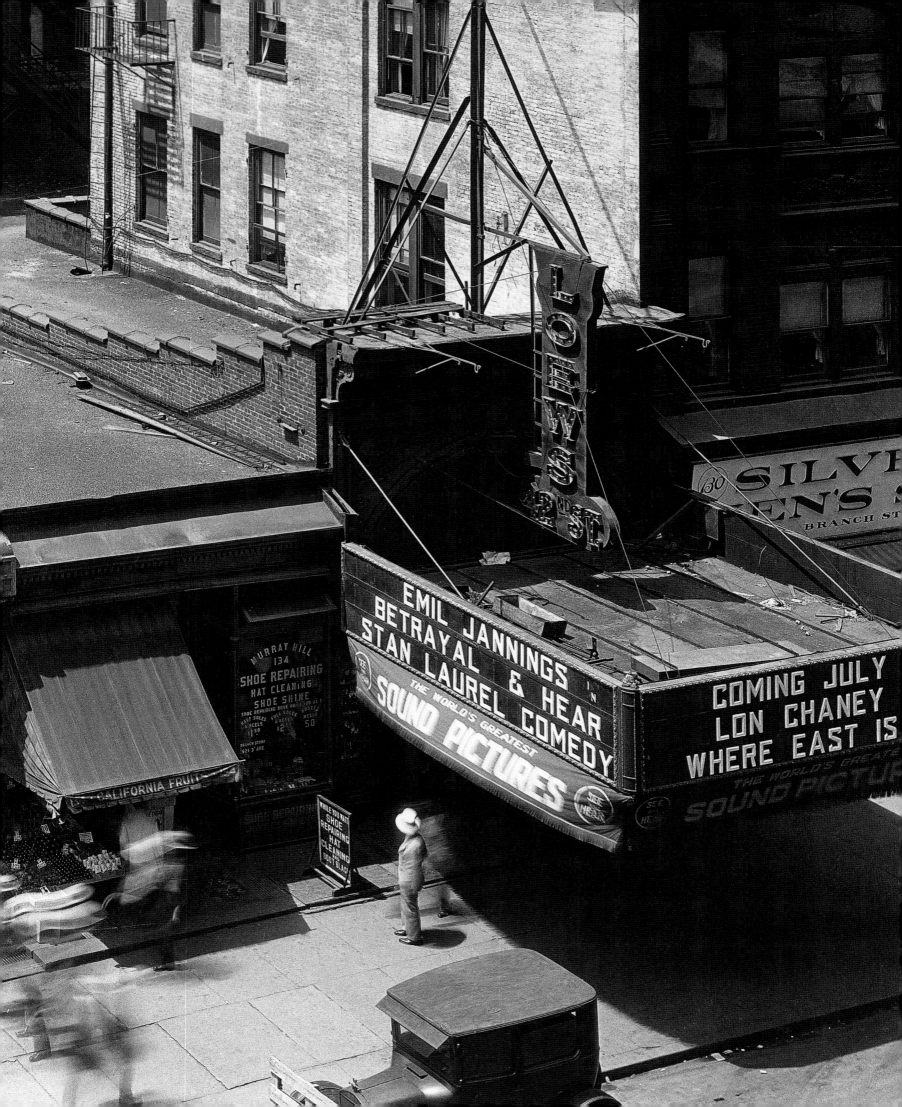

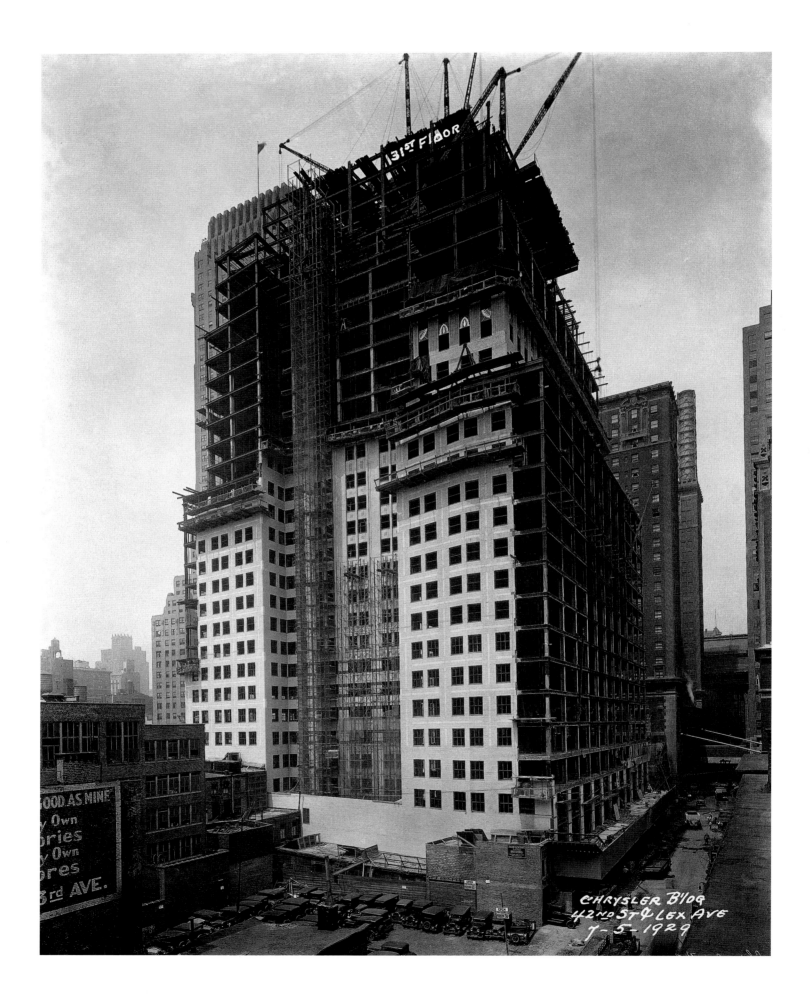

31st FLOOR

GOOD AS MINE
ly Own
ories
ly Own
res
3rd AVE.

CHRYSLER B'LDG
42ND ST & LEX AVE
7-5-1929

54

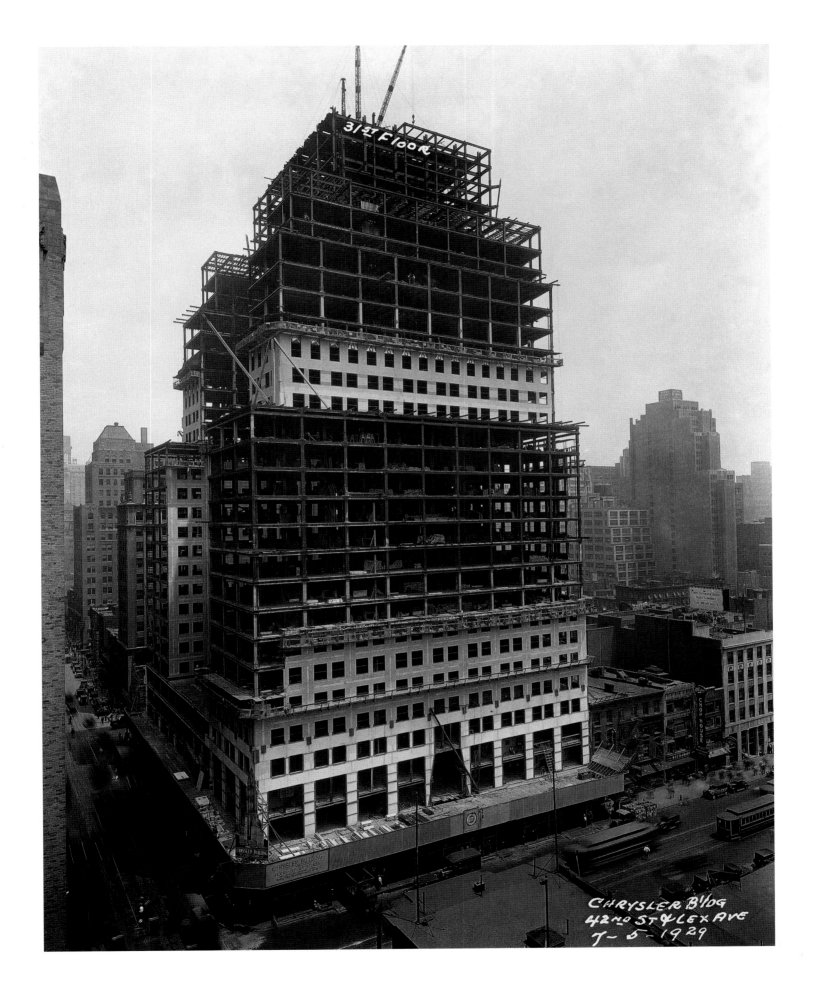

31st Floor

CHRYSLER BLDG
42ND ST & LEX AVE
7-5-1929

55

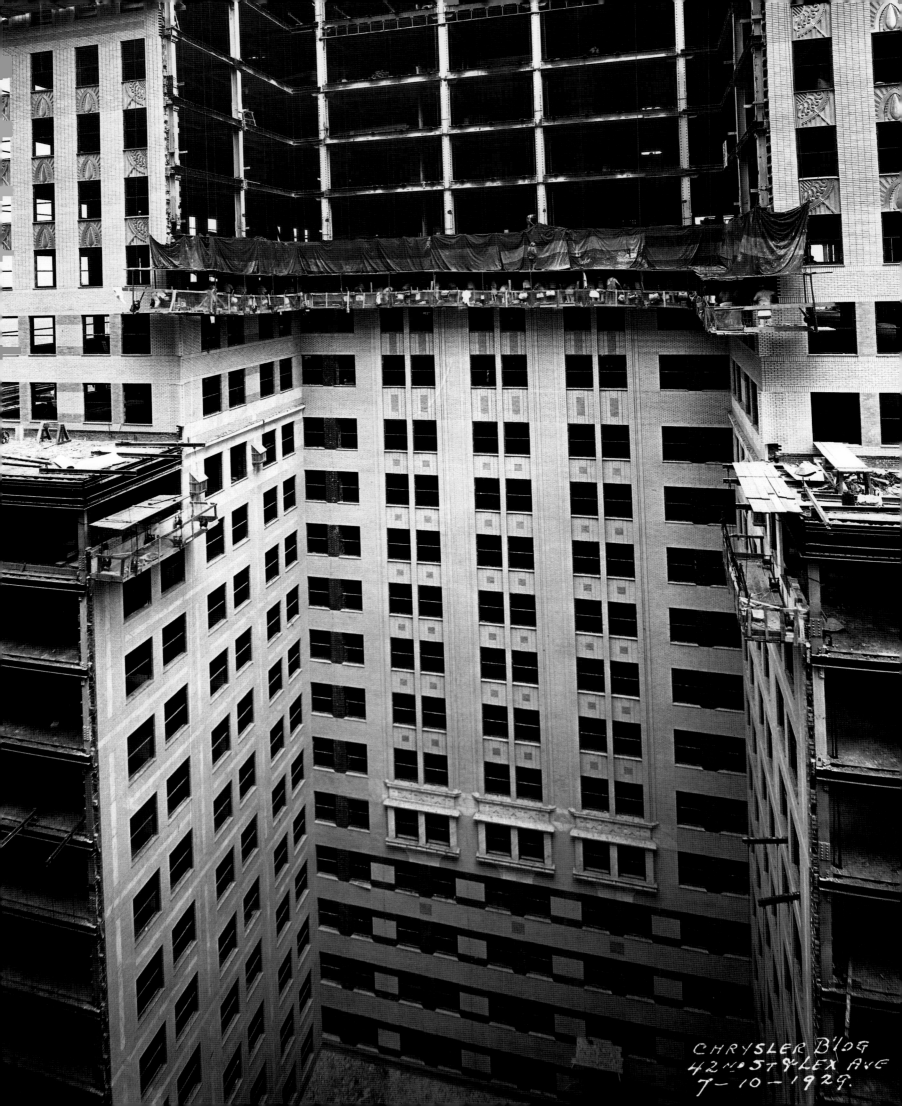

CHRYSLER B'LDG
42ND ST & LEX AVE
7-10-1929.

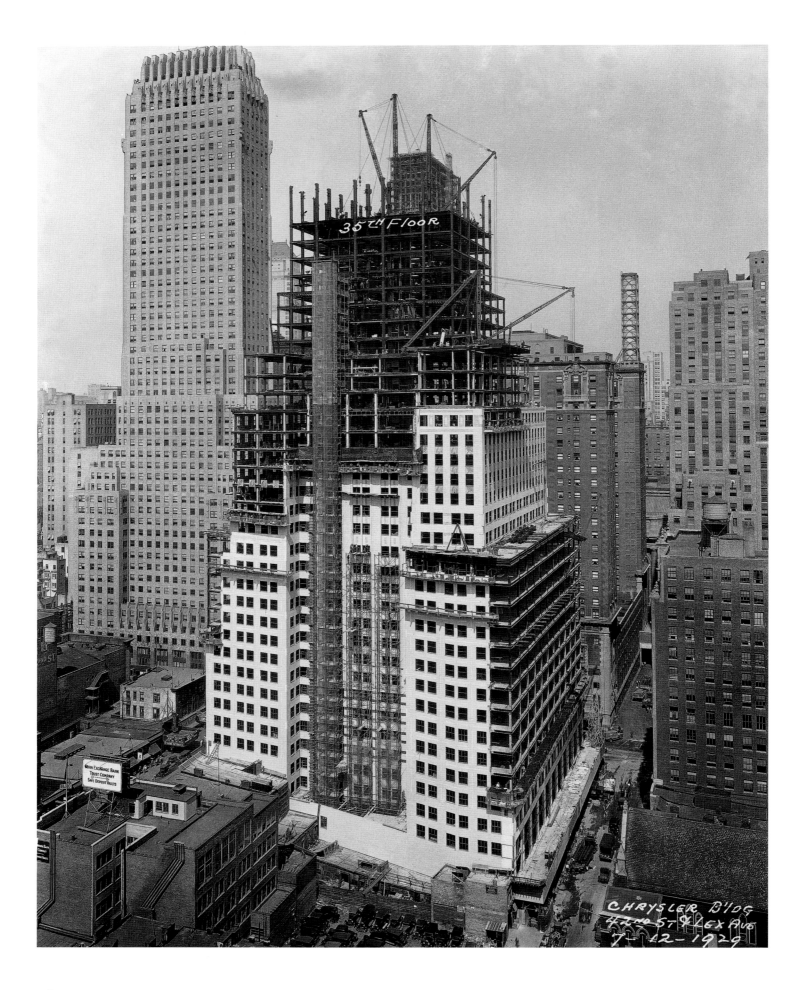

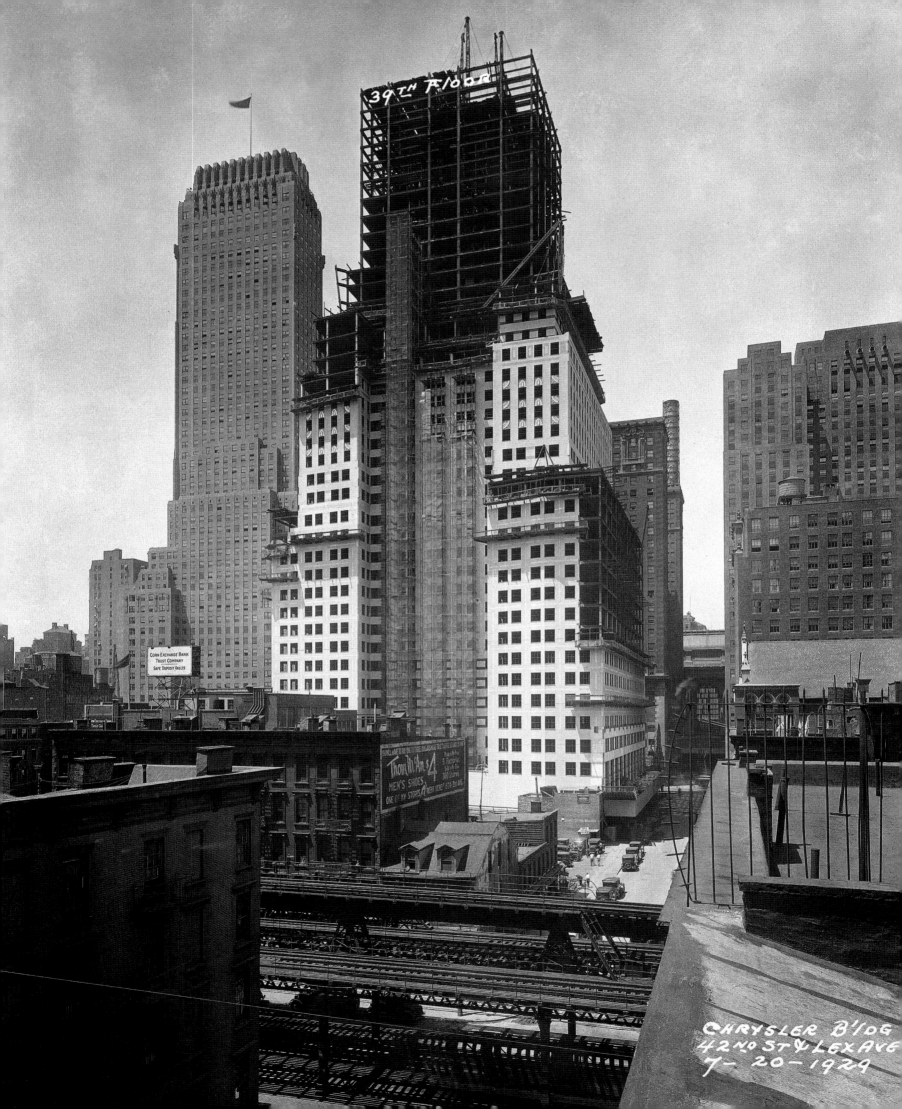

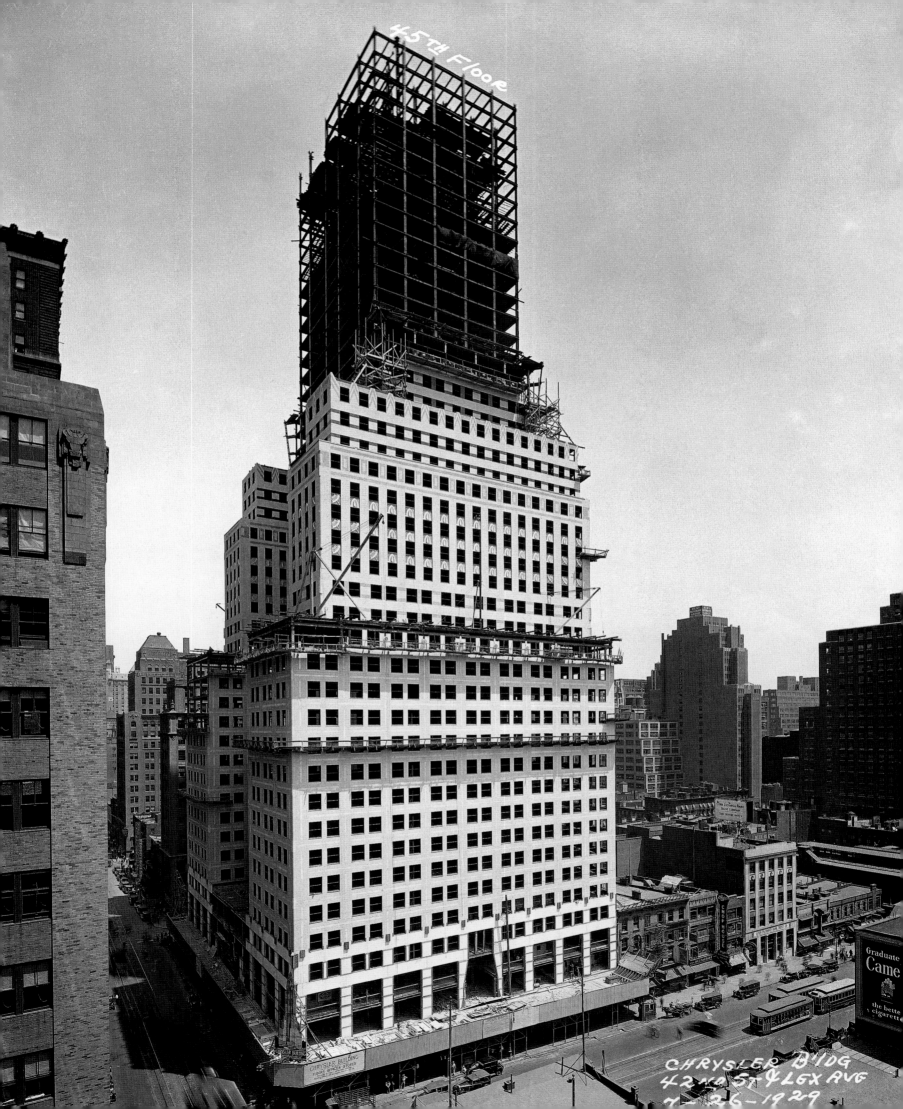

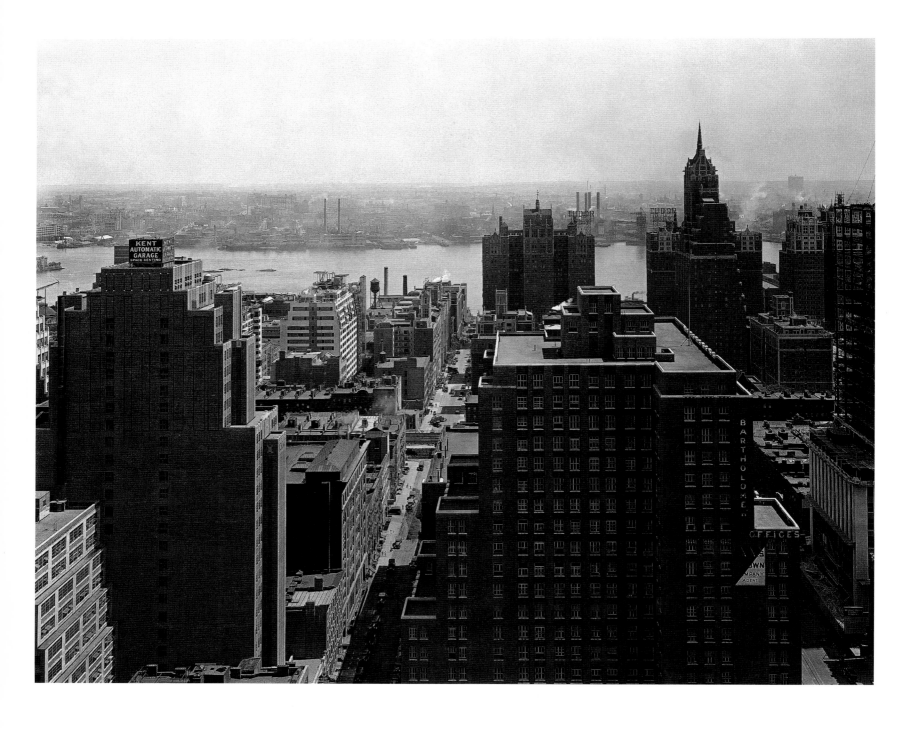

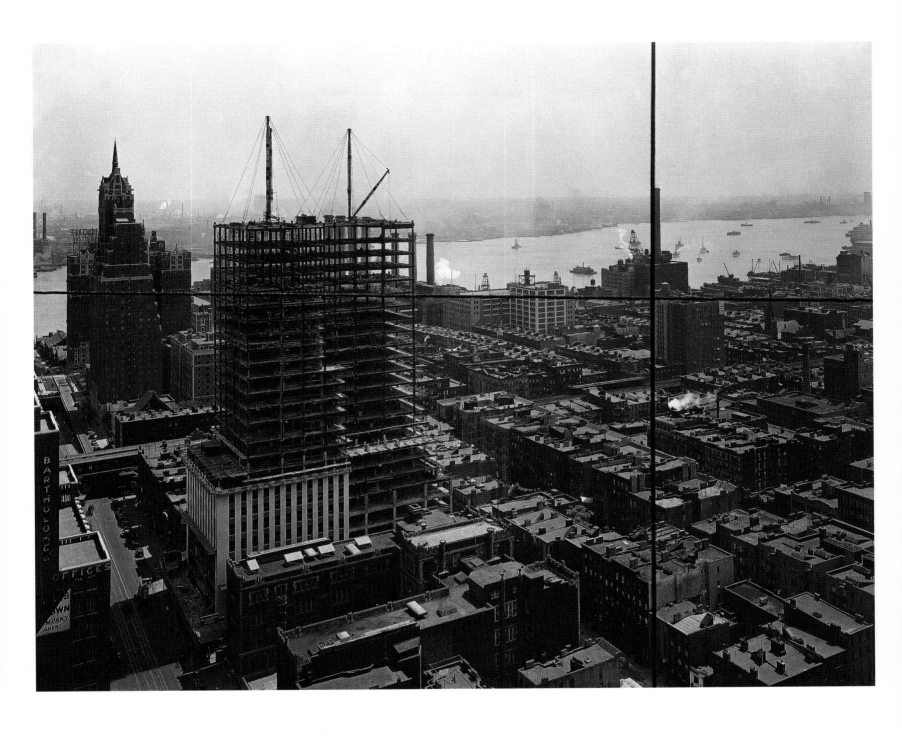

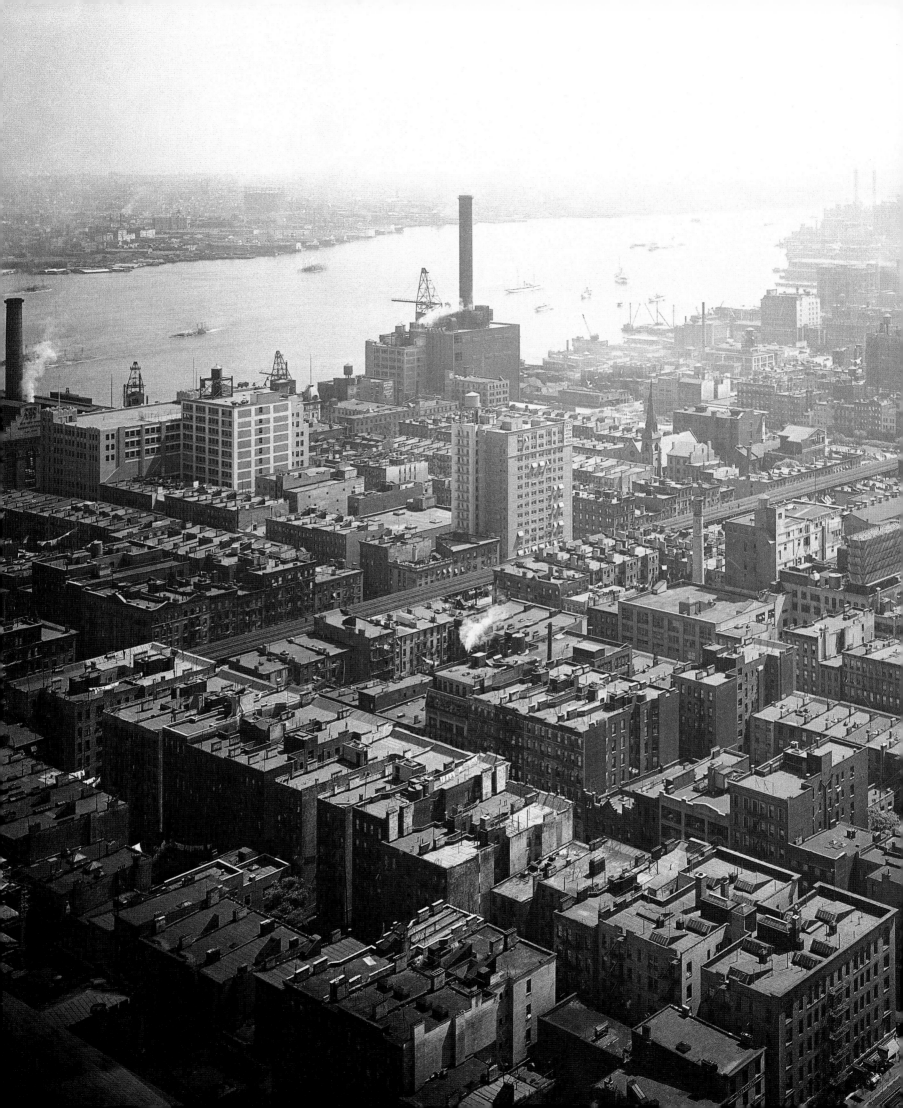

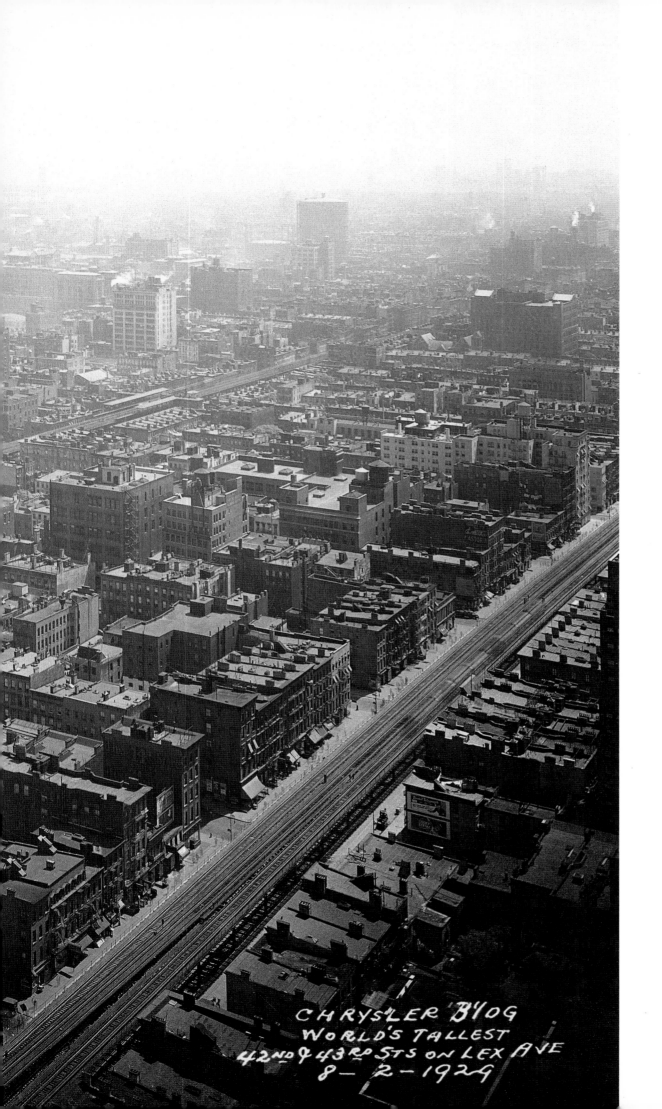

CHRYSLER BLDG
WORLD'S TALLEST
42ND & 43RD STS ON LEX AVE
8 - 2 - 1929

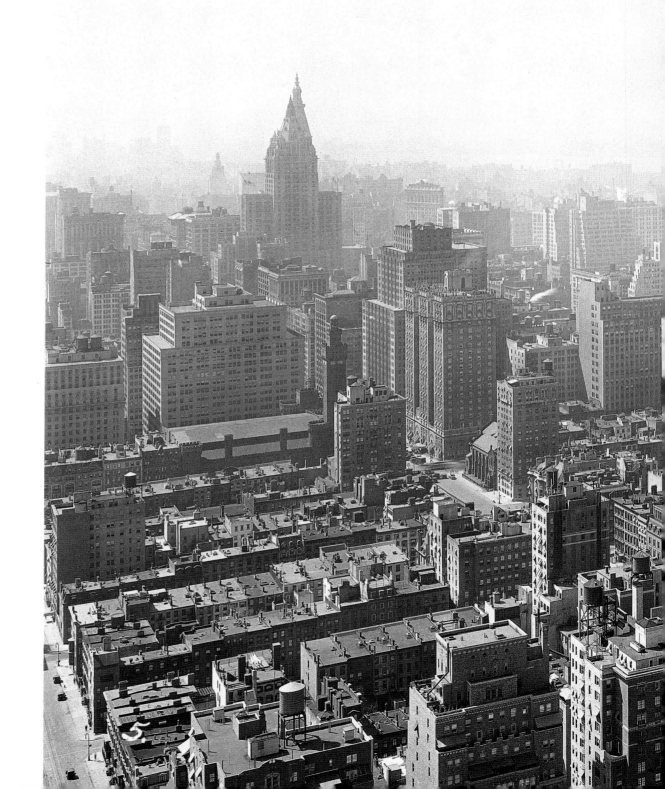

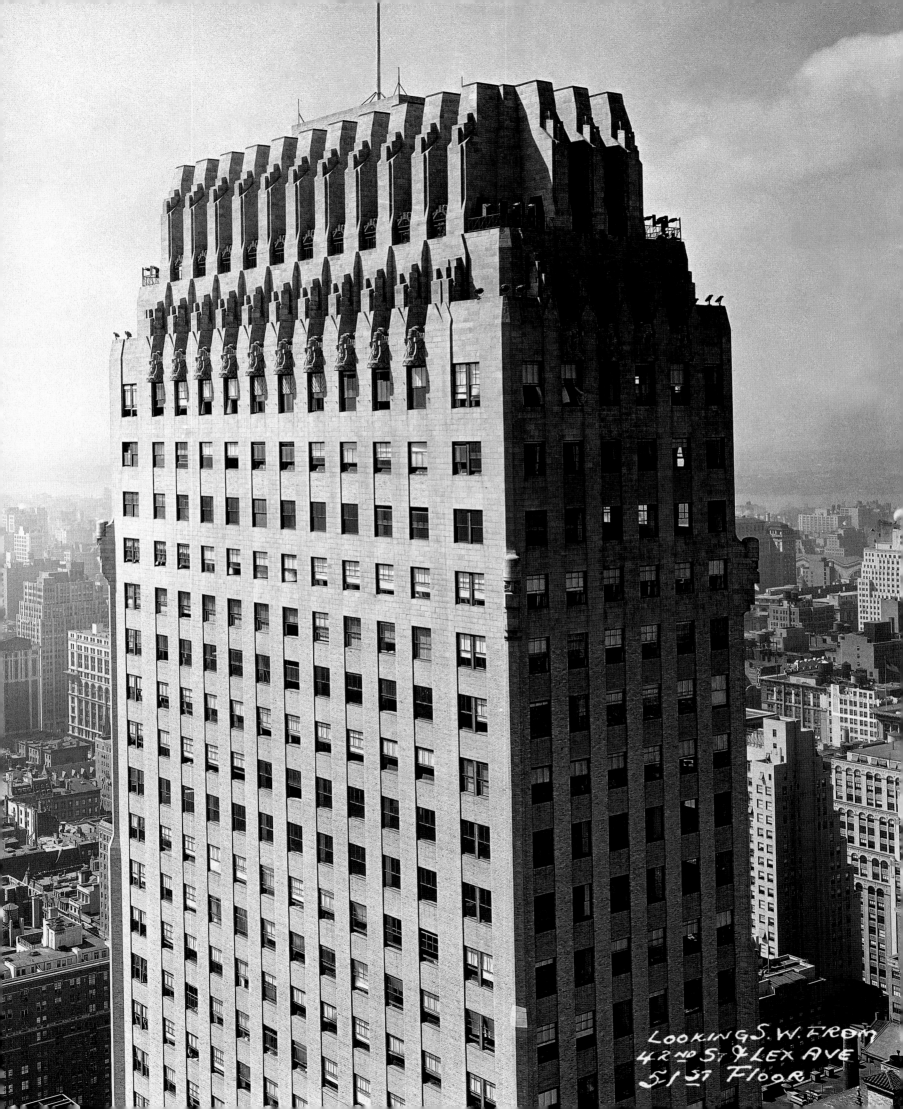

Looking S.W. From
42nd St. & Lex Ave
51st Floor

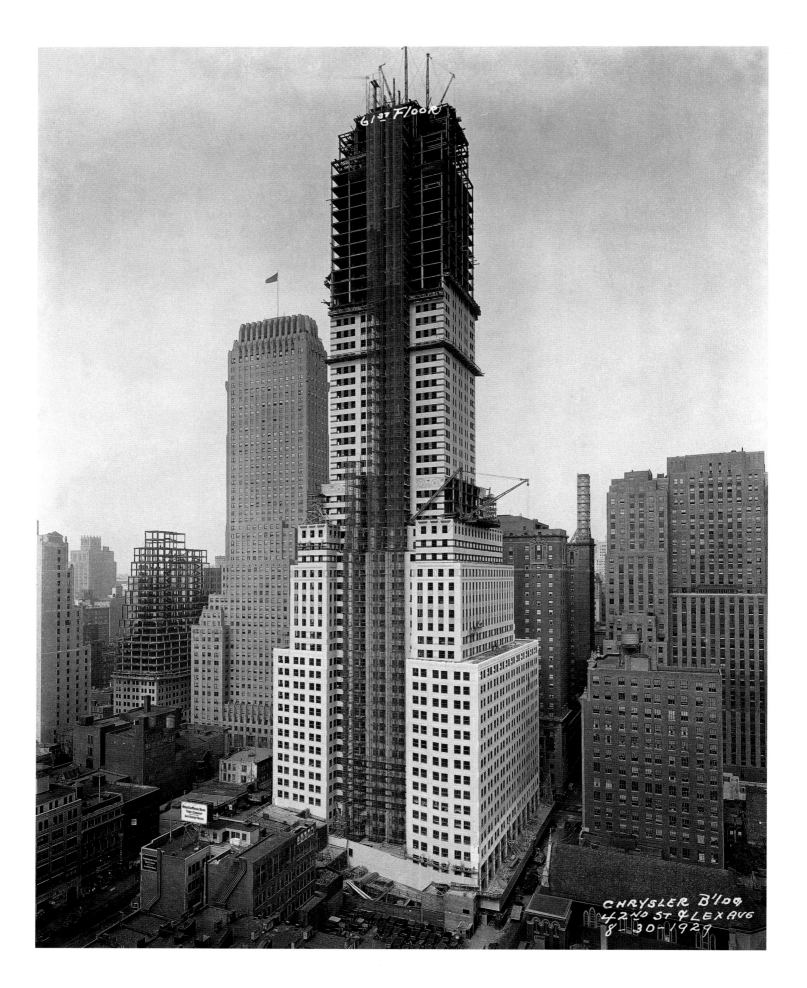

68

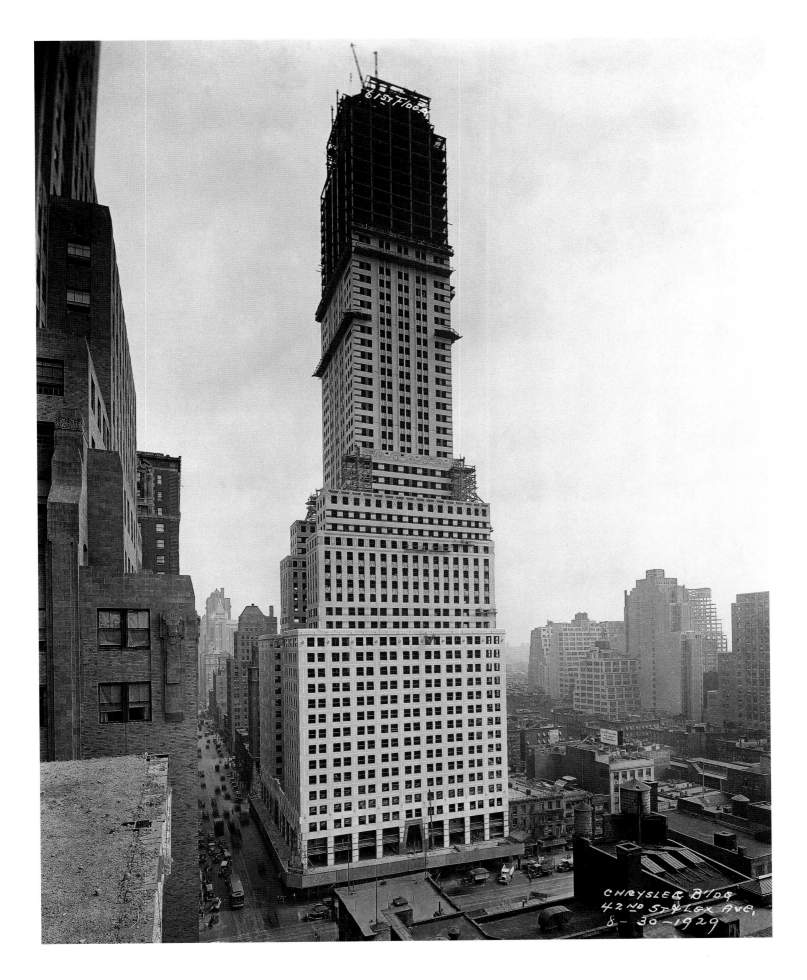

CHRYSLER BLDG
42ND ST & LEX AVE
8-30-1929

69

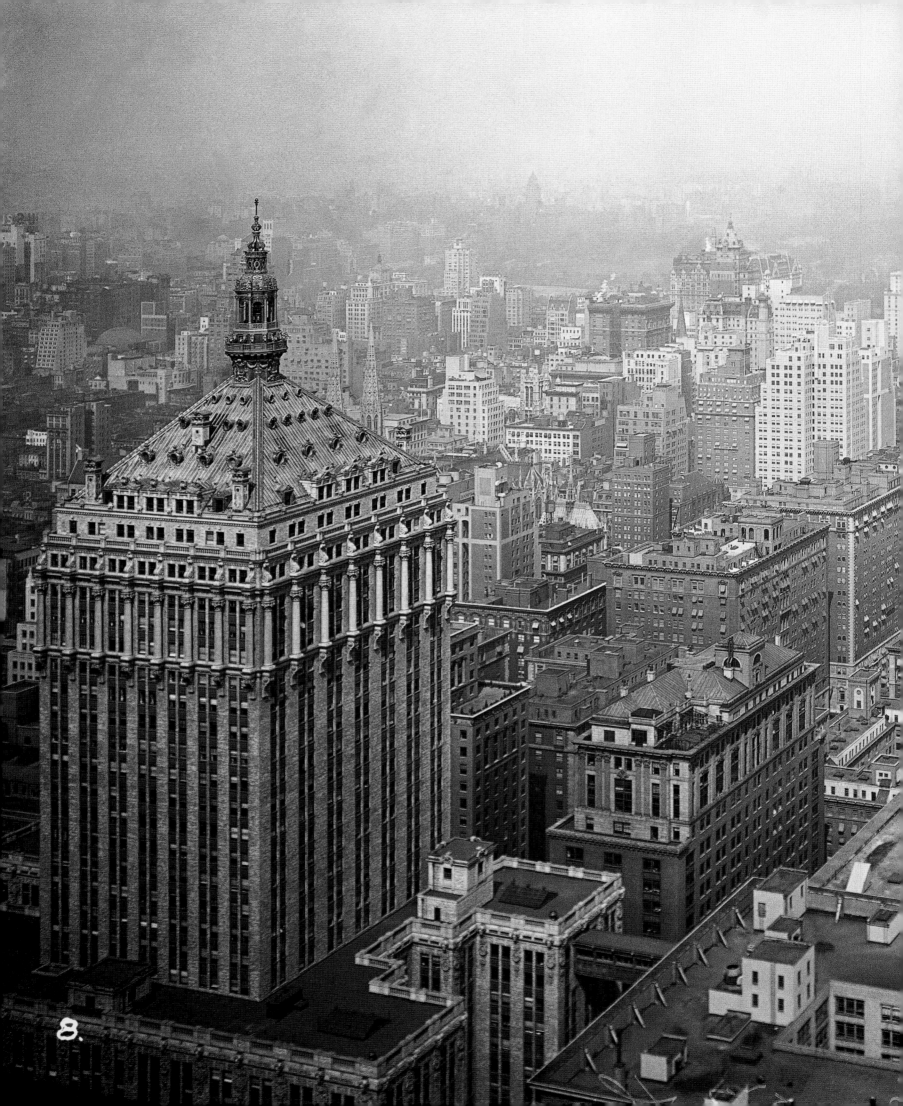

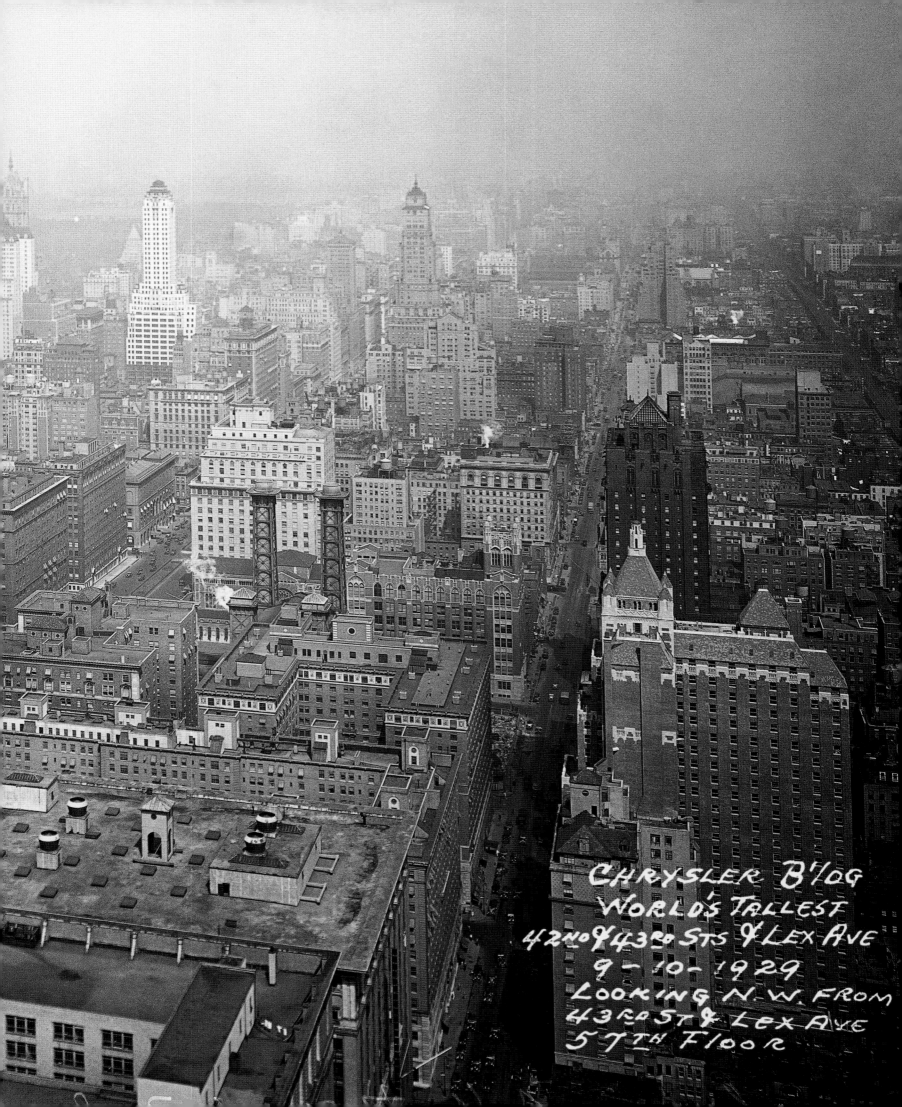

CHRYSLER B'LDG
WORLD'S TALLEST
42ND & 43RD STS & LEX AVE
9-10-1929
LOOKING N.W. FROM
43RD ST & LEX AVE
5TH FLOOR

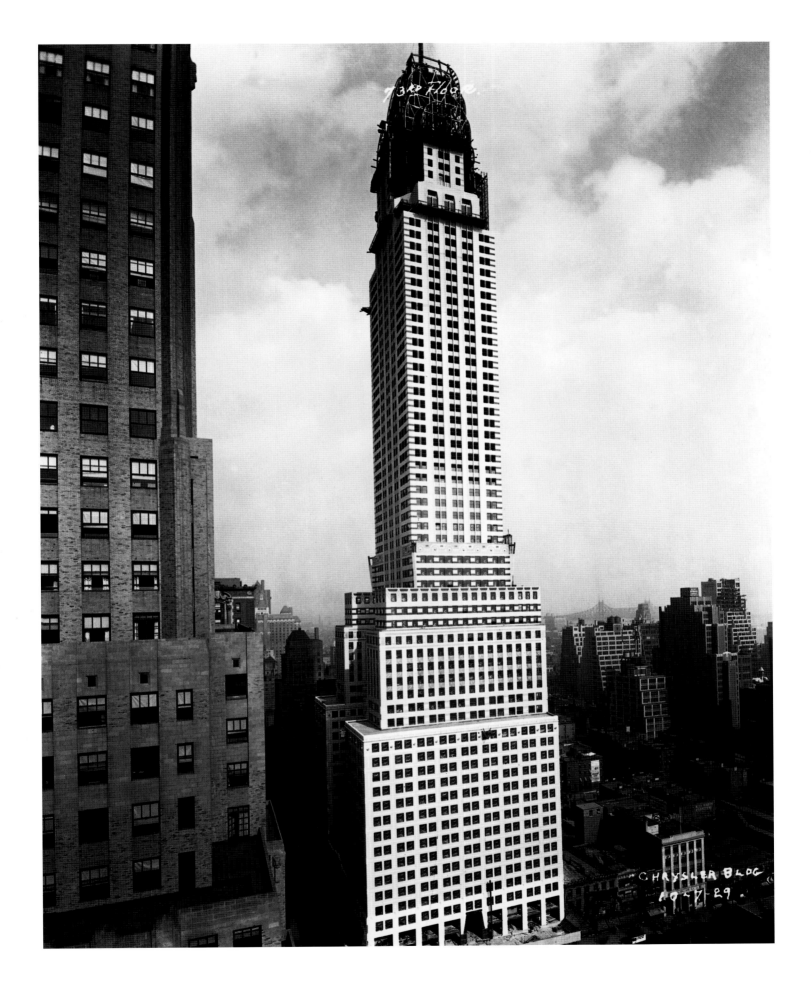

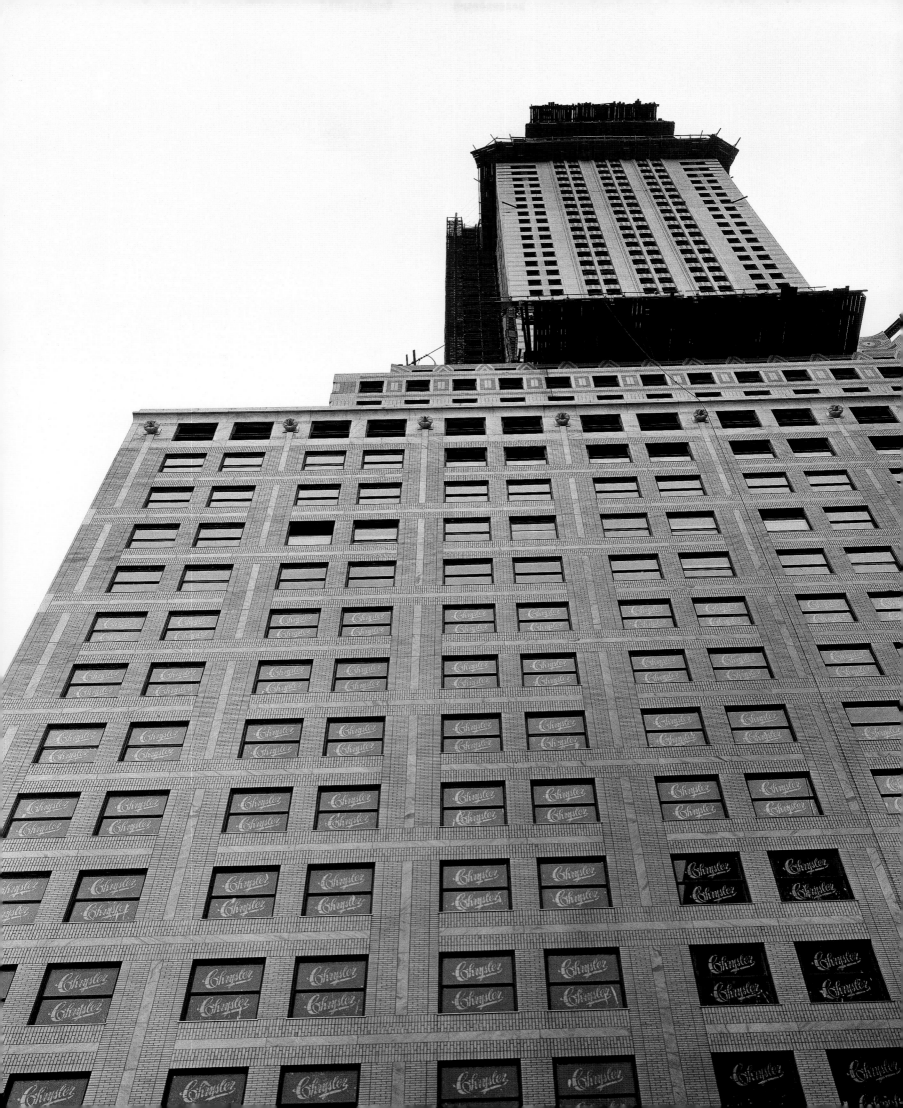

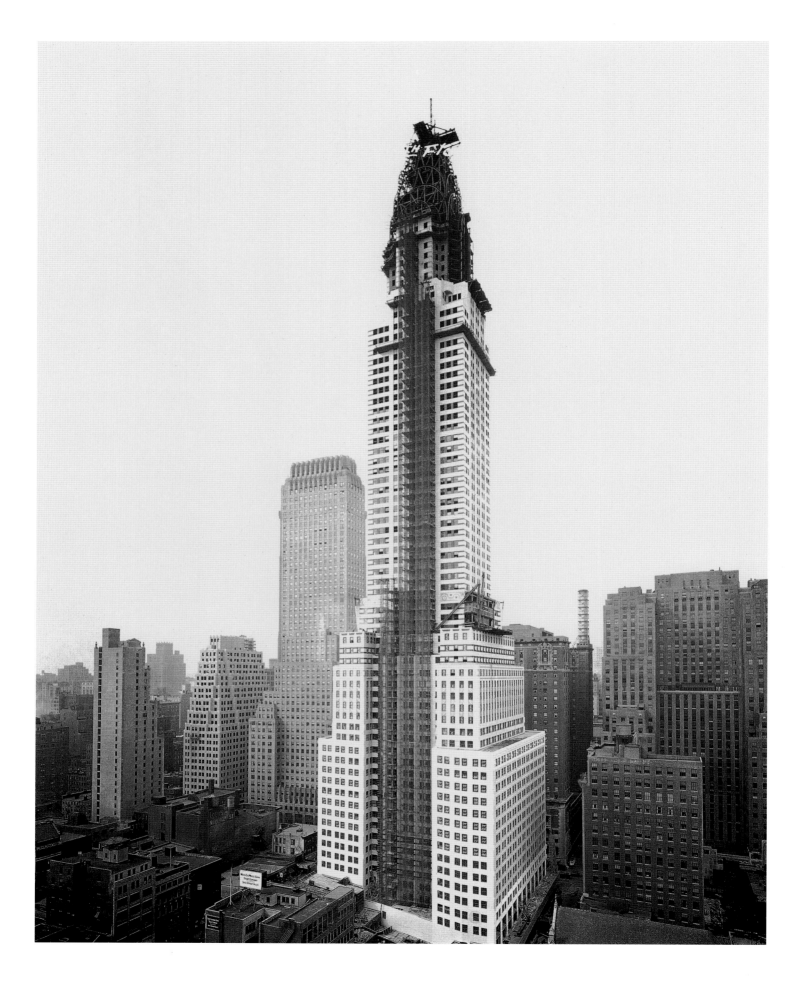

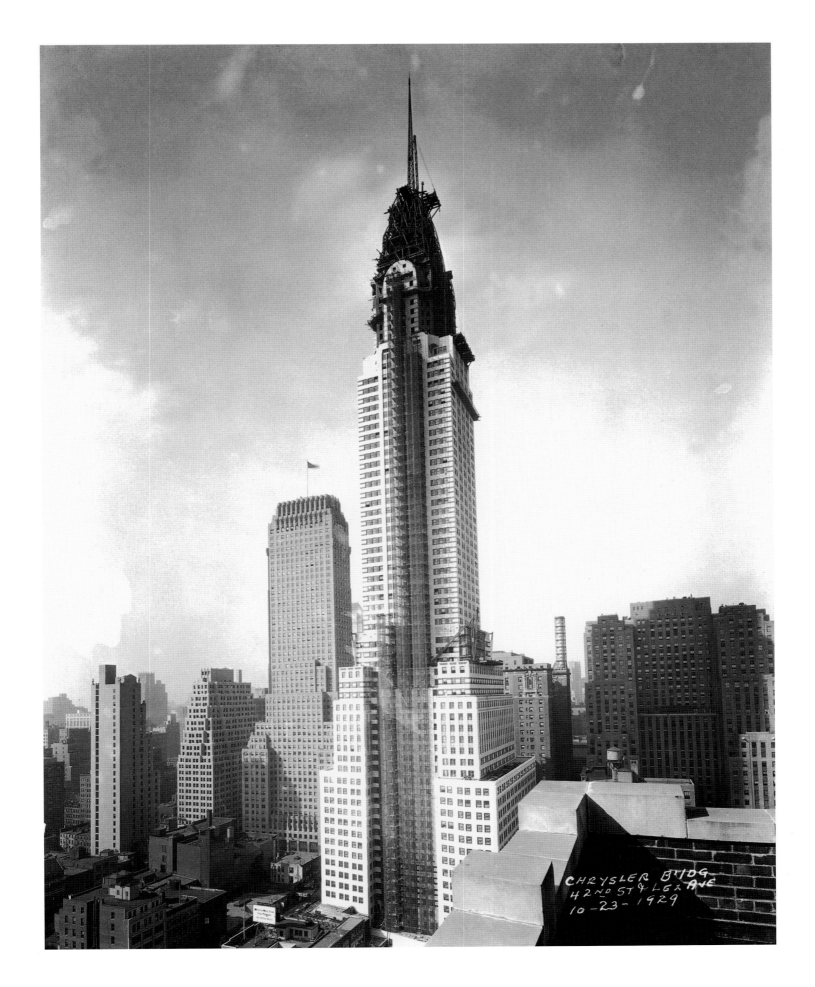

CHRYSLER BLDG.
42ND ST & LEX AVE
10-23-1929

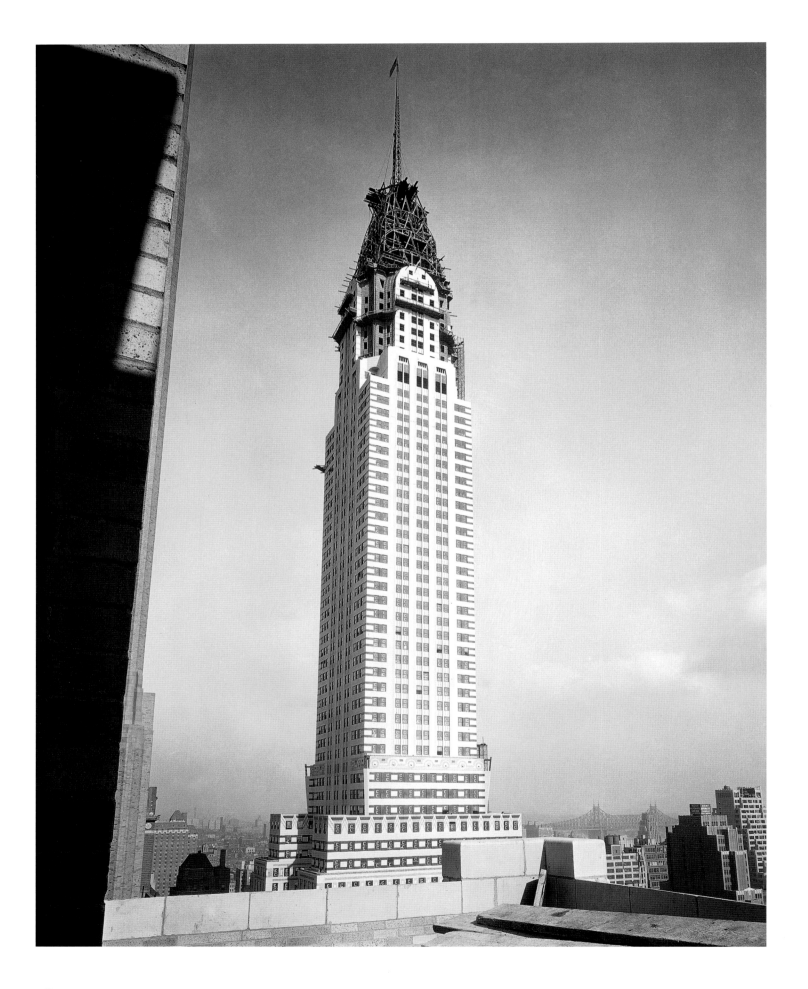

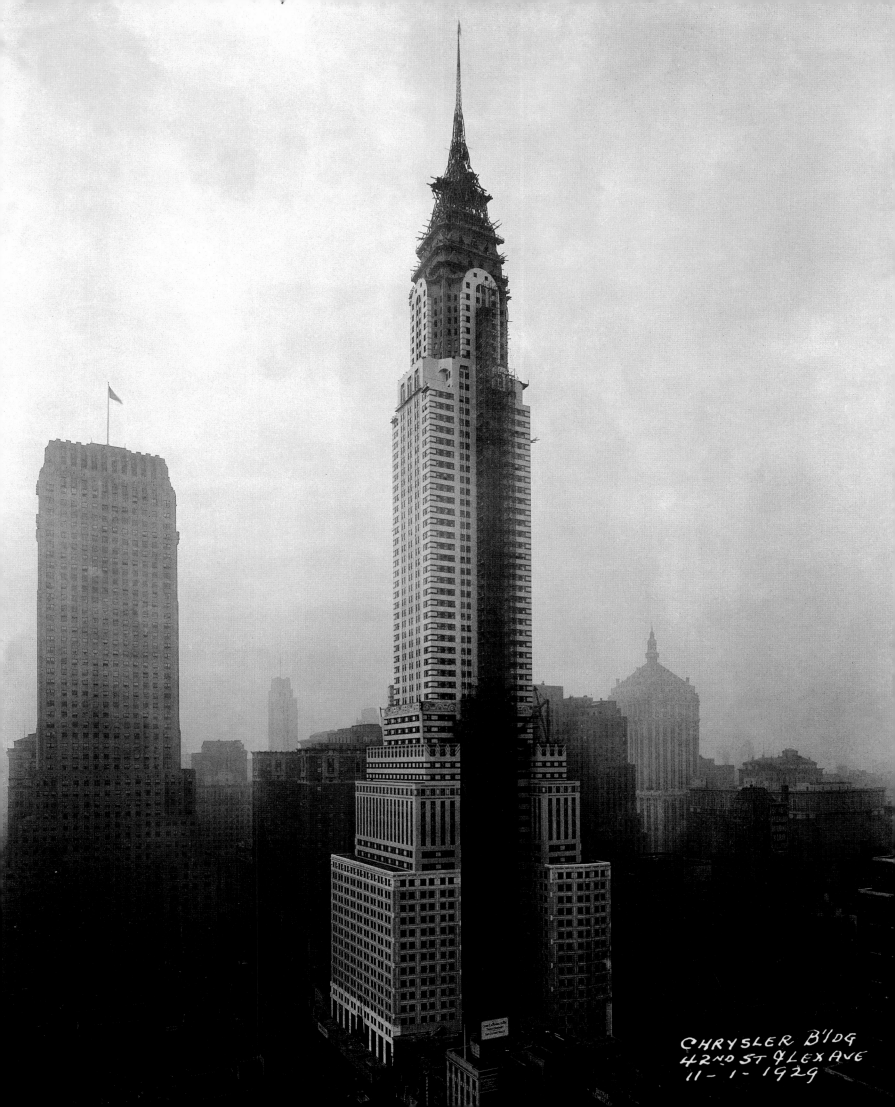

CHRYSLER B'LDG
42ND ST & LEX AVE
11-1-1929

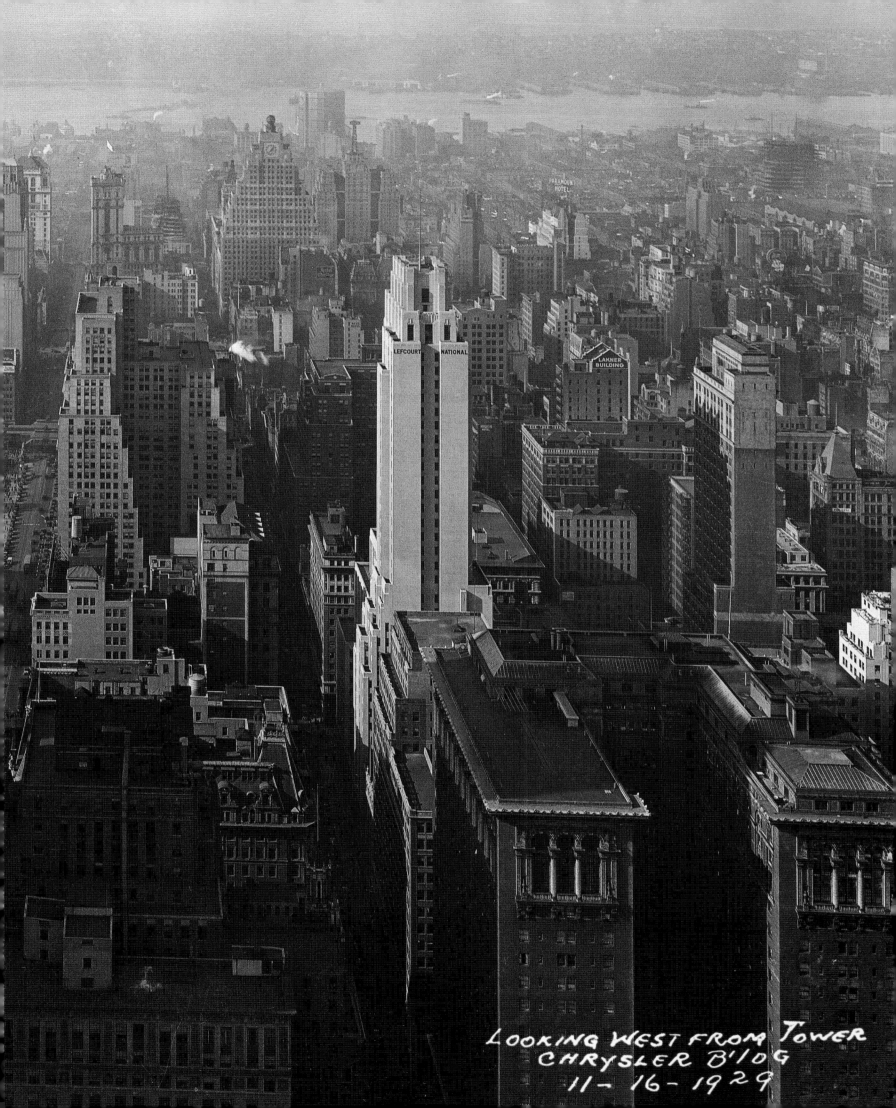

LOOKING WEST FROM TOWER
CHRYSLER B'LDG
11-16-1929

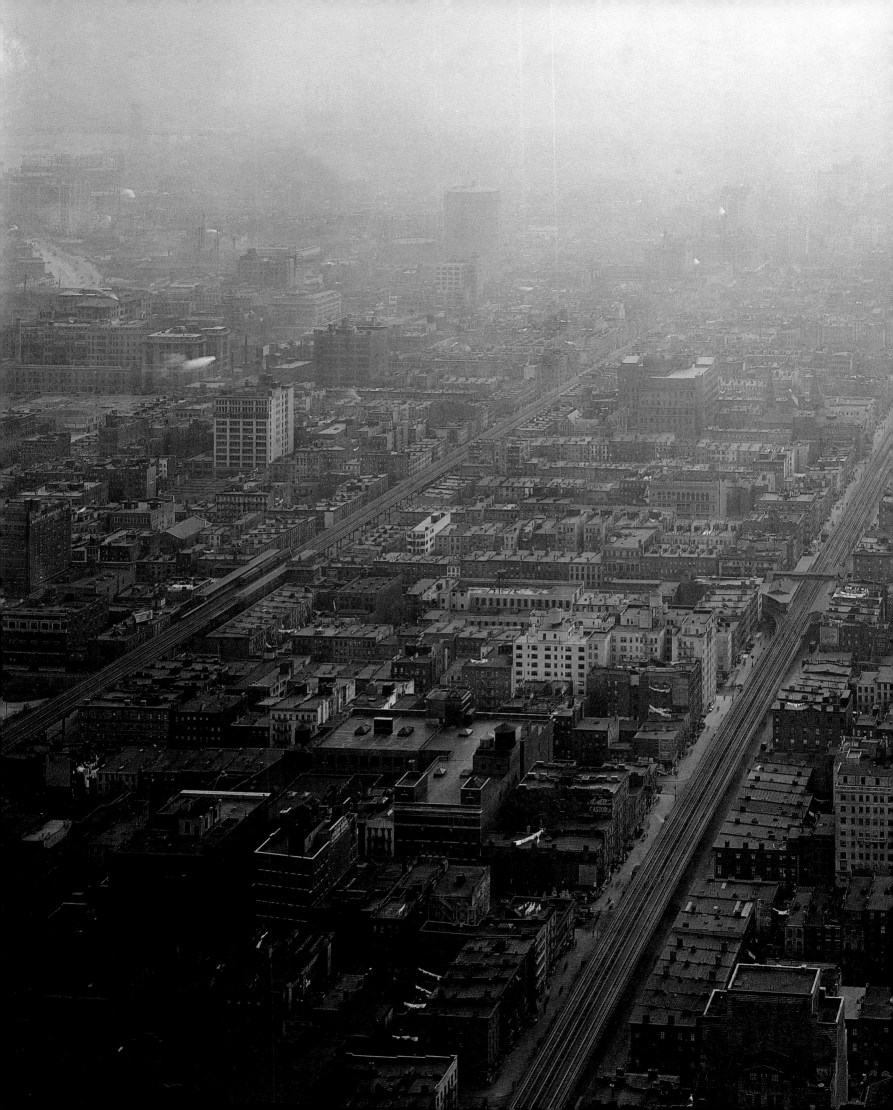

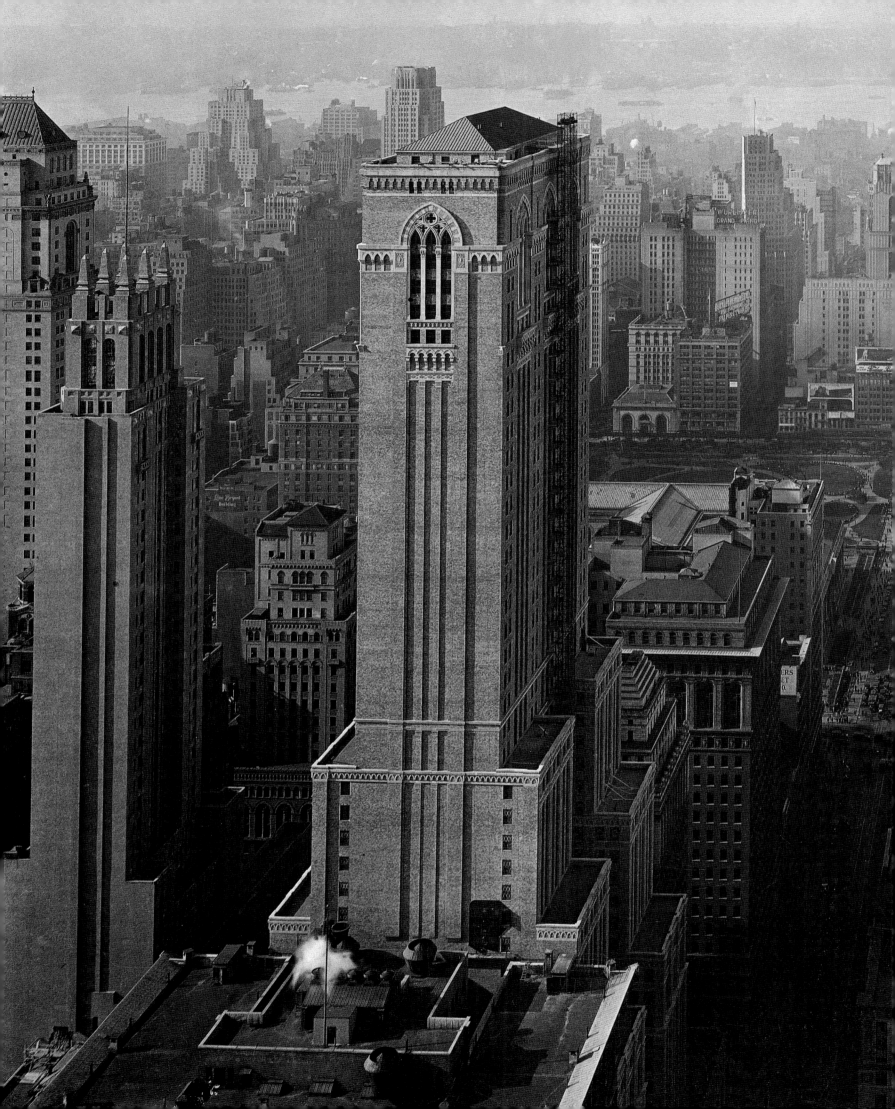

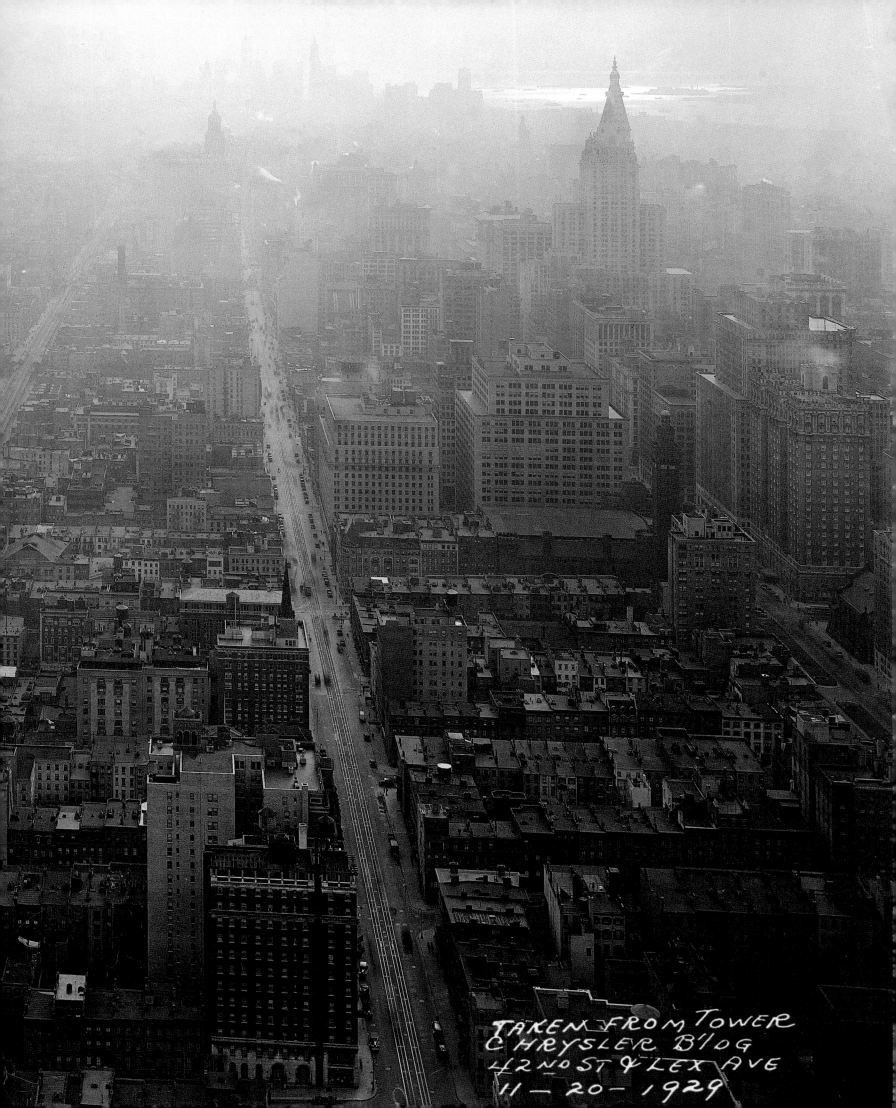

TAKEN FROM TOWER
CHRYSLER B'DG
42ND ST & LEX AVE
11 — 20 — 1929

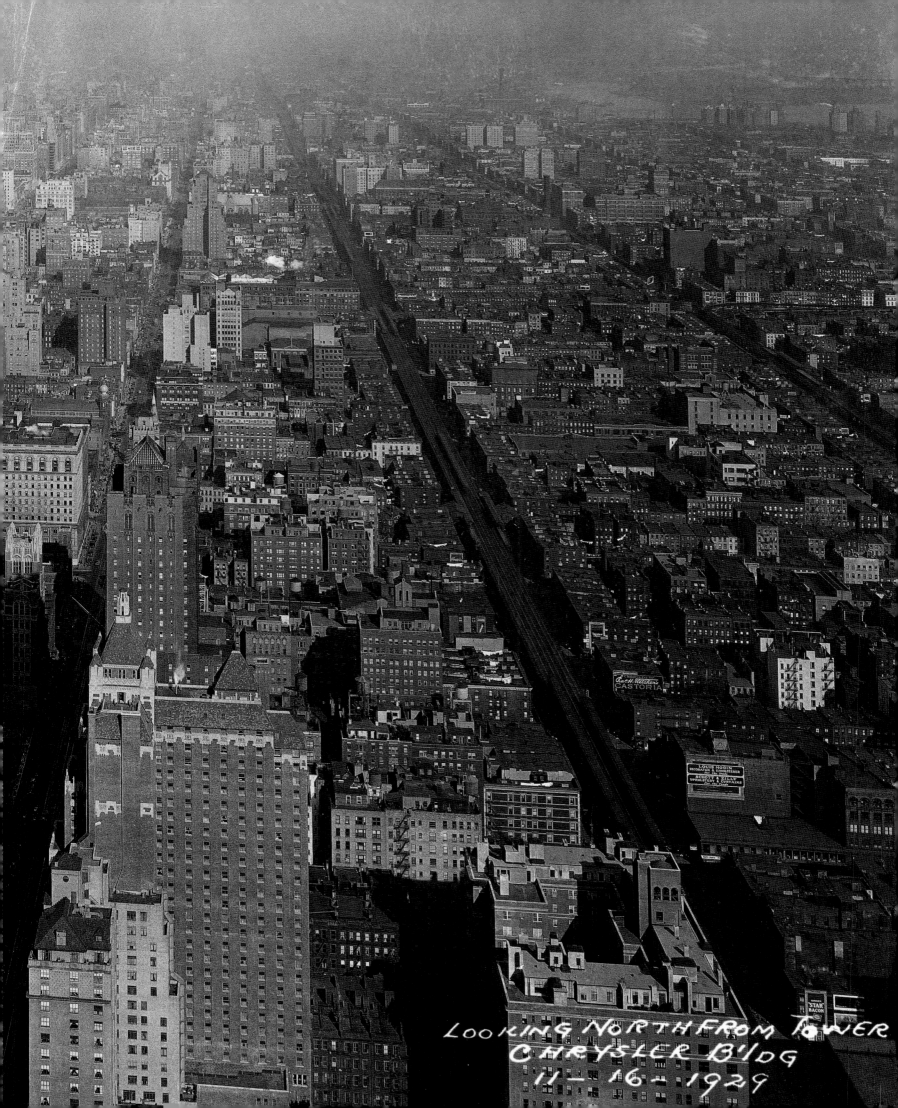

LOOKING NORTH FROM TOWER
CHRYSLER B'LDG
11-16-1929

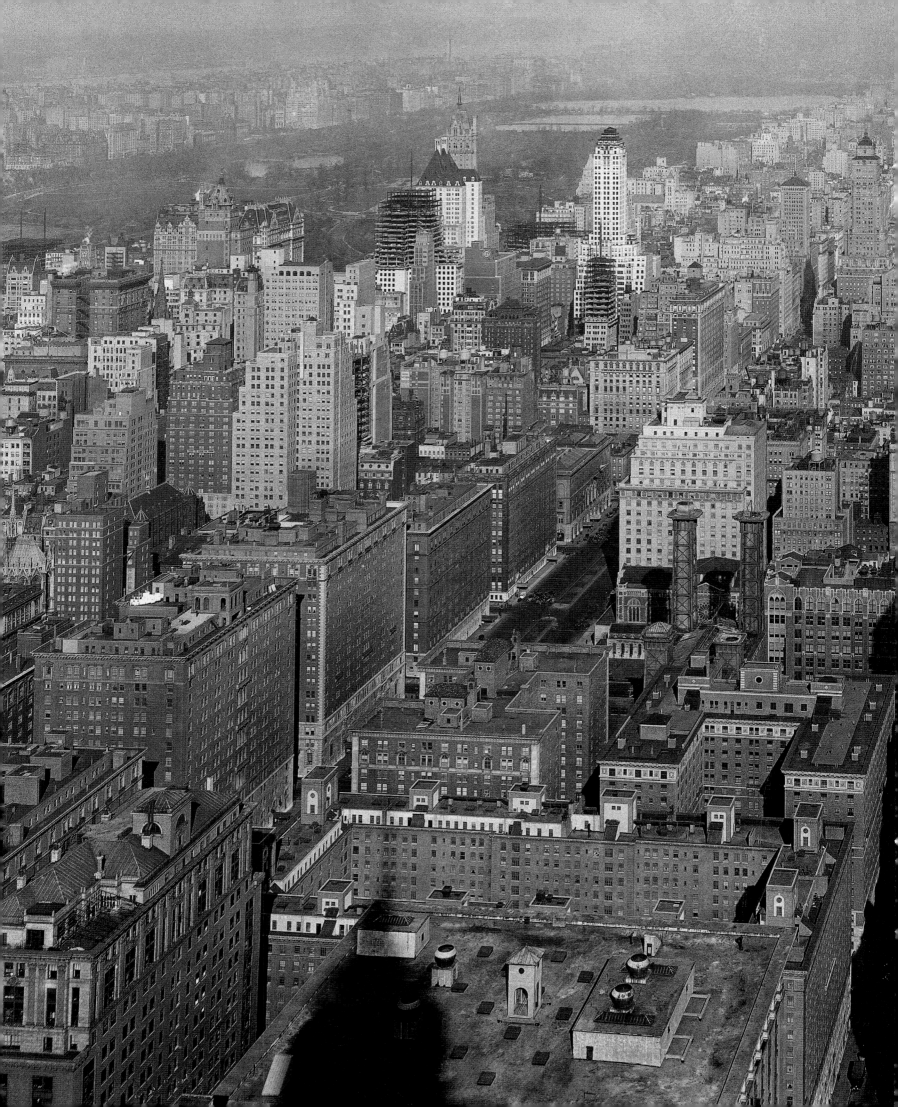

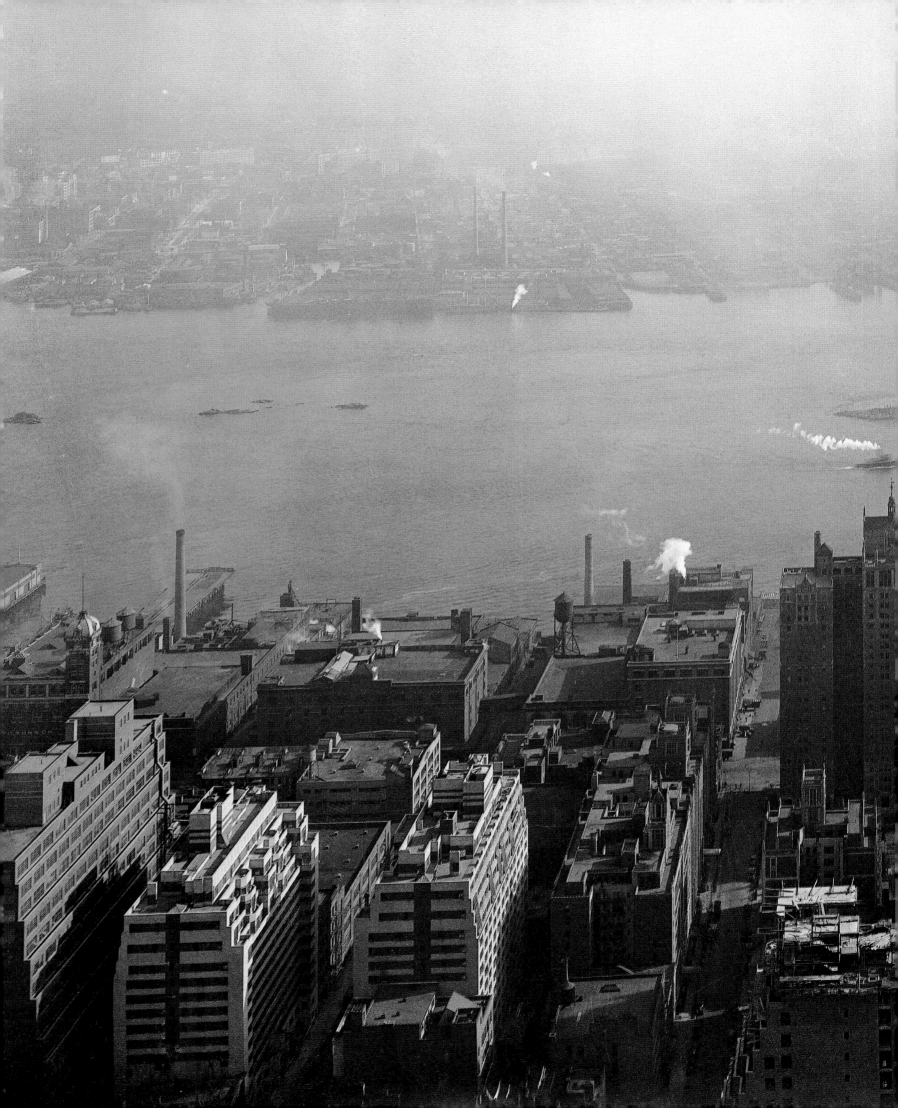

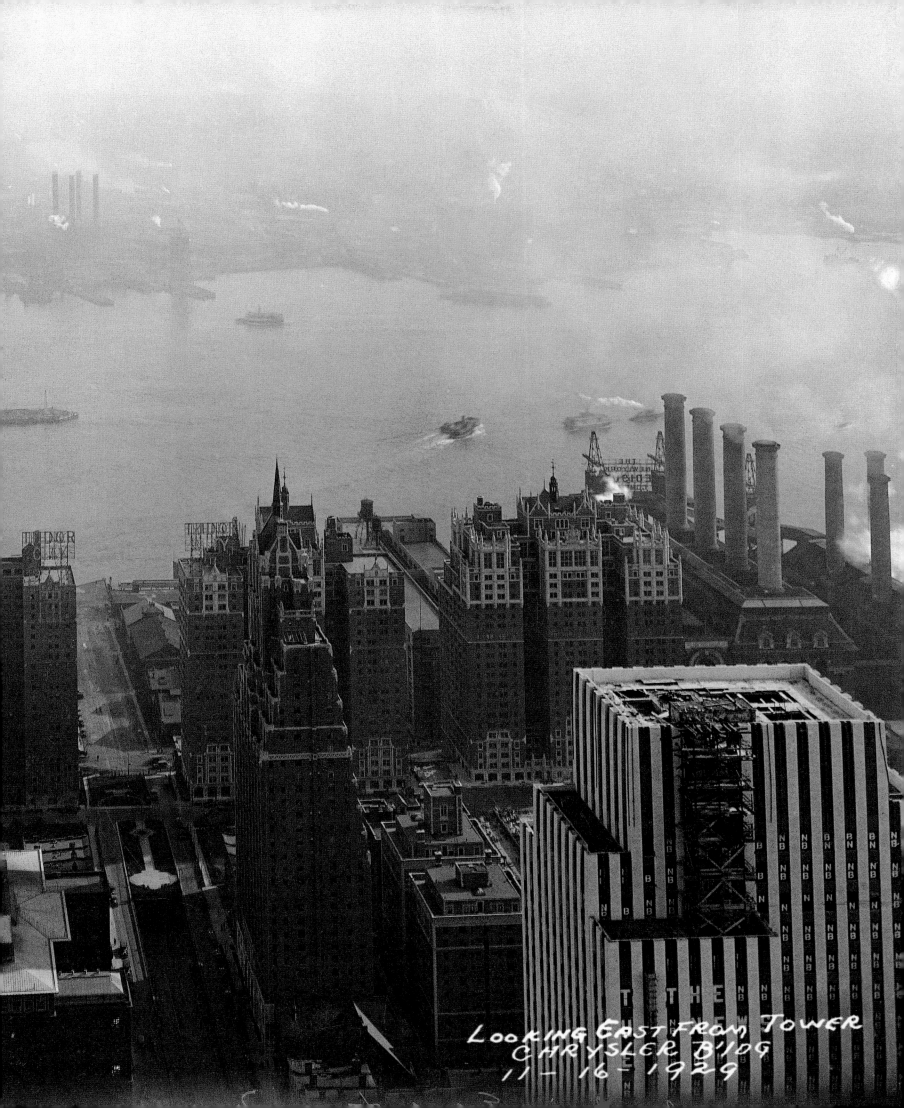

Looking East From Tower
CHRYSLER B'LDG
11—16—1929

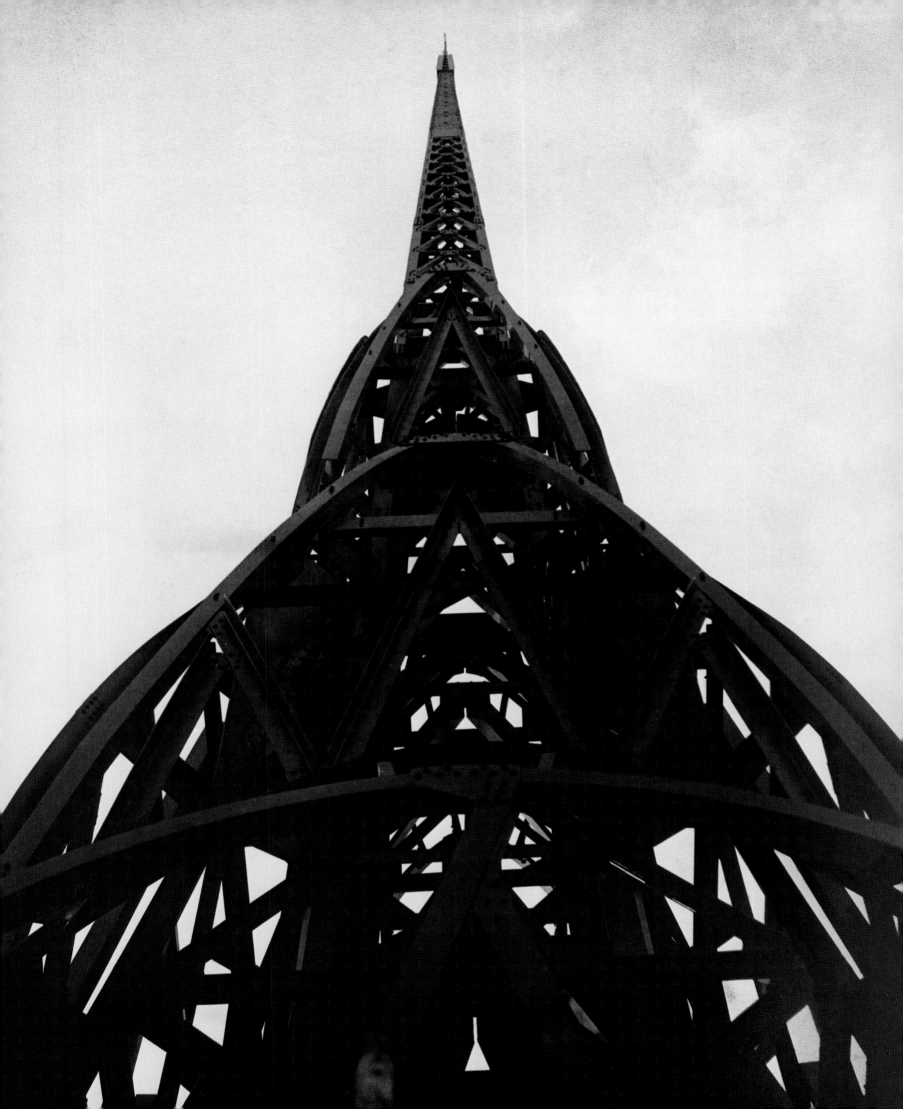

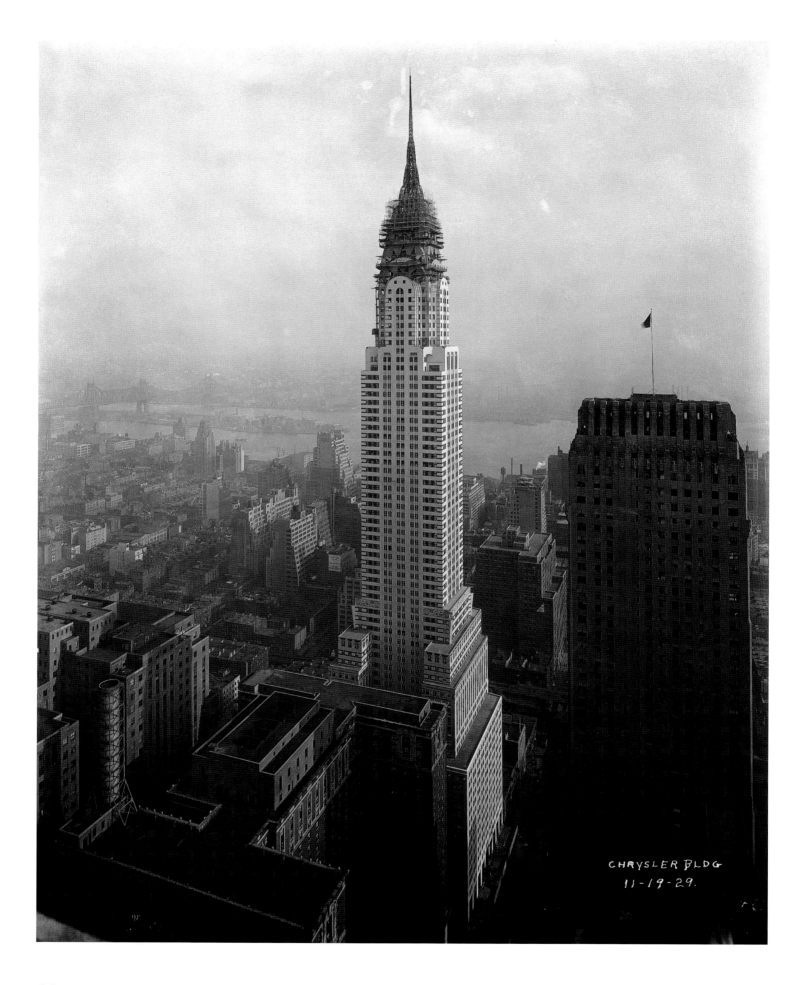

CHRYSLER BLDG
11-19-29.

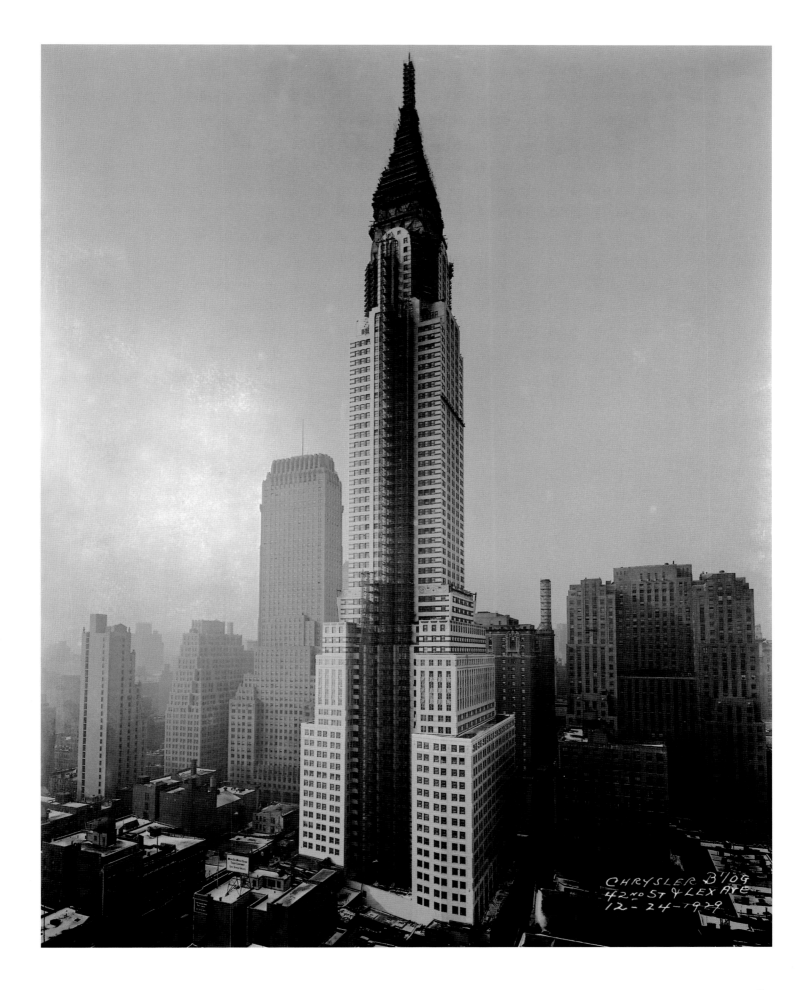

CHRYSLER B'LDG
42ND ST & LEX AVE
12-24-1929

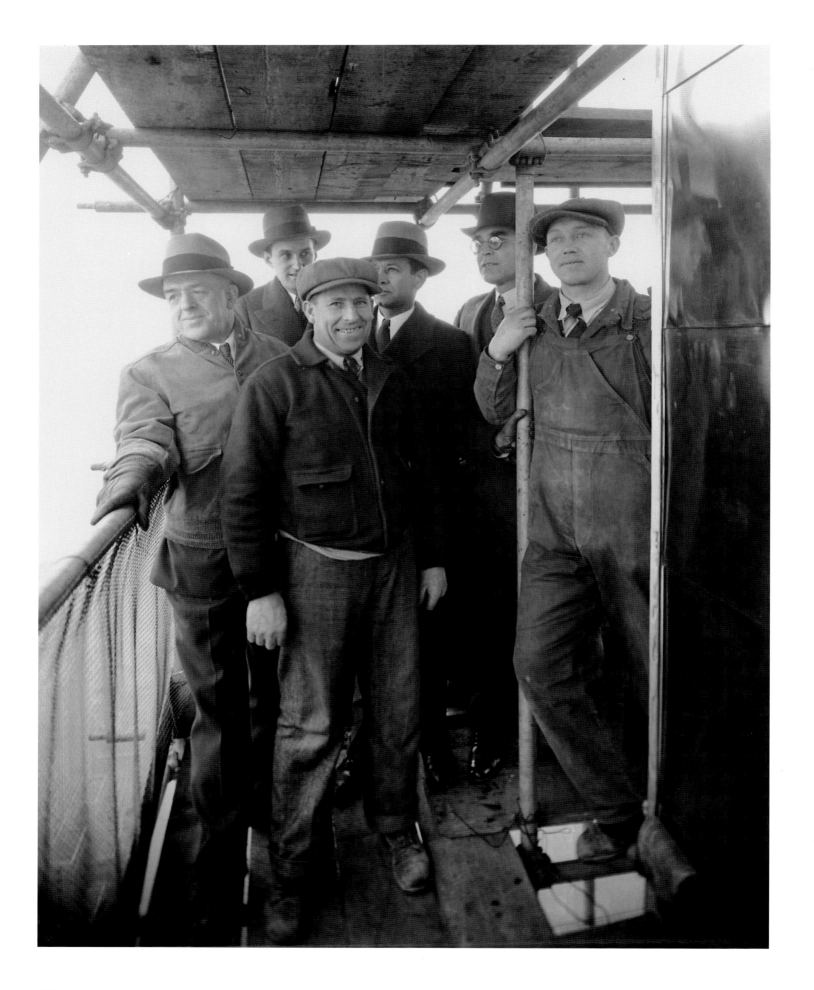

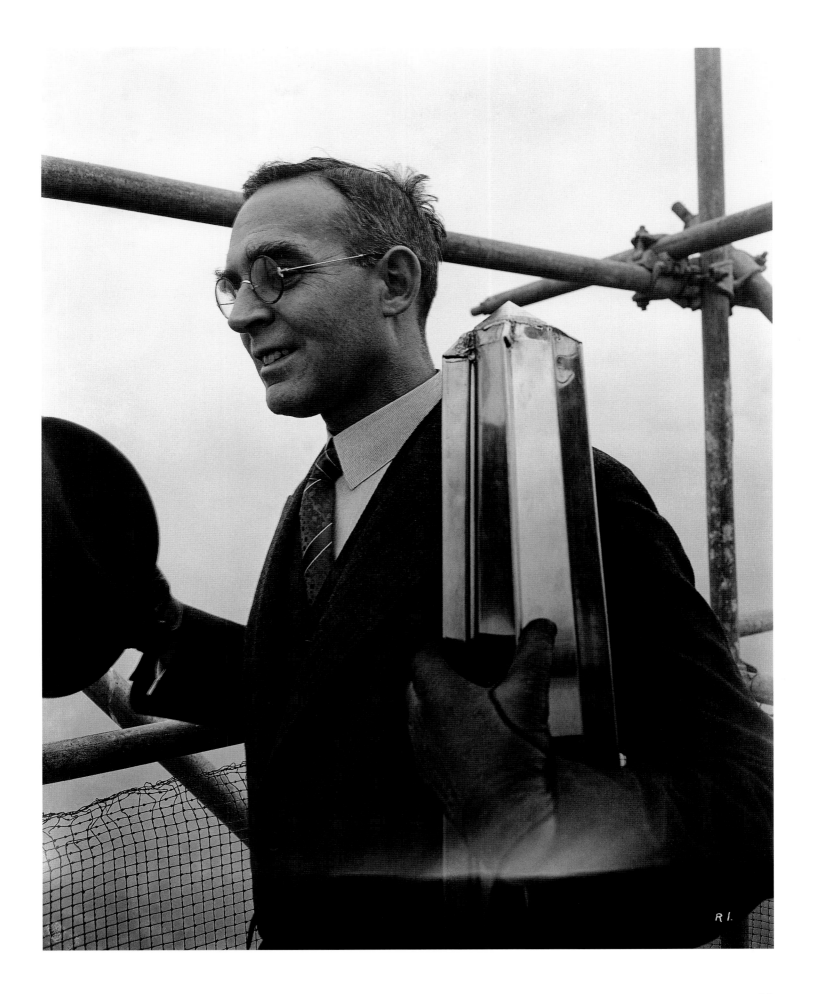

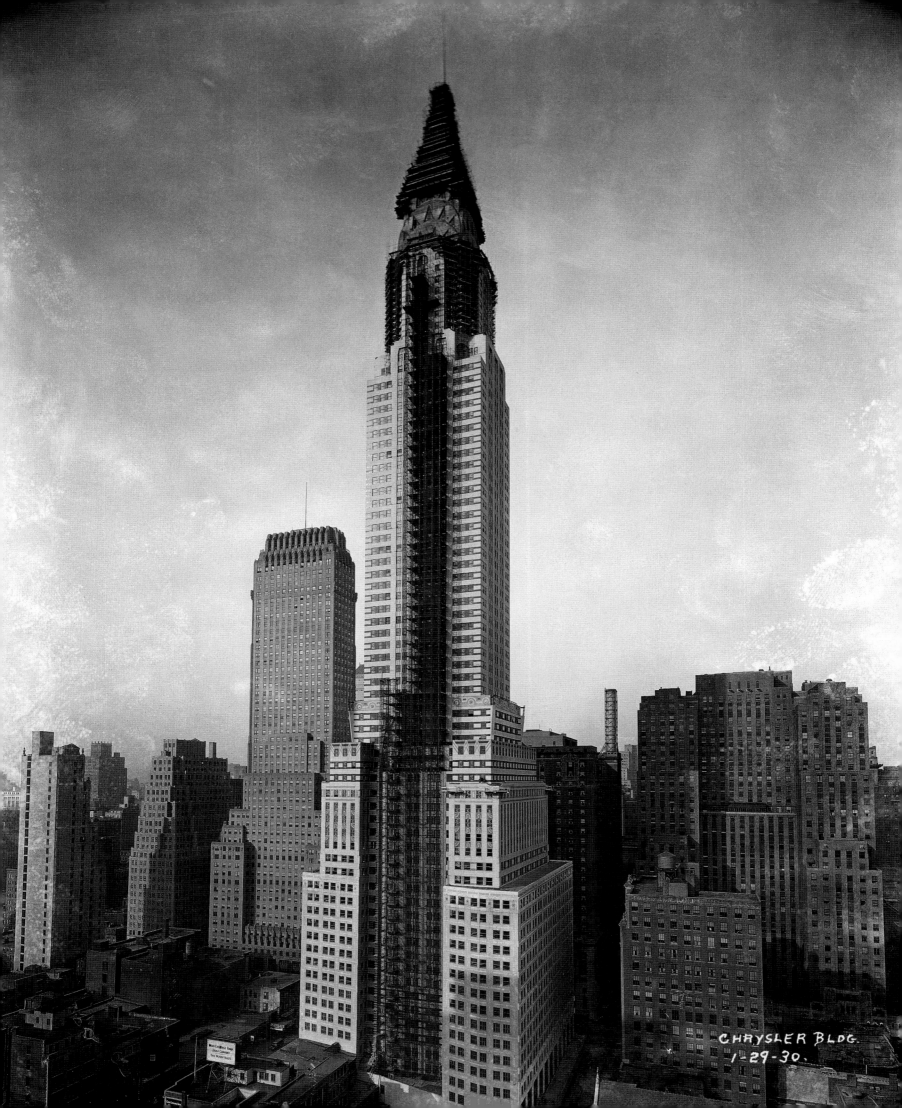

CHRYSLER BLDG.
1-29-30.

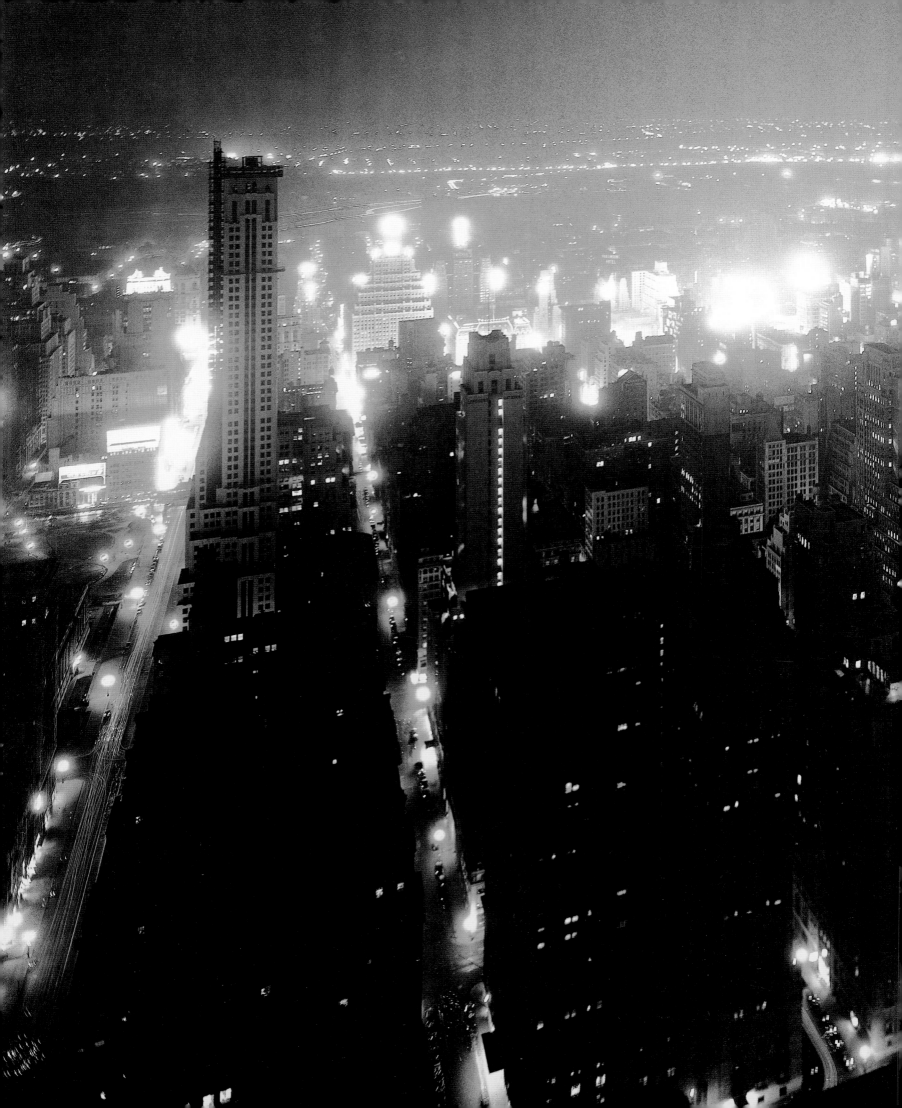

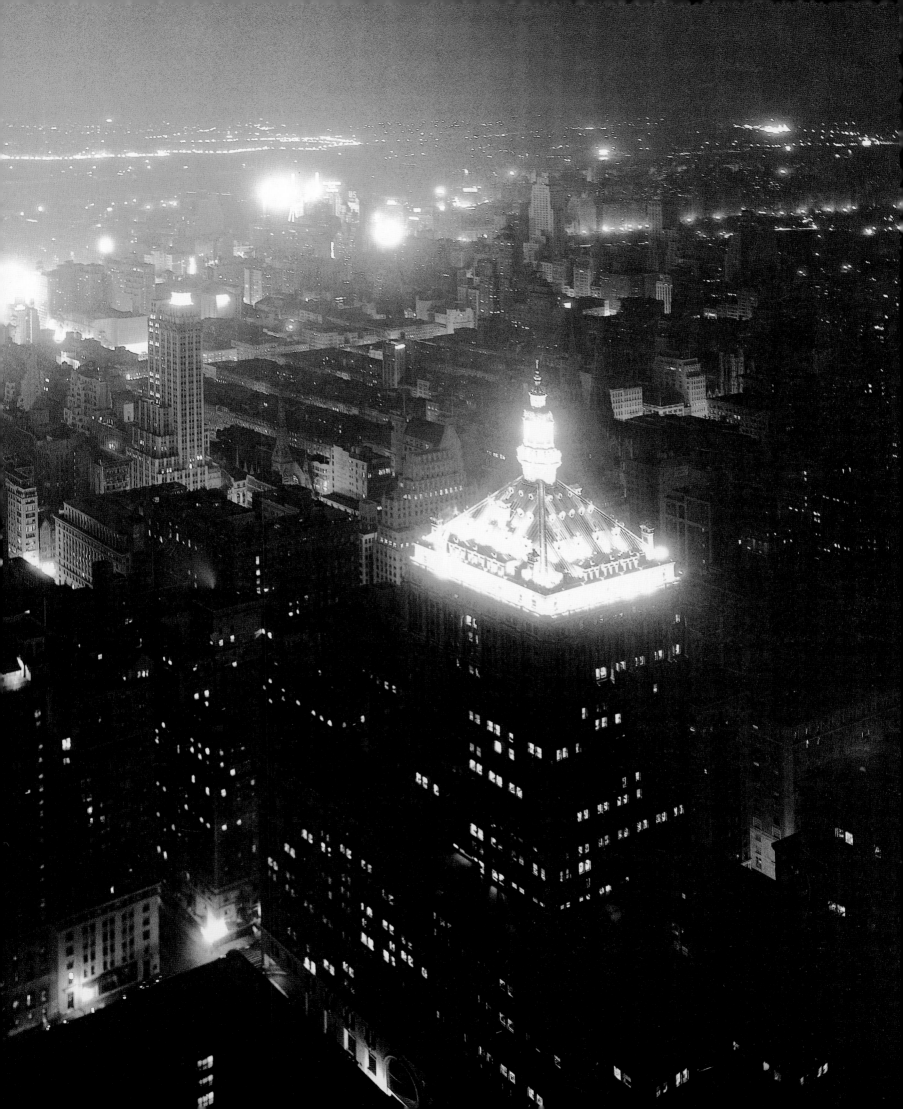

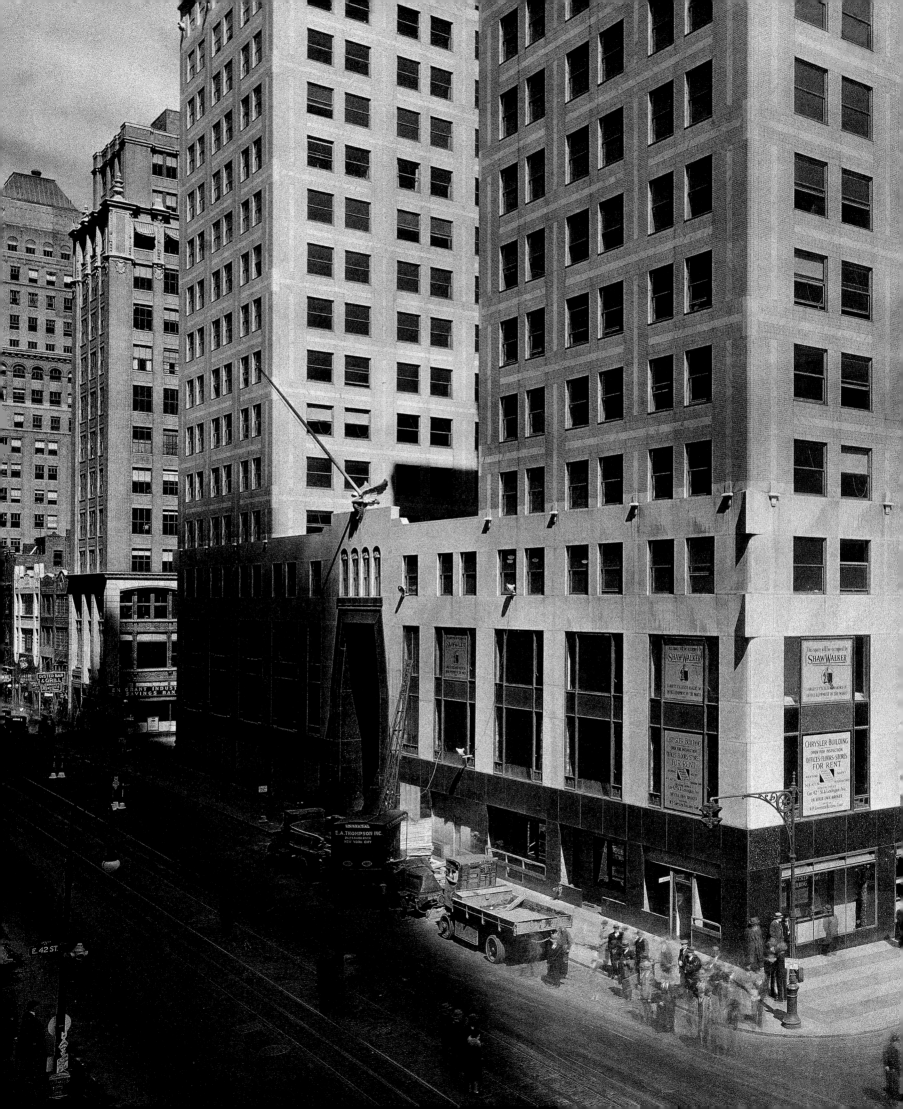

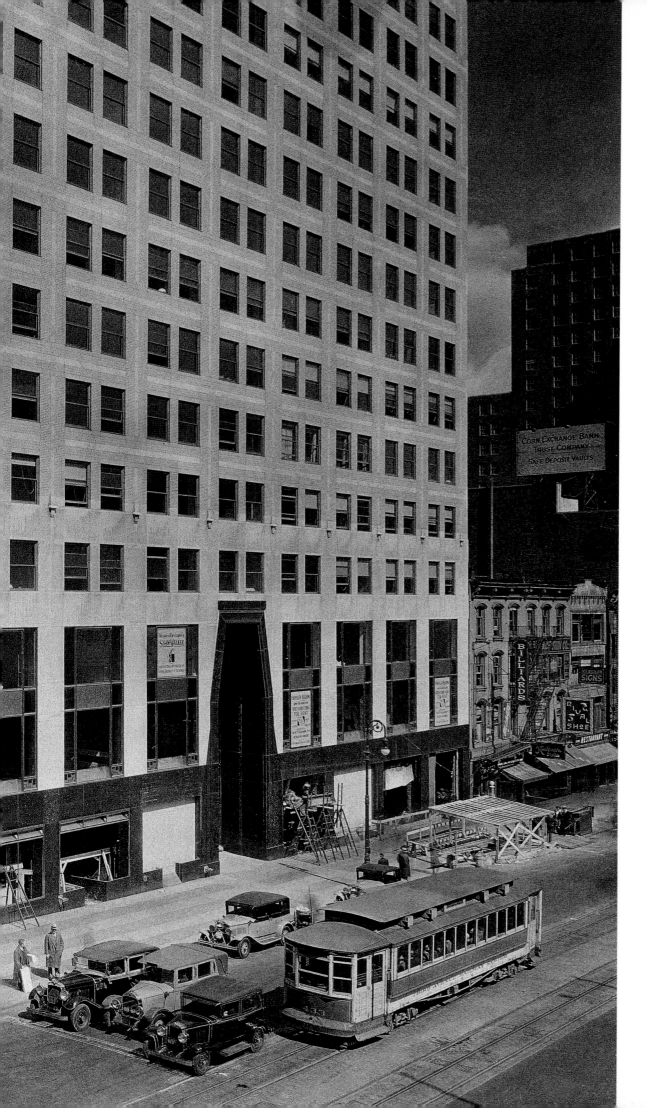

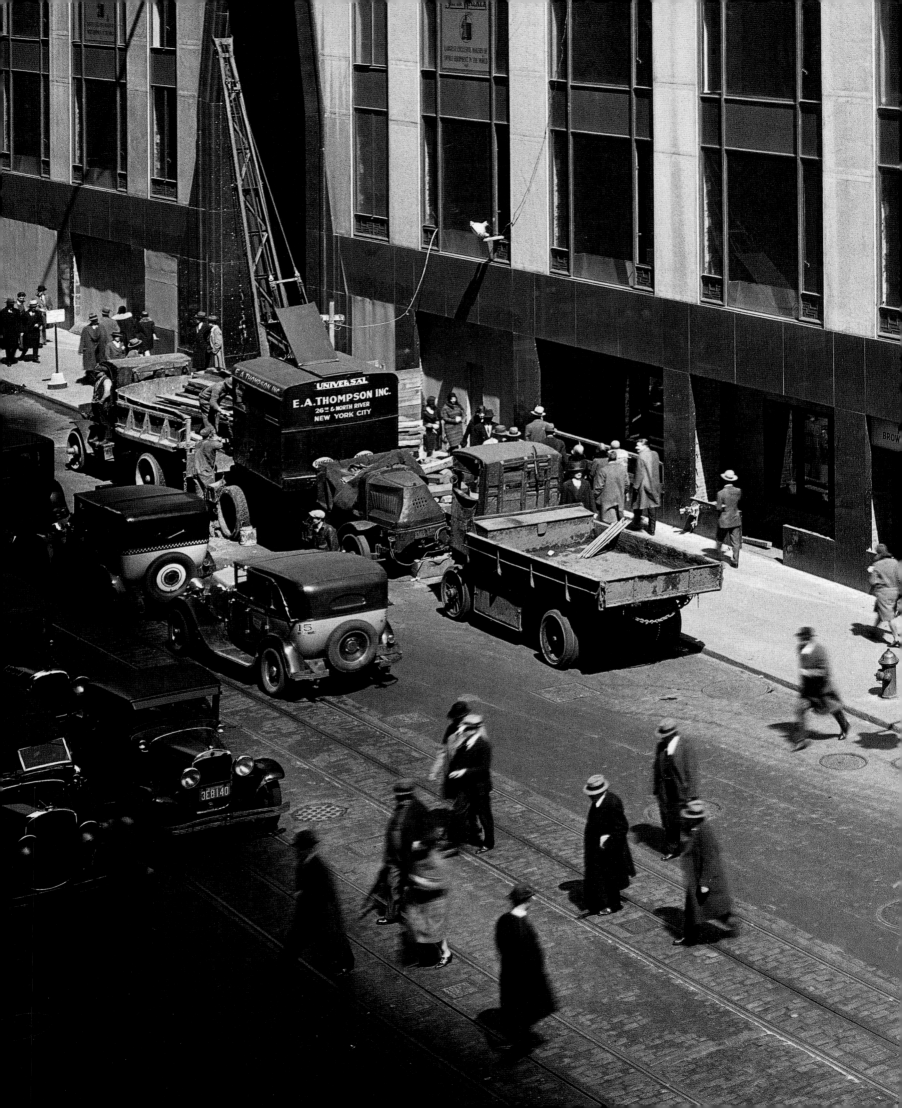

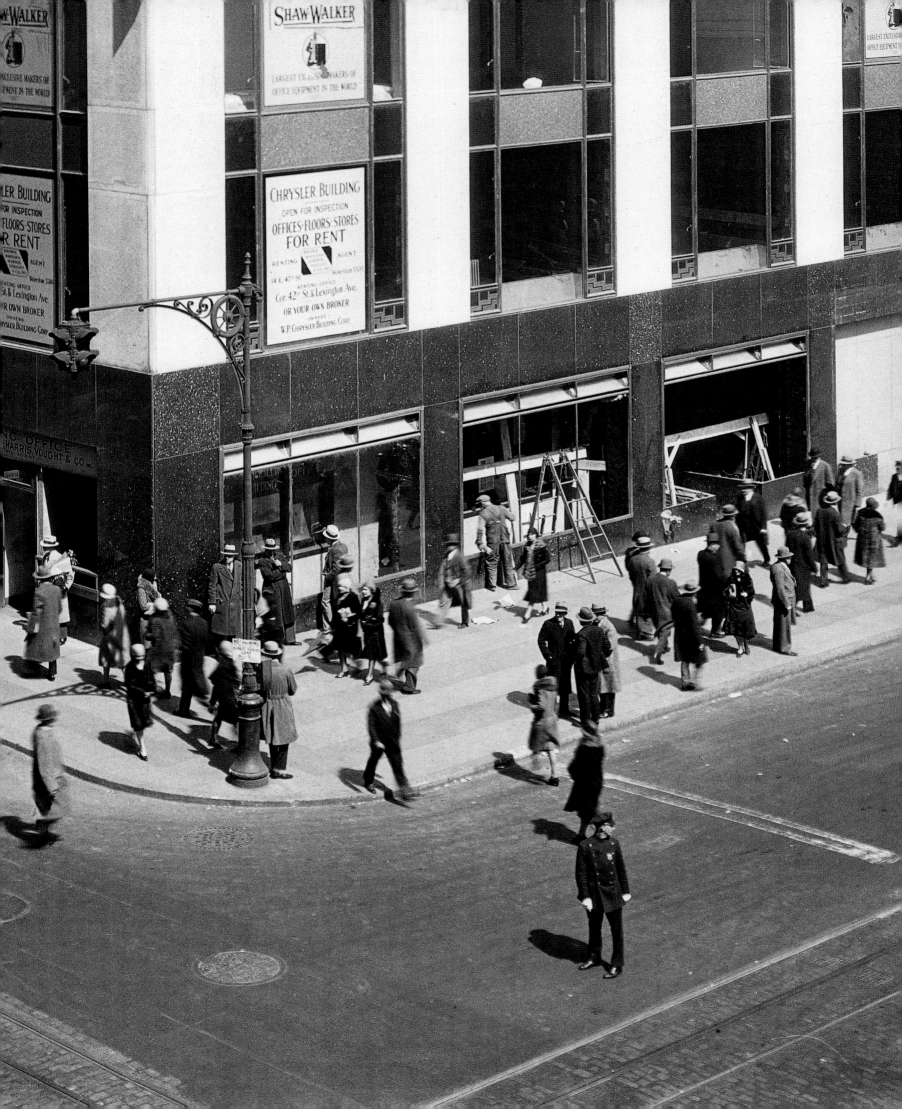

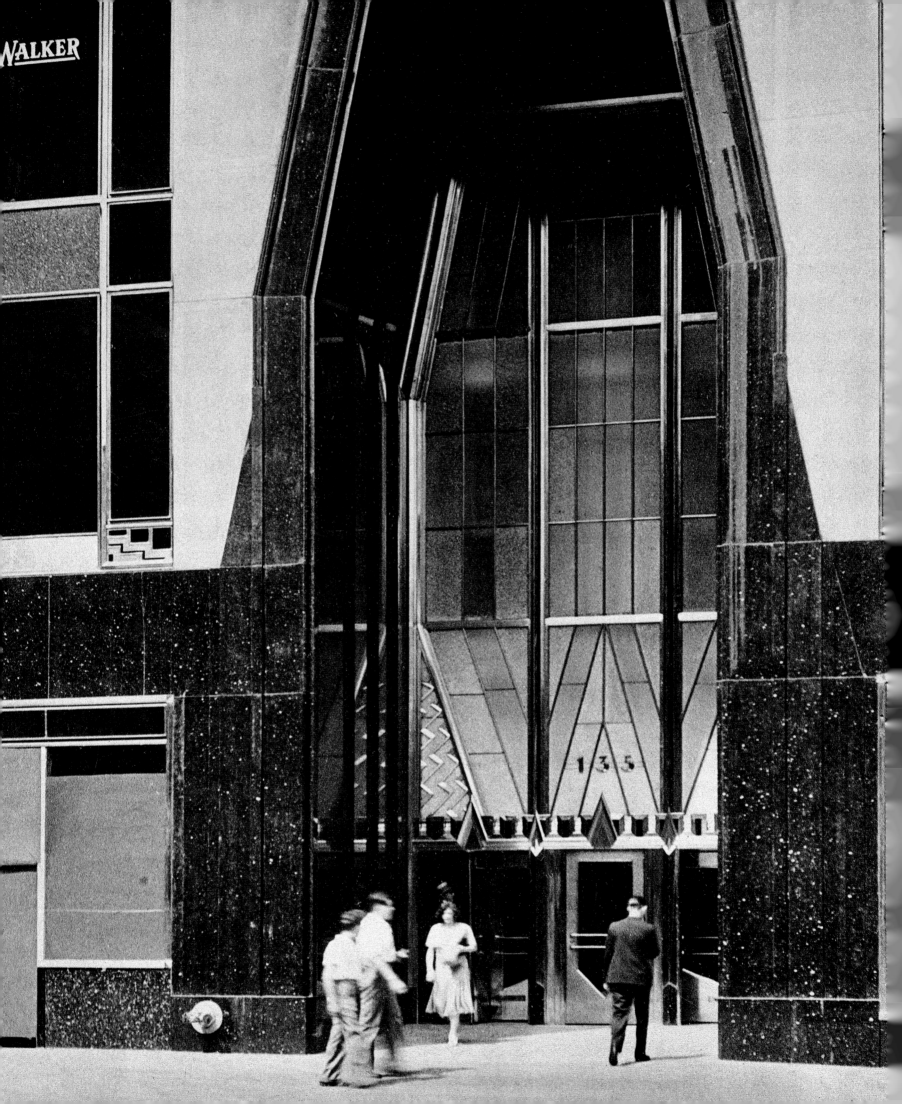

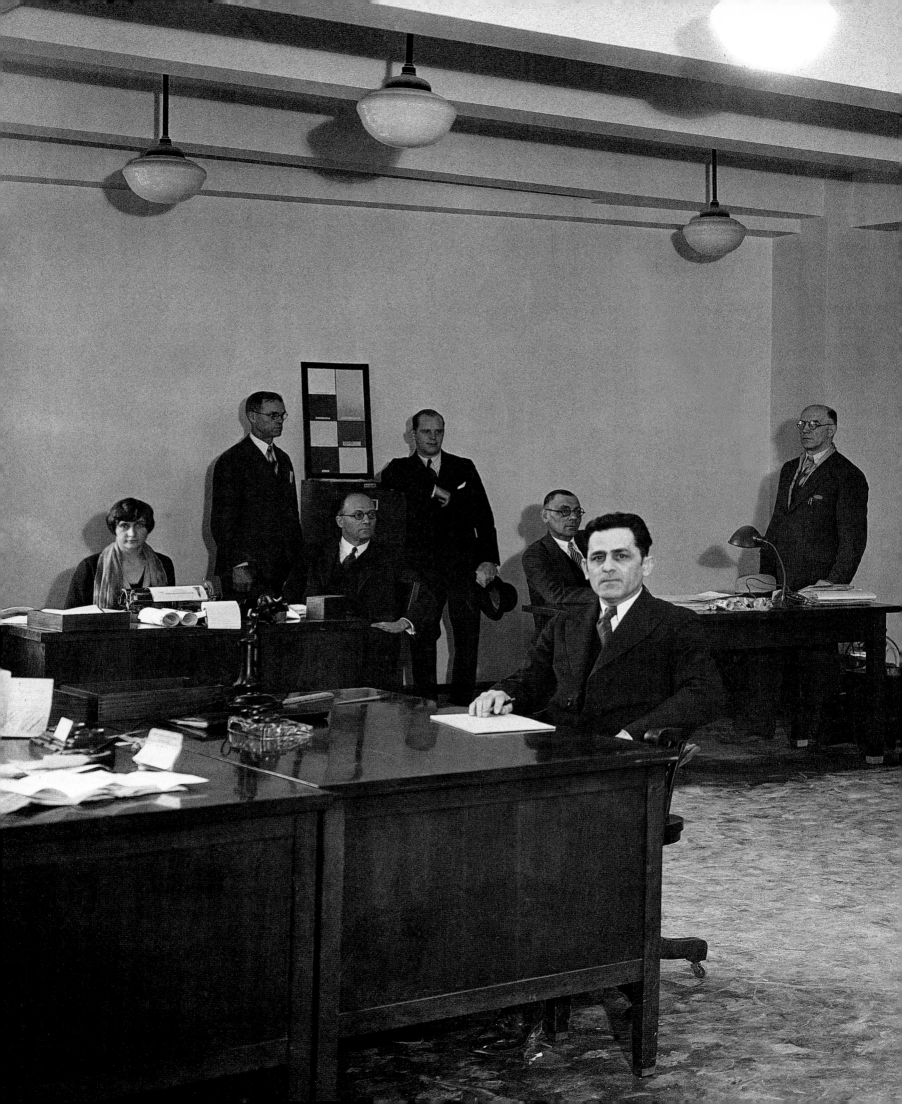

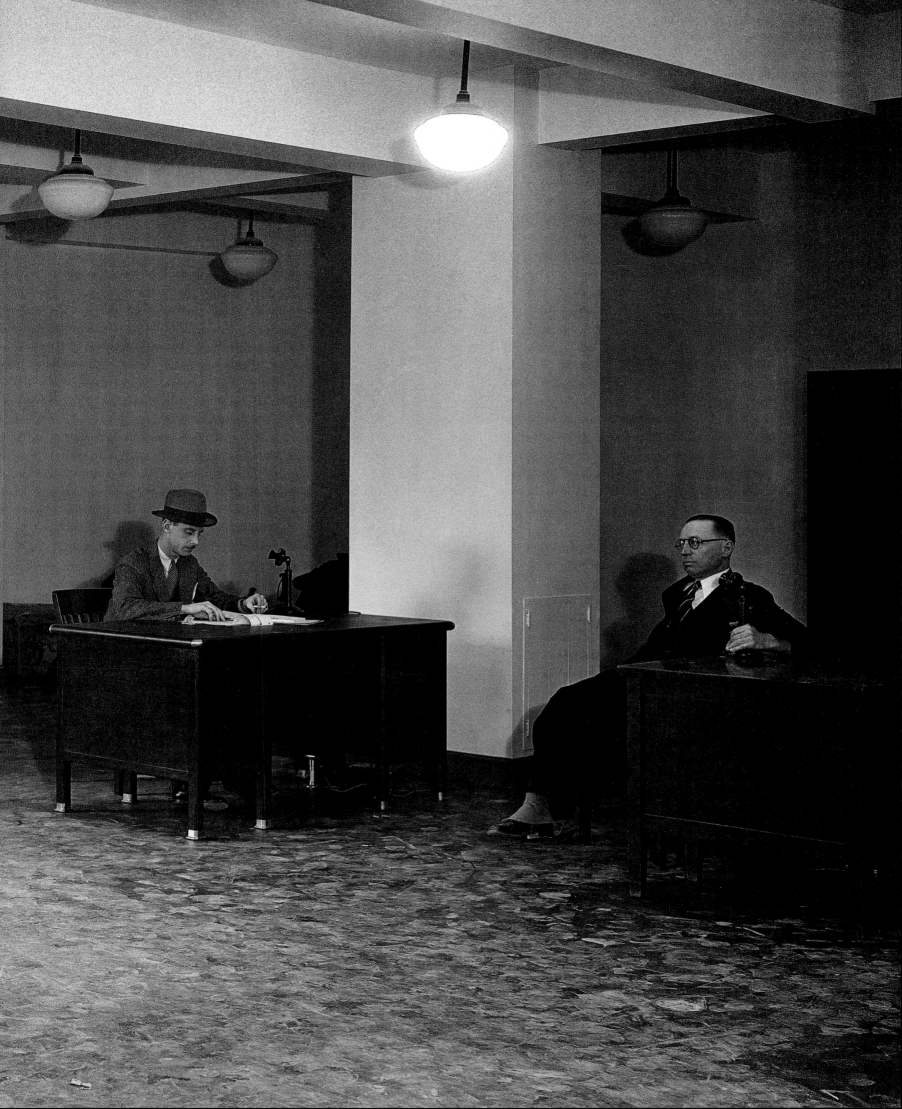

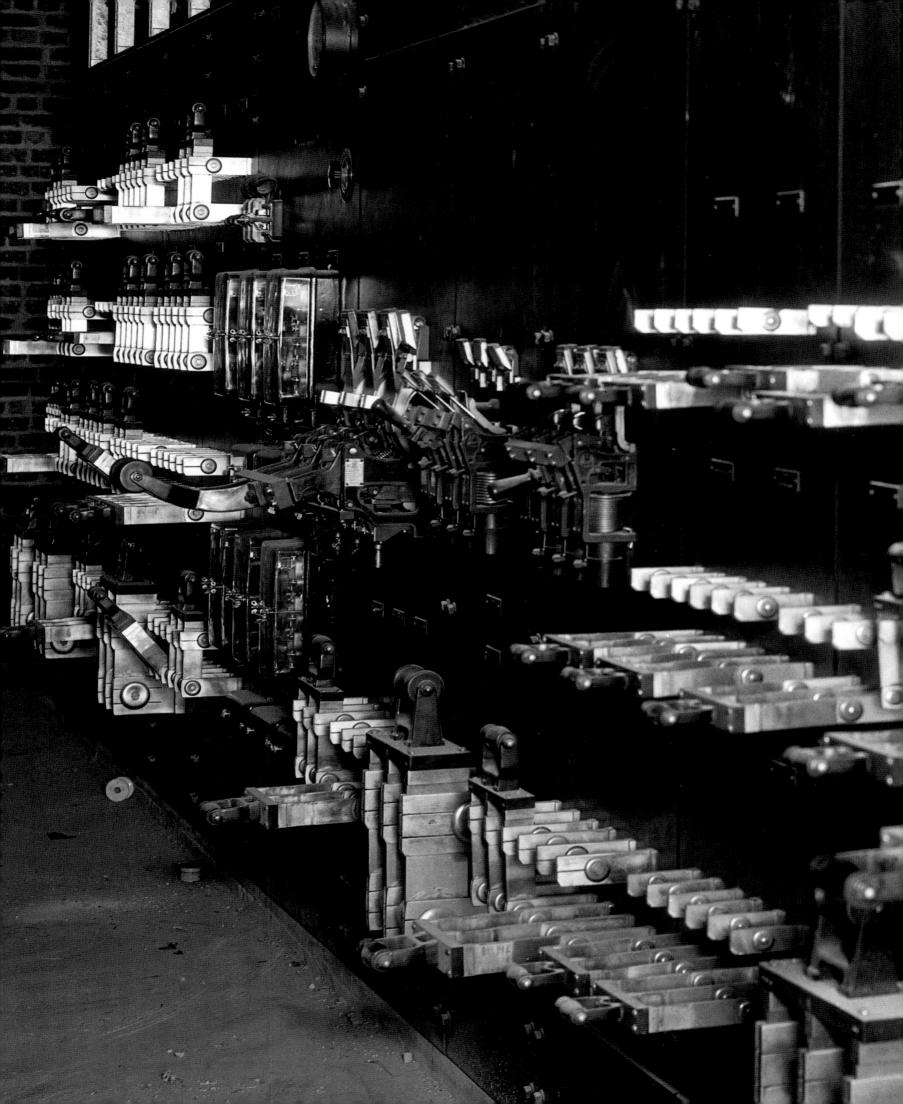

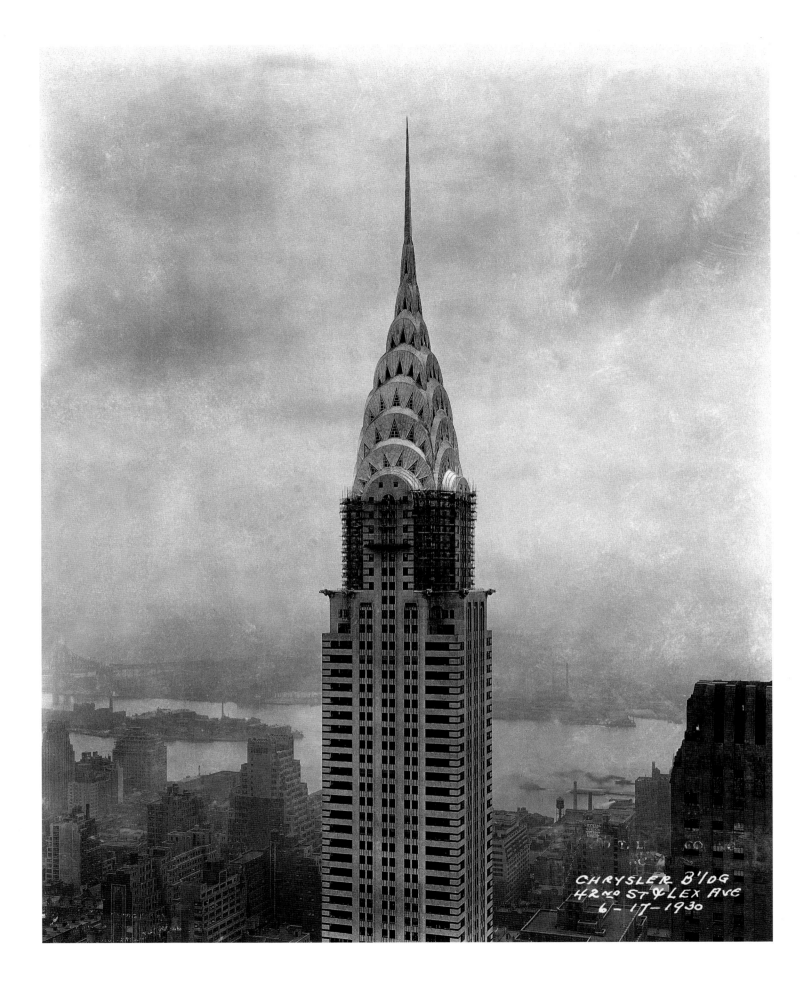

CHRYSLER B'LDG
42ND ST & LEX AVE
6-17-1930

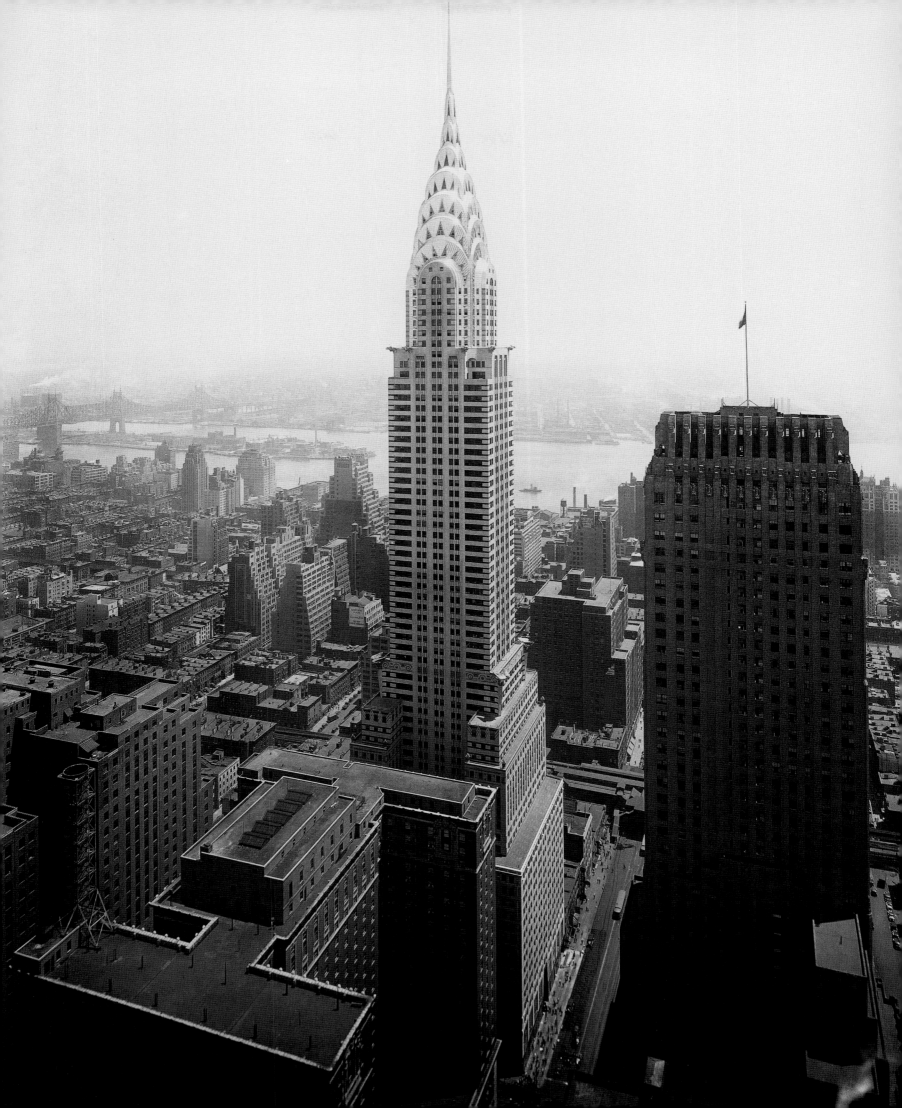

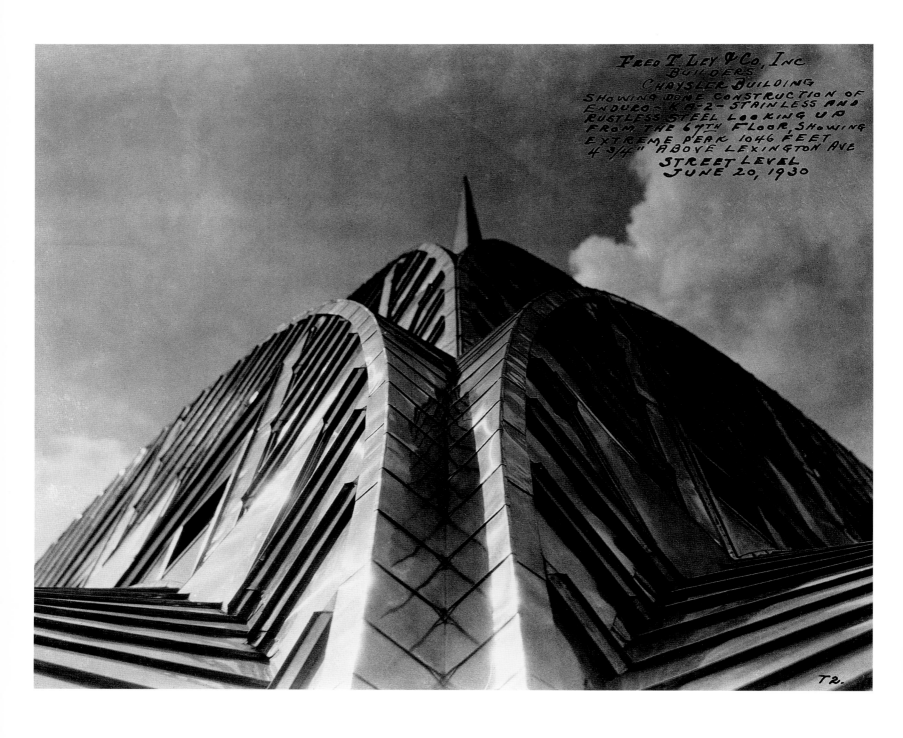

Fred T Ley & Co, Inc
Builders
Chrysler Building
Showing Dome Construction of
Enduro-KA-2-Stainless and
Rustless Steel Looking up
From the 69th Floor, Showing
Extreme Peak 1046 Feet
4 3/4" Above Lexington Ave
Street Level
June 20, 1930

T2.

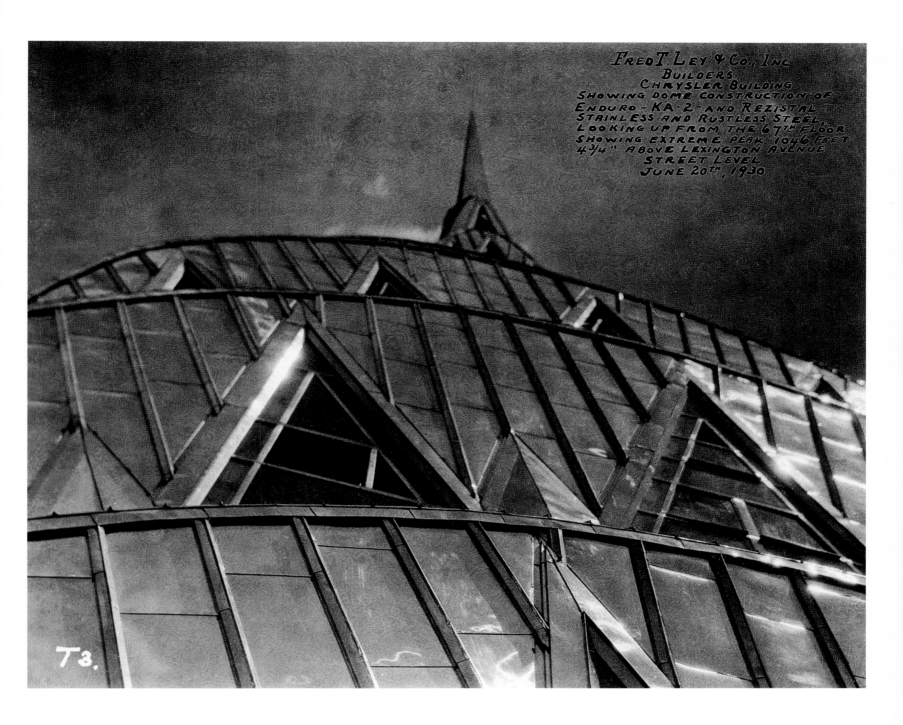

FRED T. LEY & CO., INC
BUILDERS
CHRYSLER BUILDING
SHOWING DOME CONSTRUCTION OF
ENDURO - KA-2- AND REZISTAL
STAINLESS AND RUSTLESS STEEL,
LOOKING UP FROM THE 67TH FLOOR
SHOWING EXTREME PEAK 1046 FEET
4 3/4" ABOVE LEXINGTON AVENUE
STREET LEVEL
JUNE 20TH, 1930

T3.

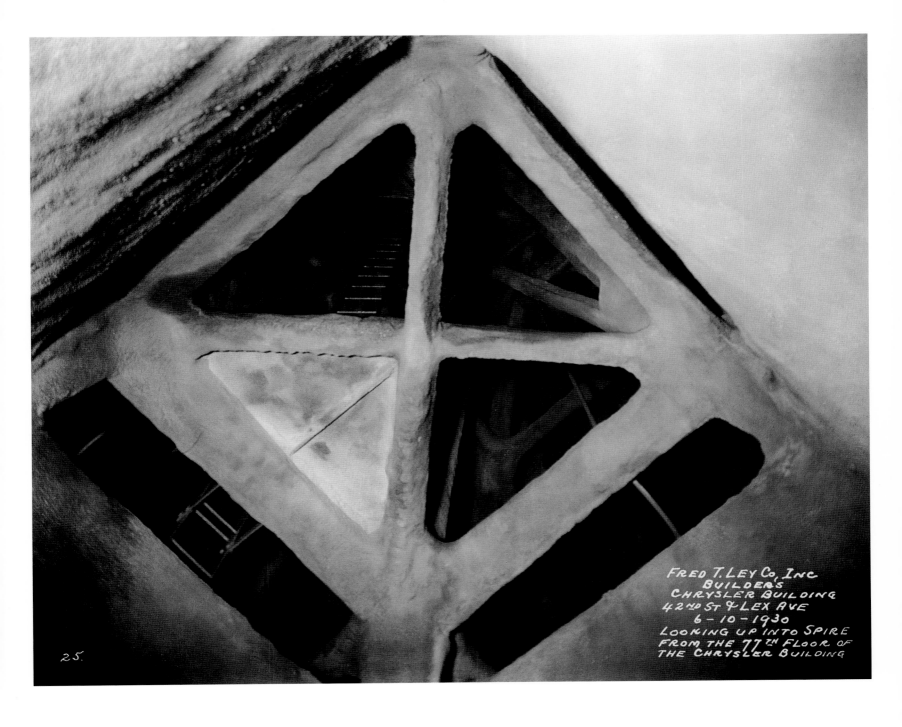

25.

Fred T. Ley Co, Inc
Builders
Chrysler Building
42nd St & Lex Ave
6 - 10 - 1930
Looking up into Spire
from the 77th Floor of
the Chrysler Building

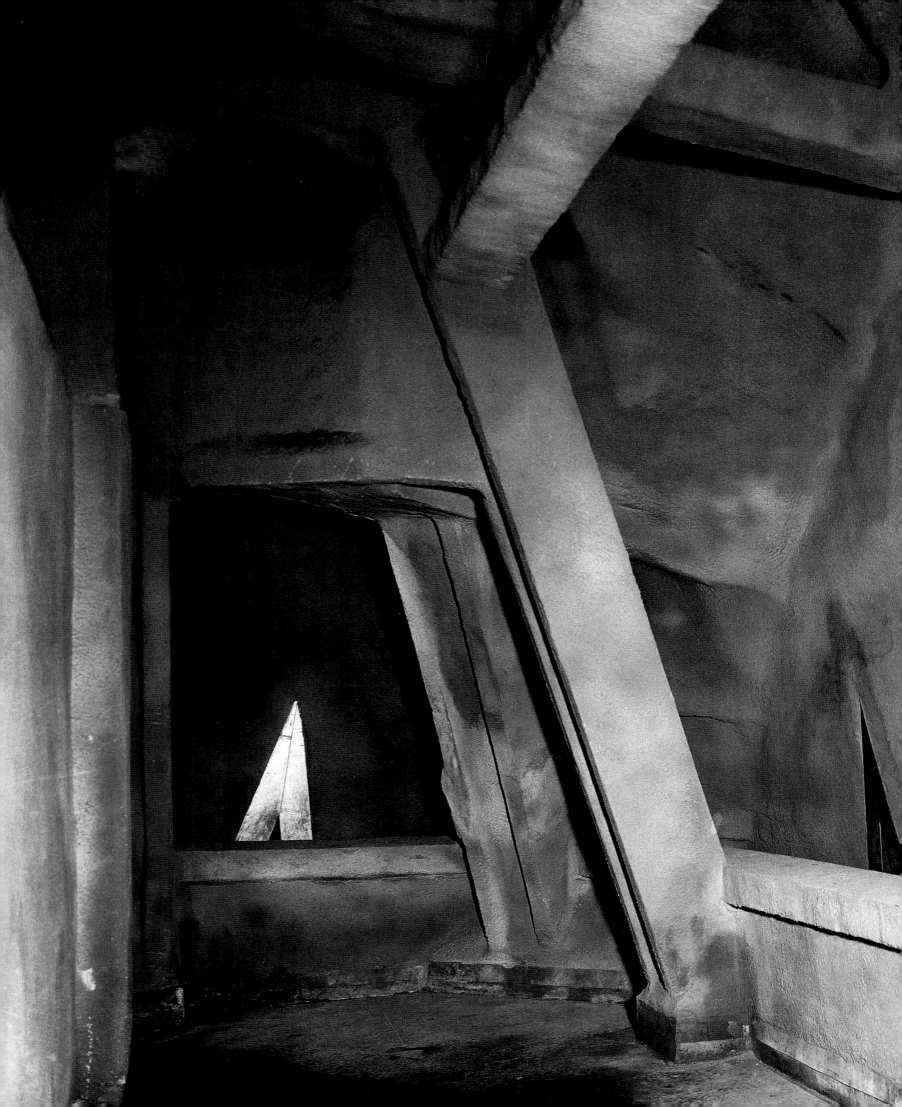

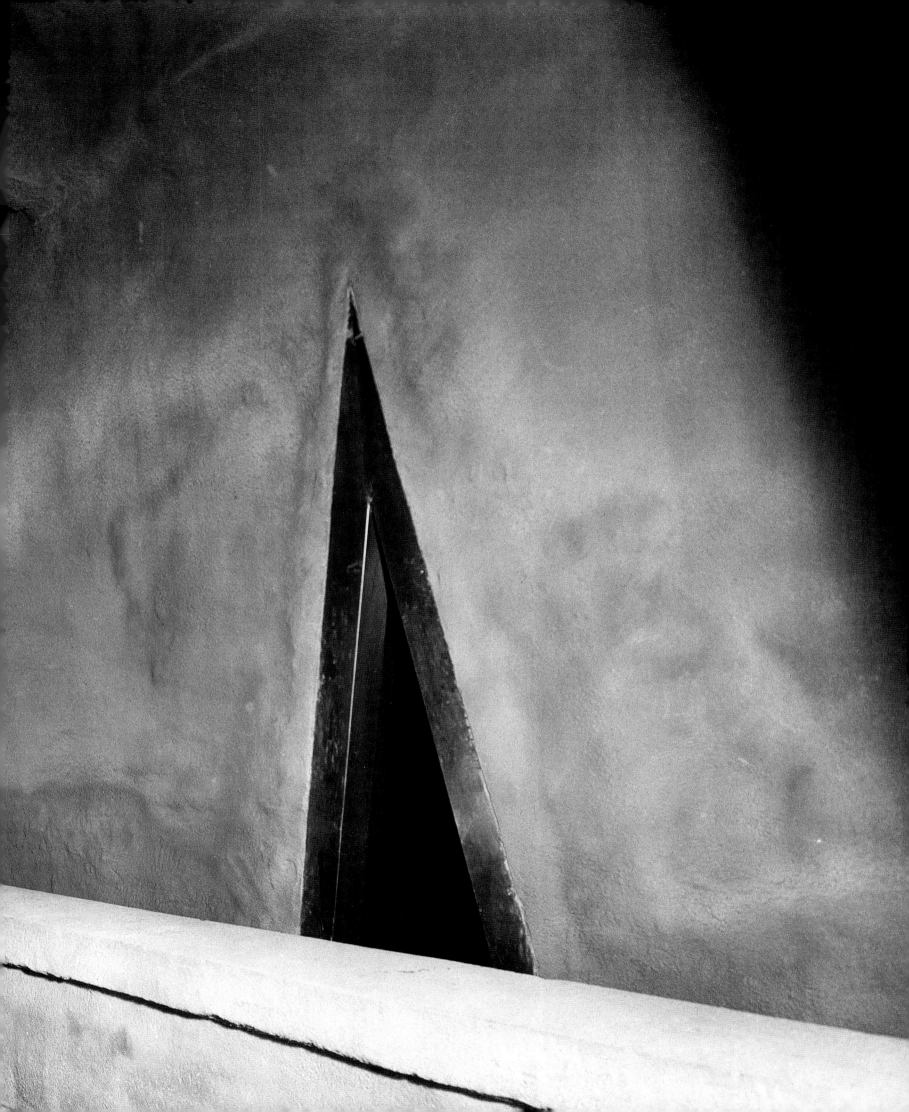

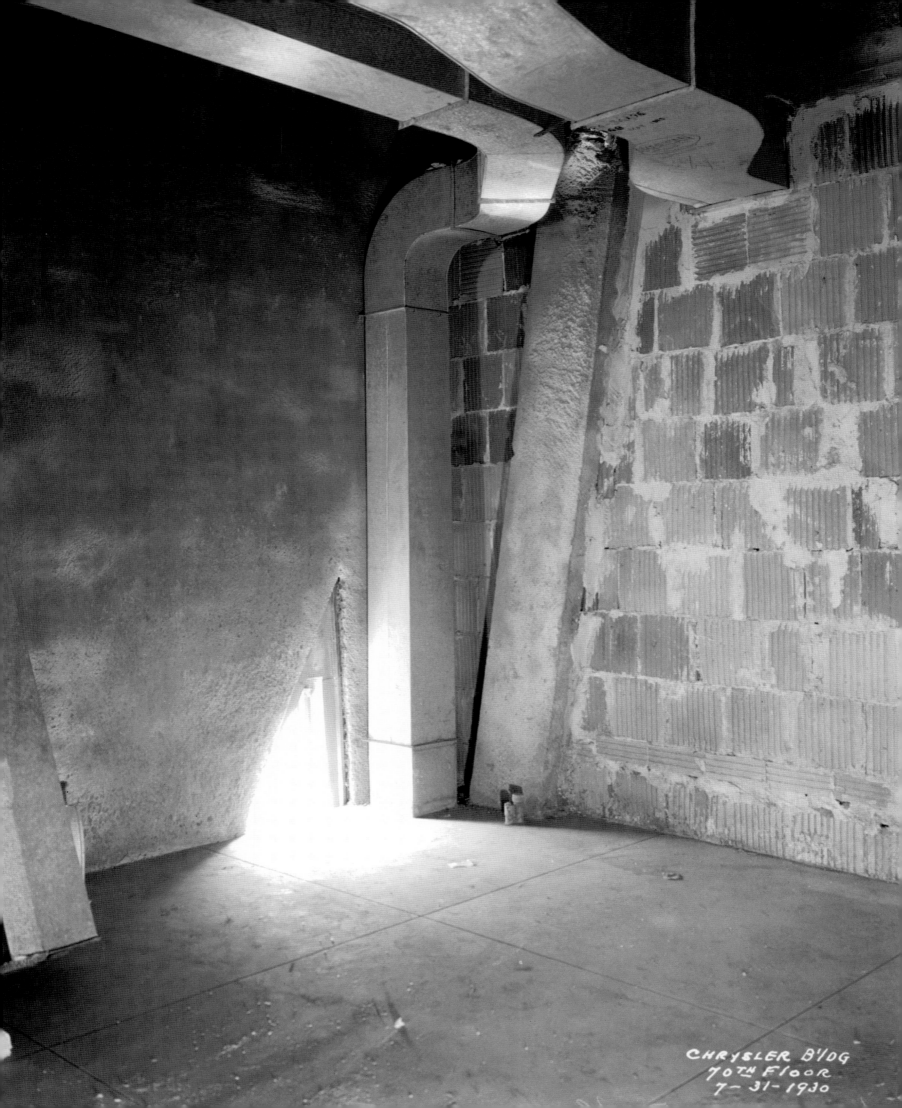

CHRYSLER B'LDG
70TH FLOOR
7-31-1930

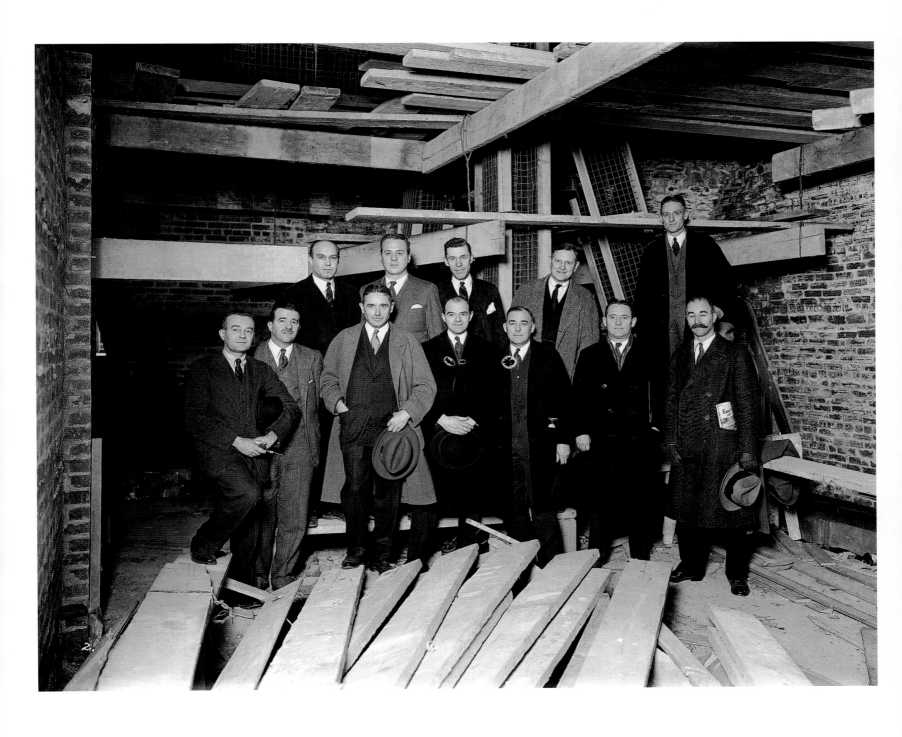

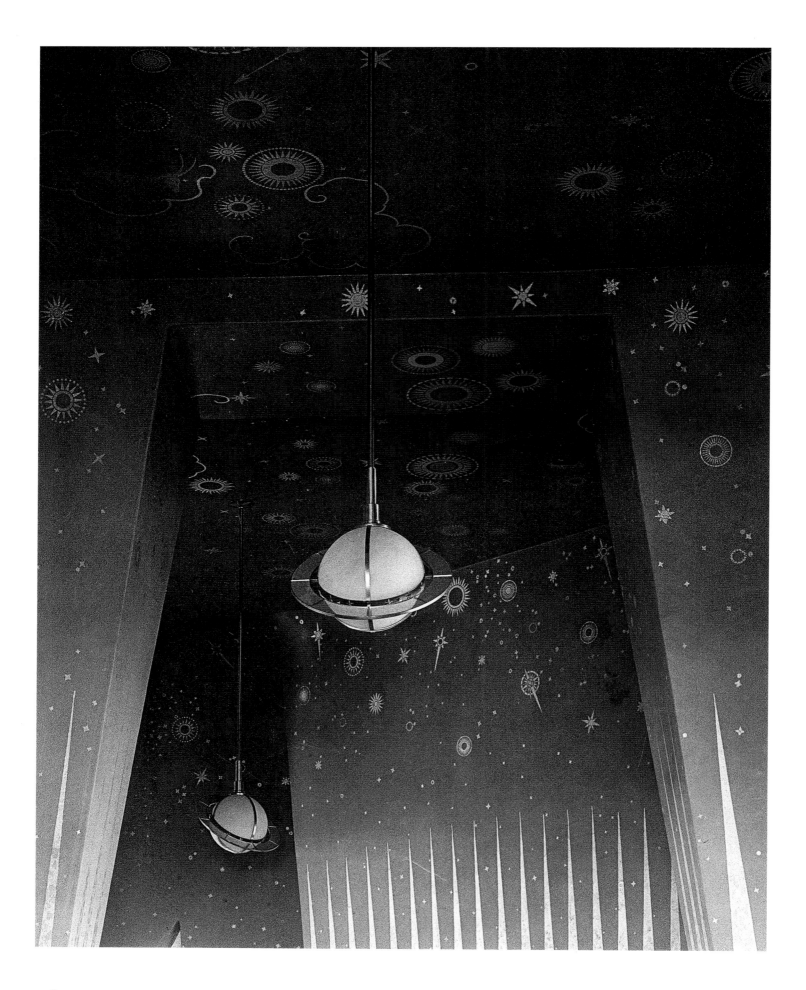

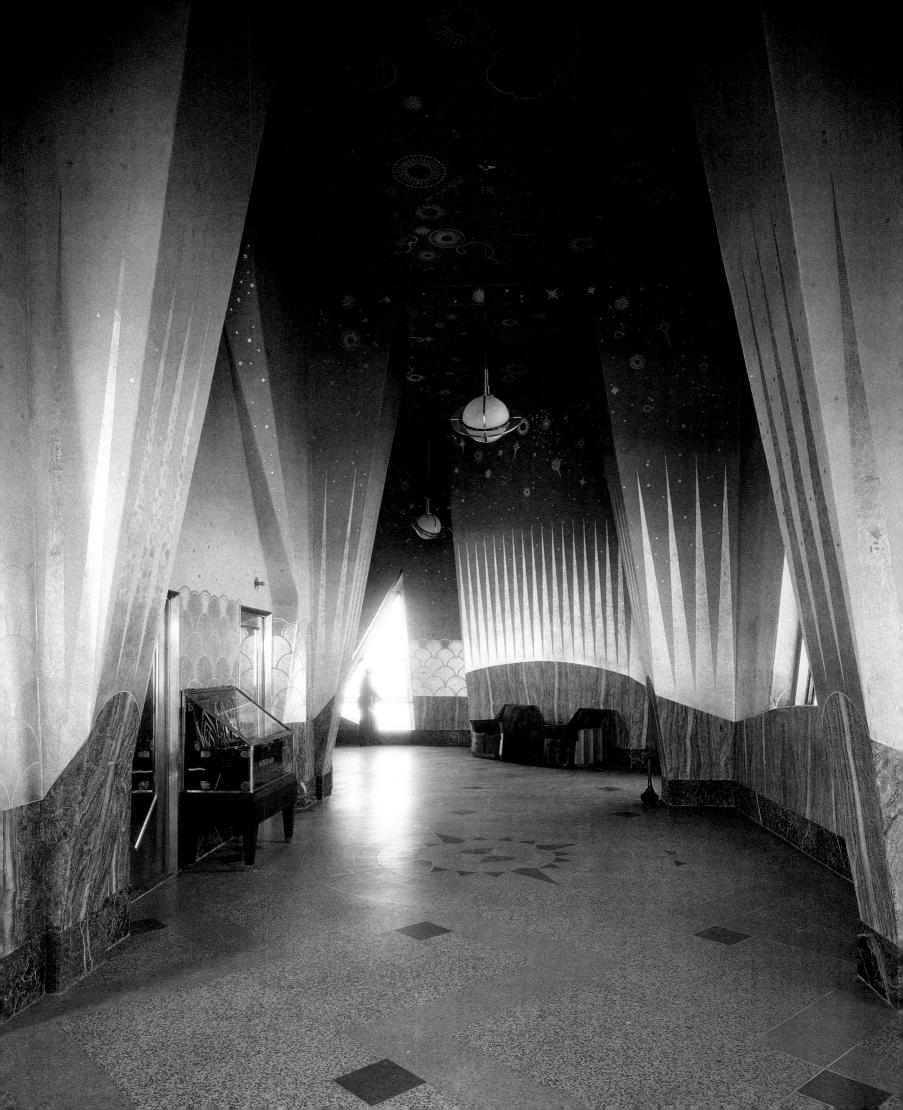

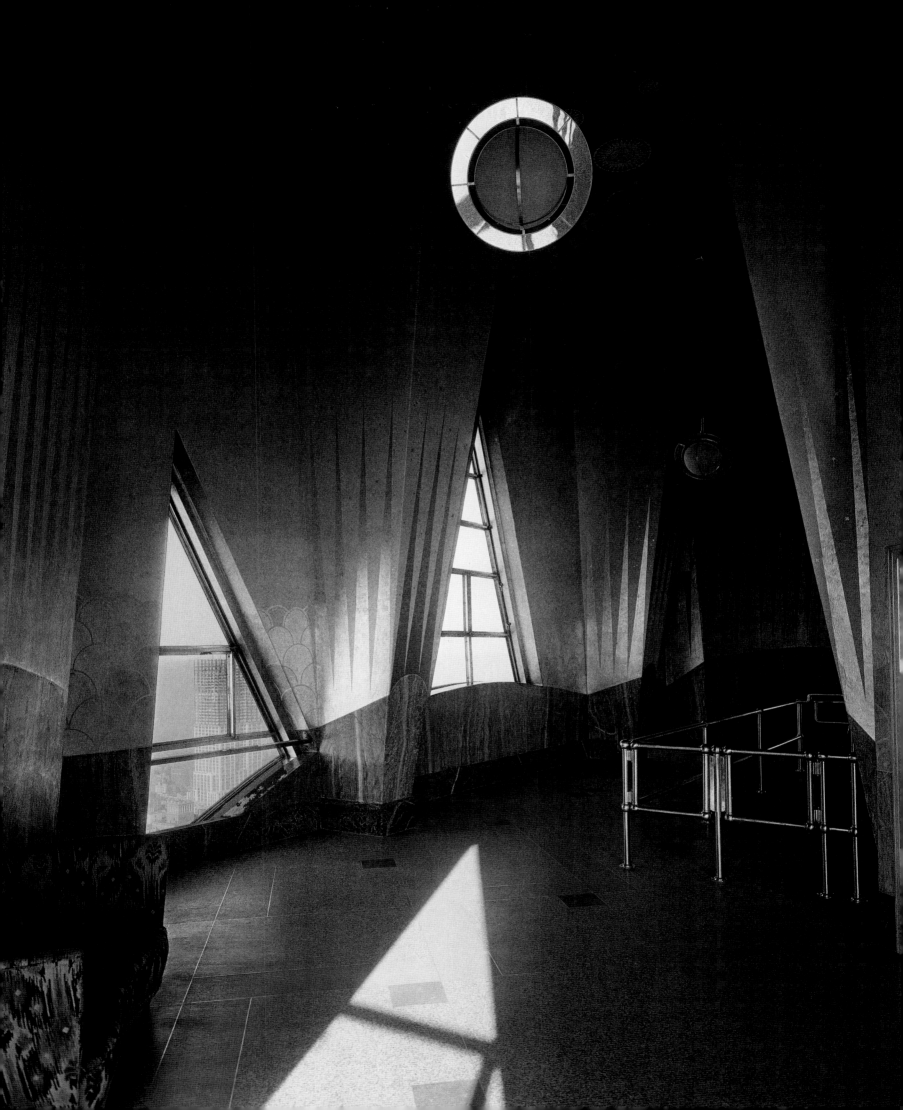

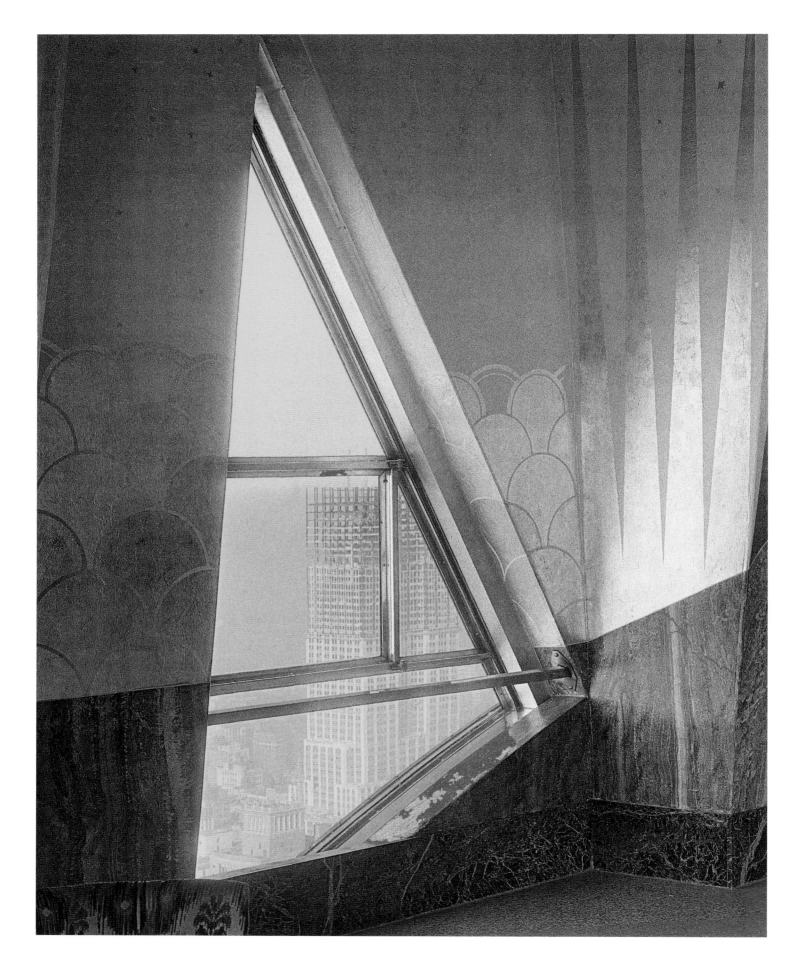

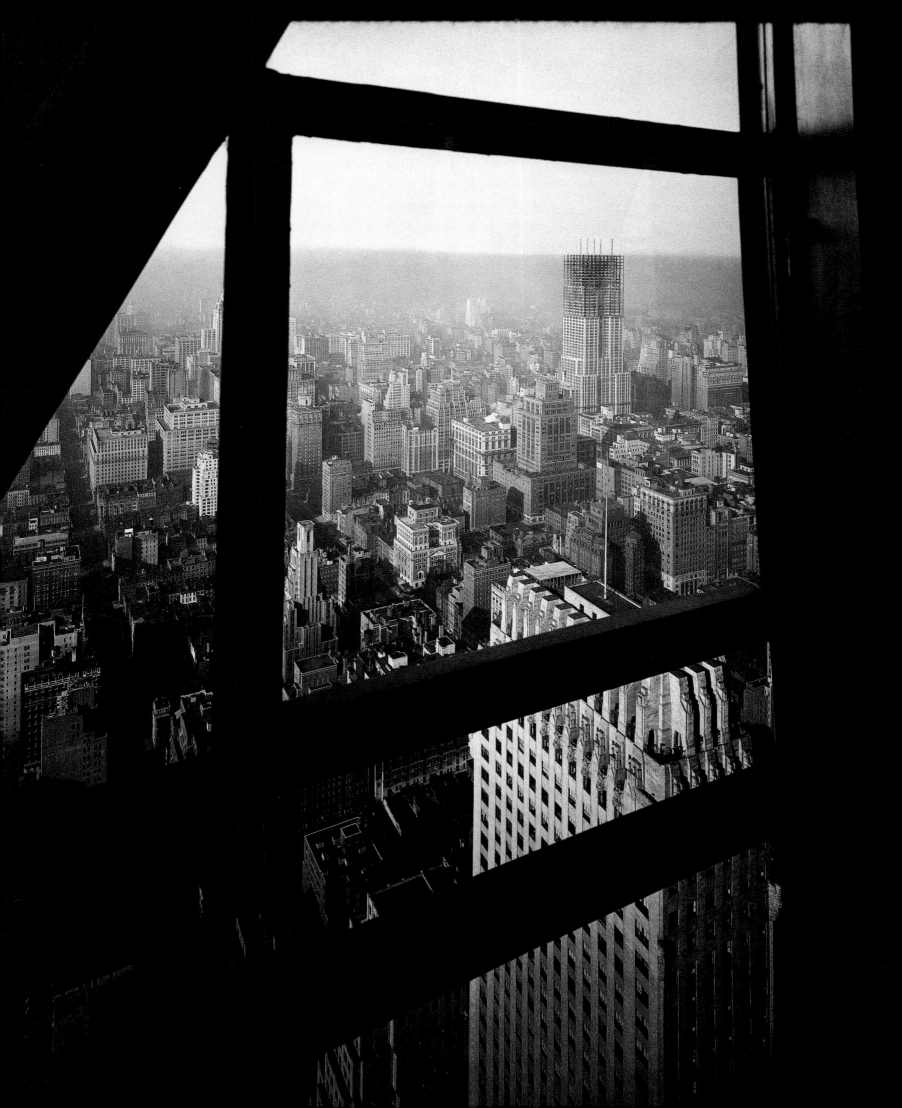

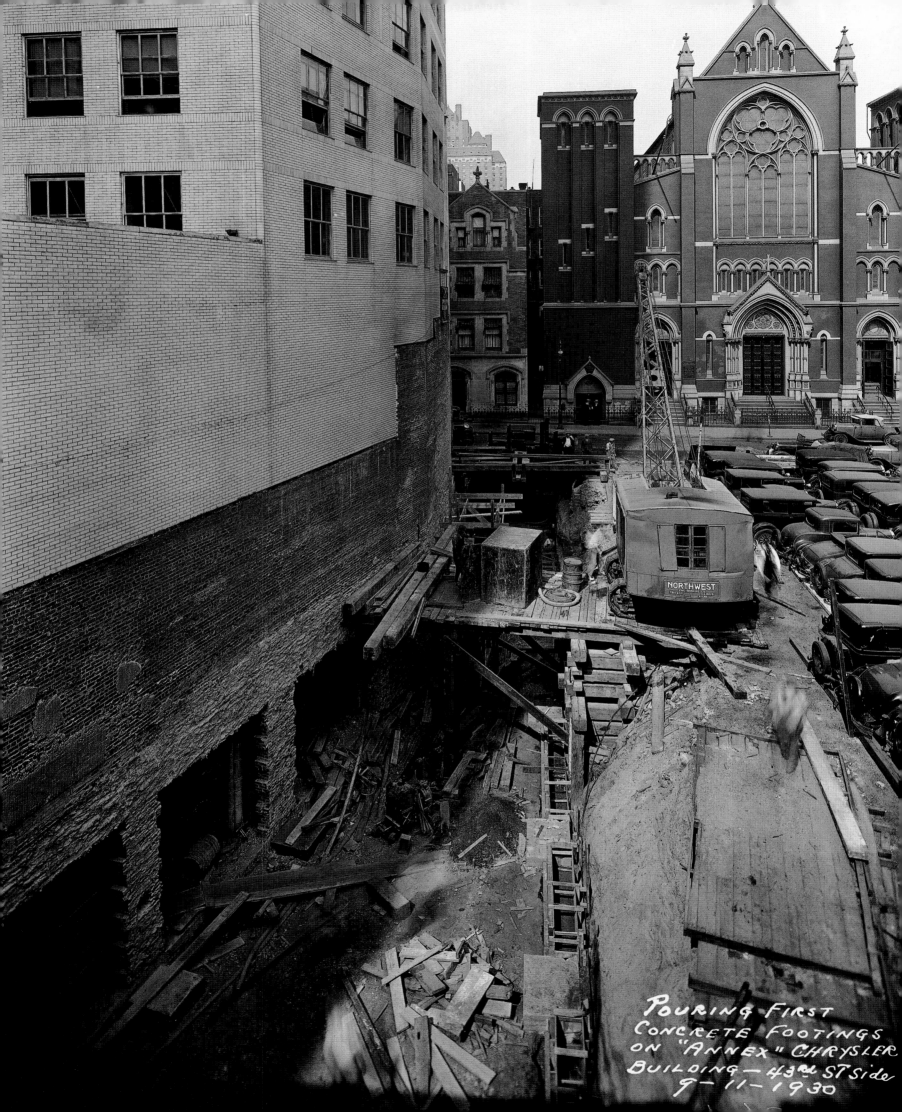

POURING FIRST CONCRETE FOOTINGS ON "ANNEX" CHRYSLER BUILDING — 43rd ST Side 9-11-1930

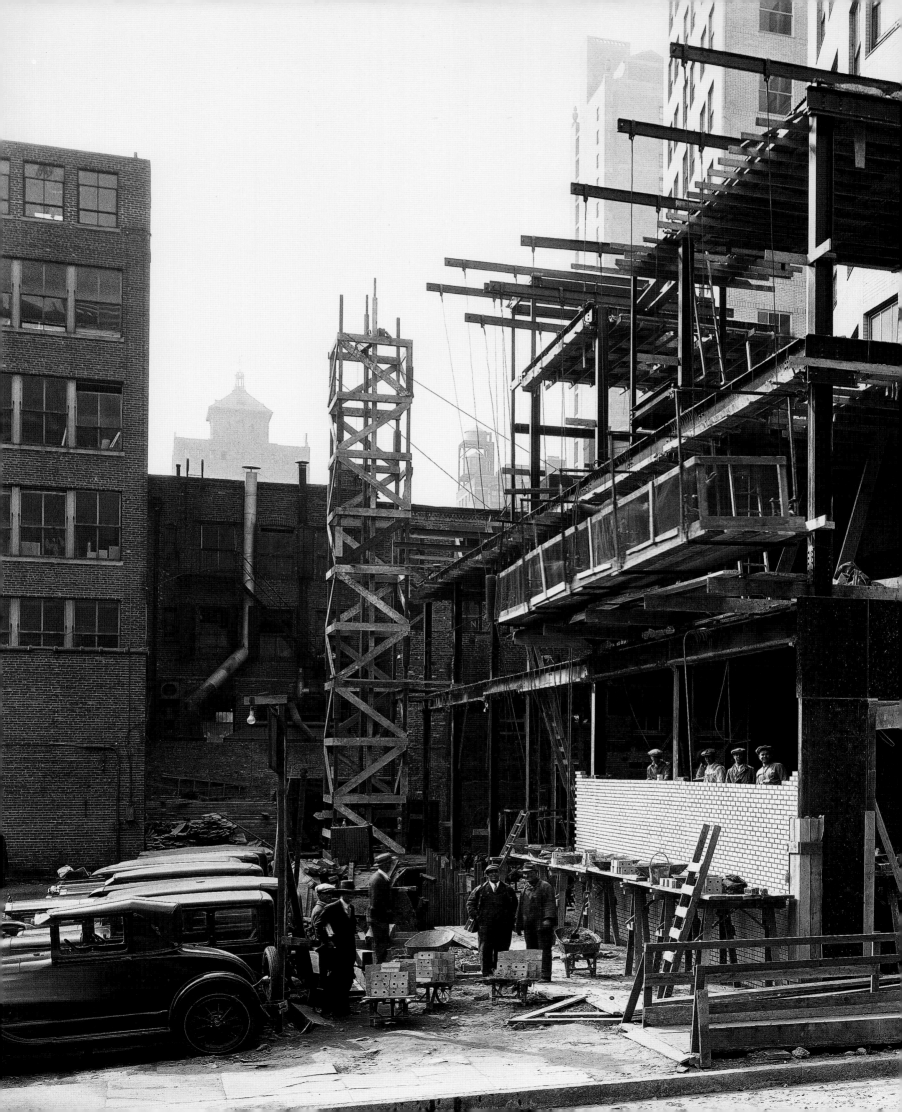

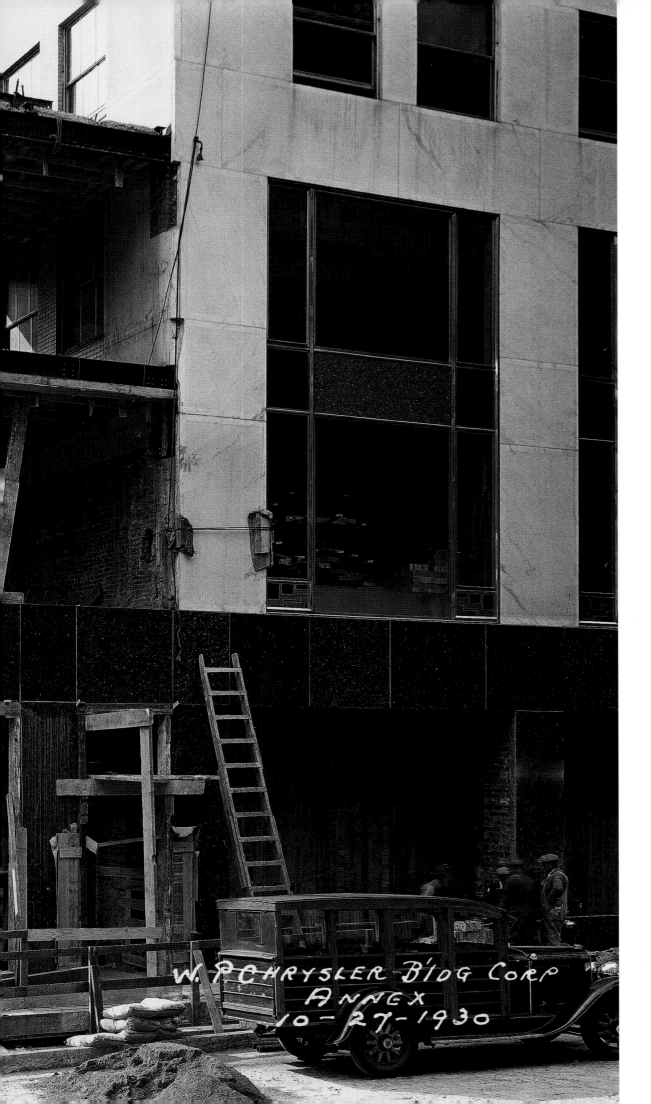

W. P. CHRYSLER B'IdG CORP
ANNEX
10-27-1930

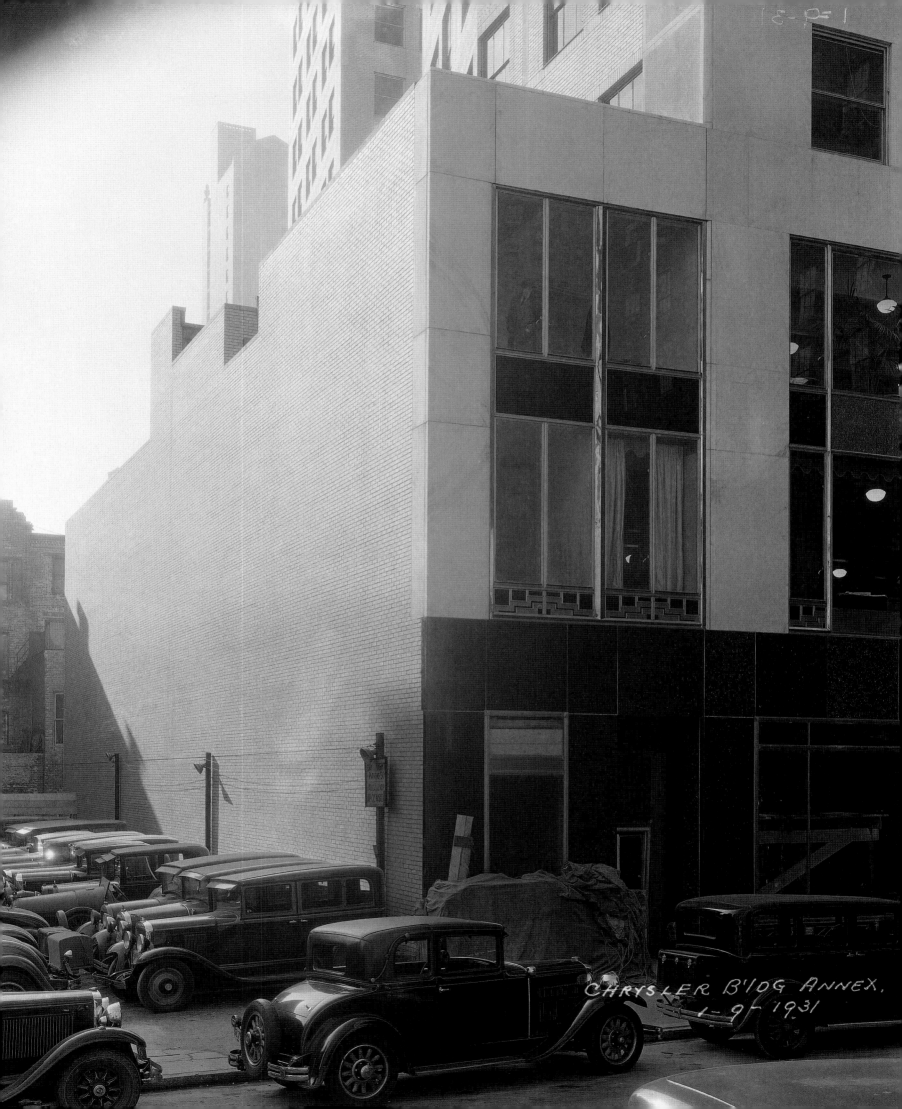

CHRYSLER B'LDG ANNEX.
1-9-1931

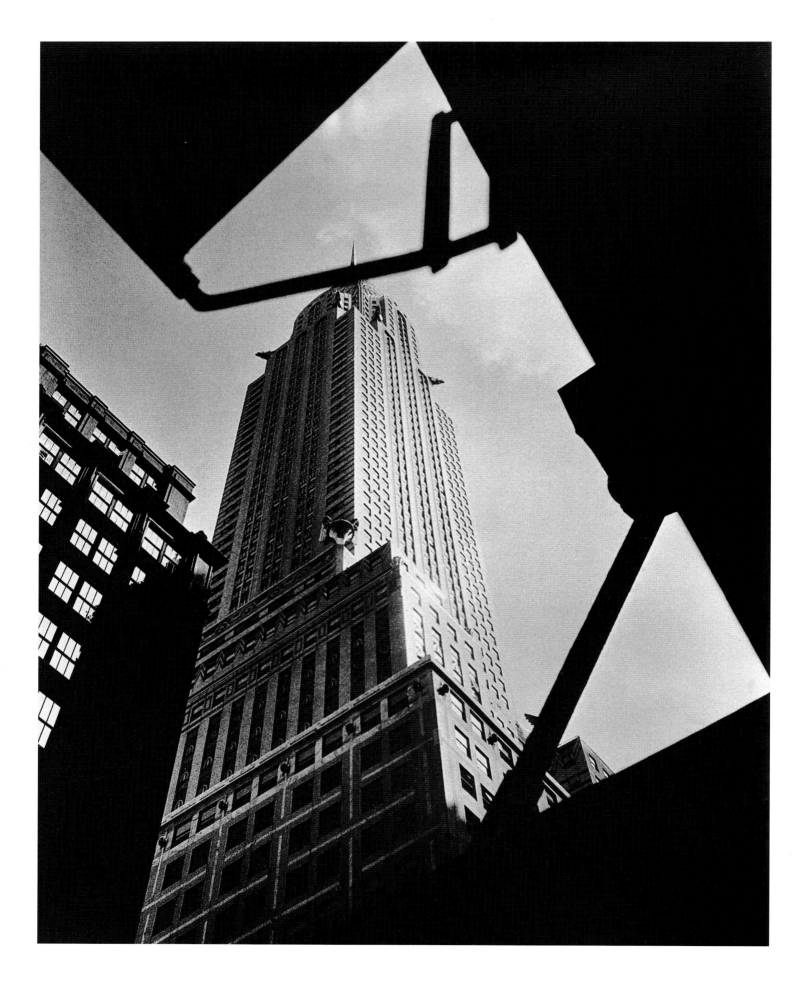

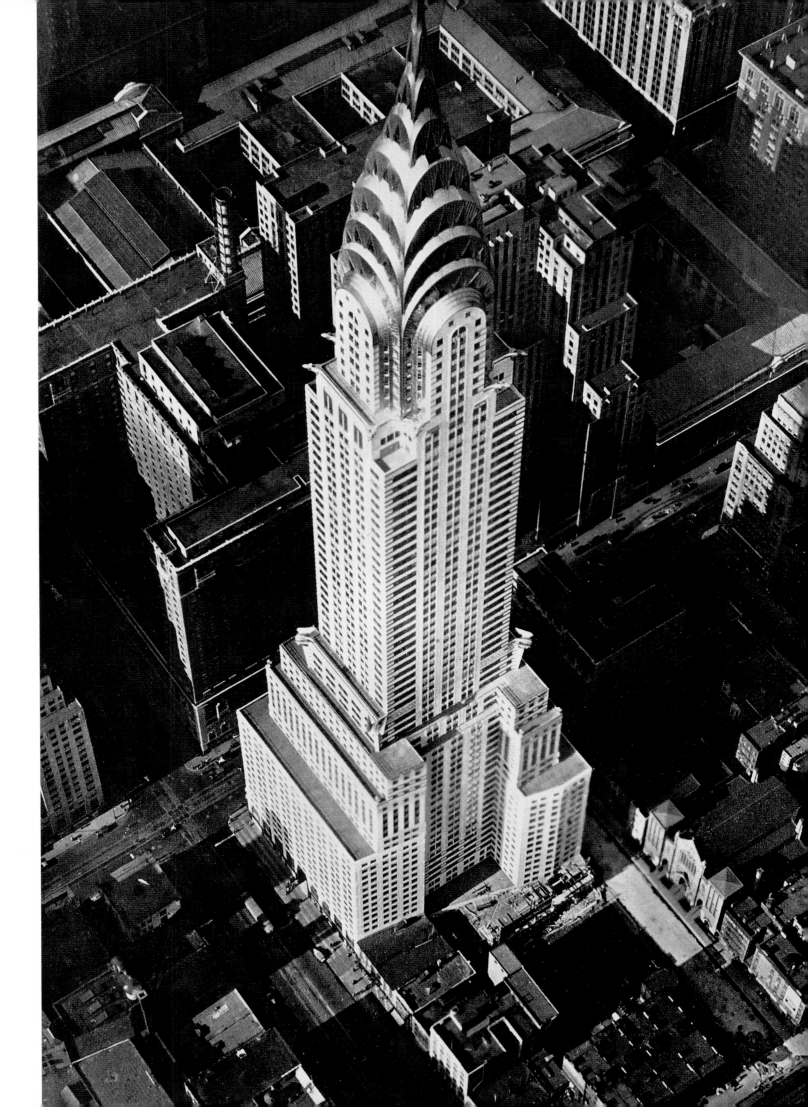

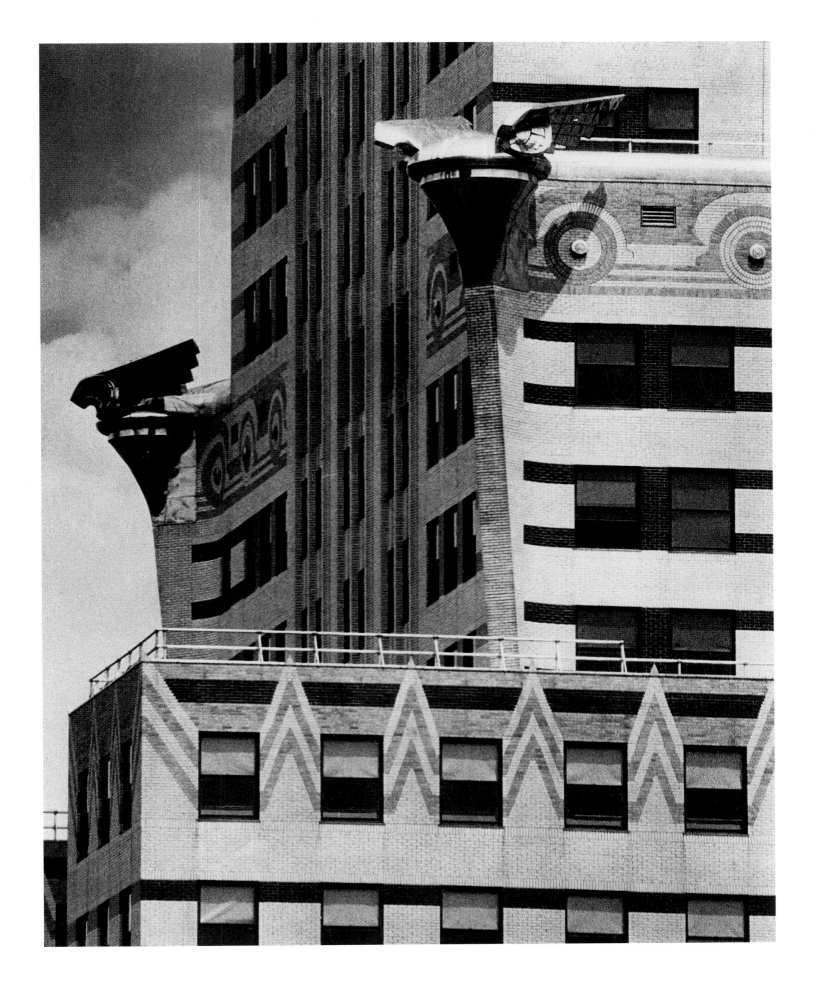

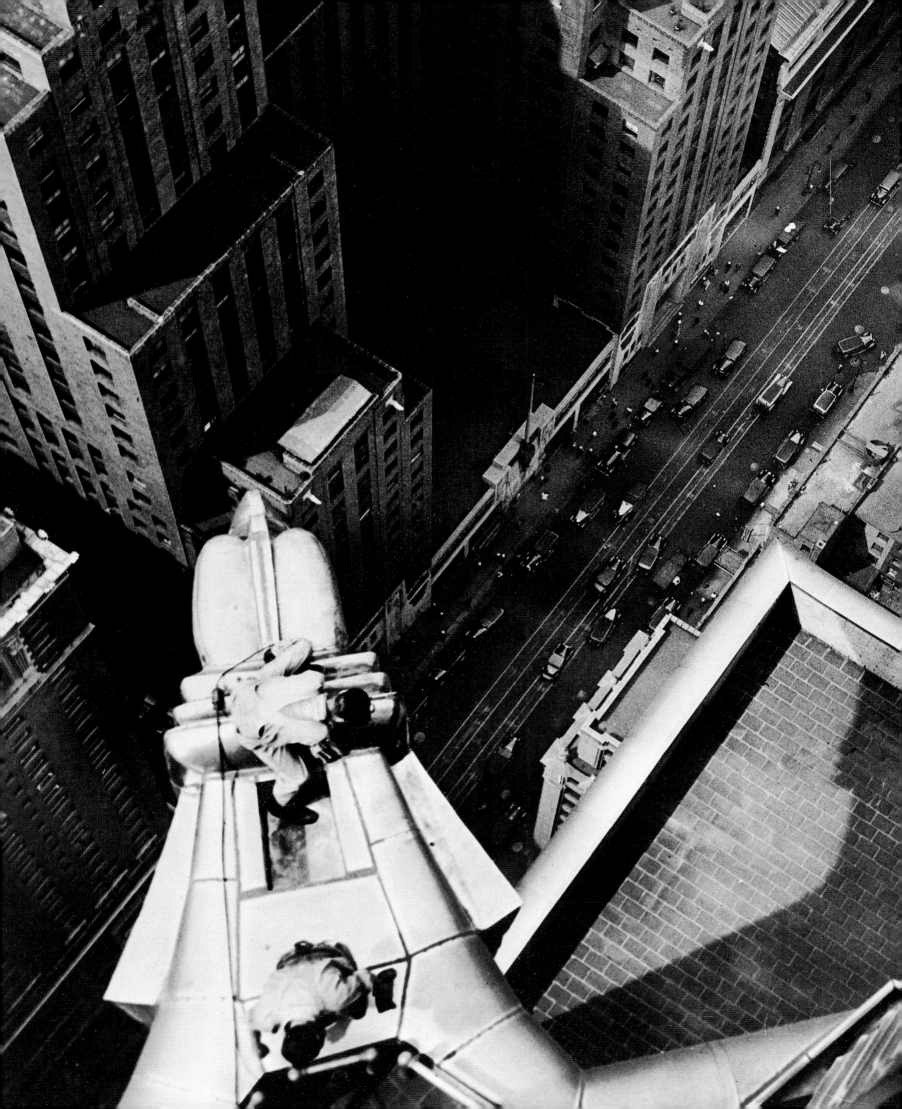

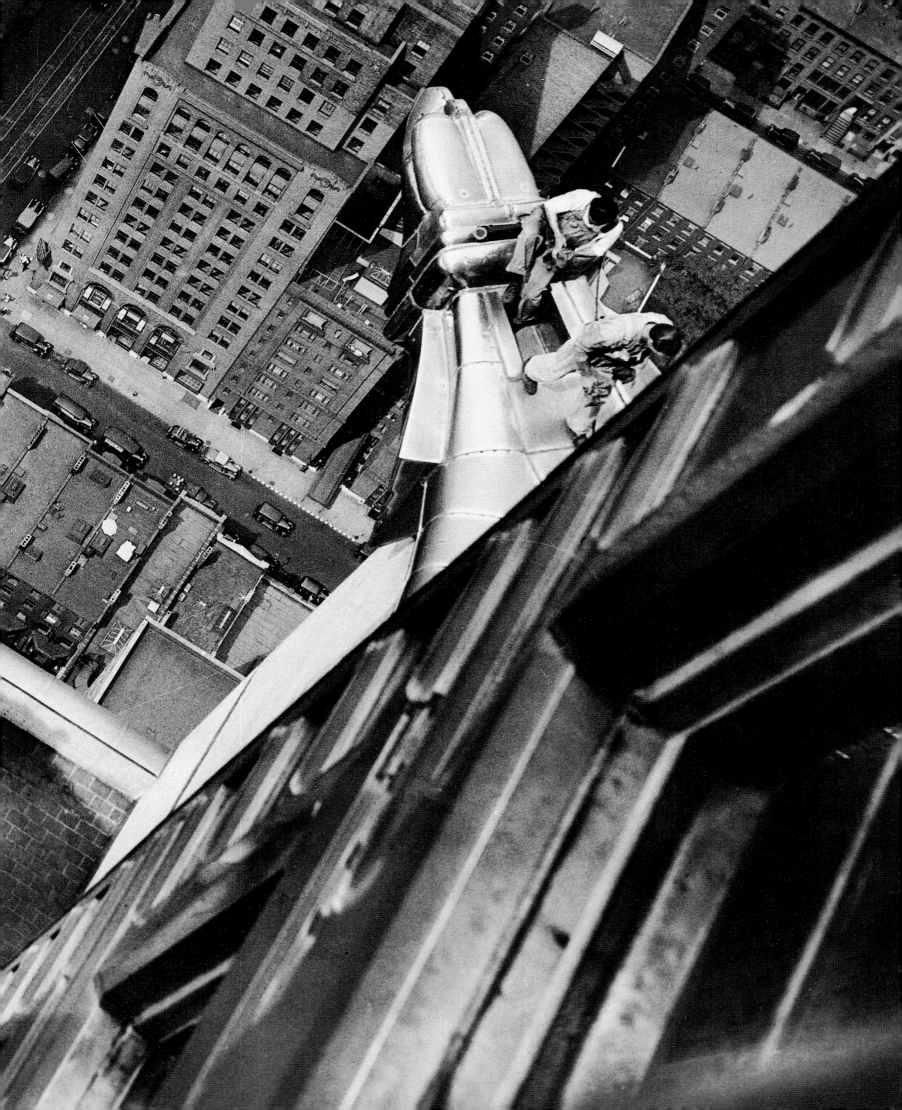

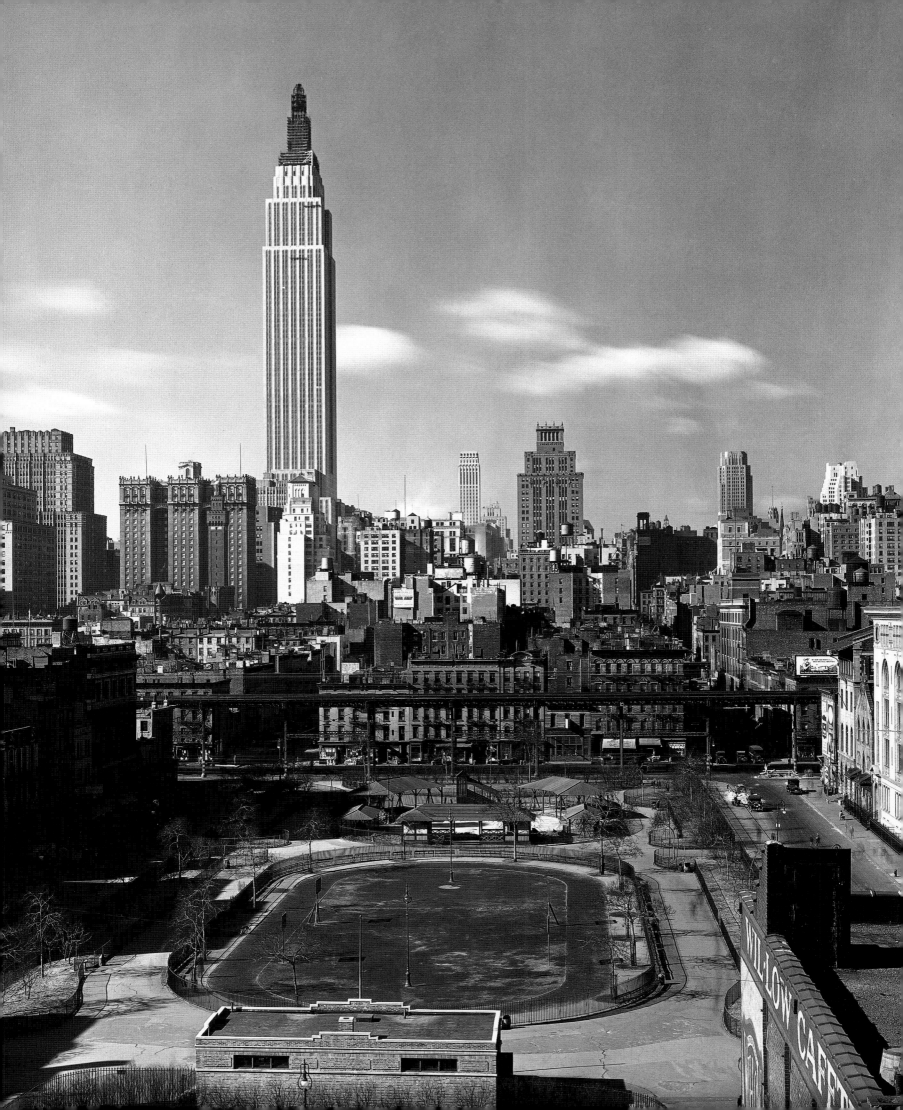

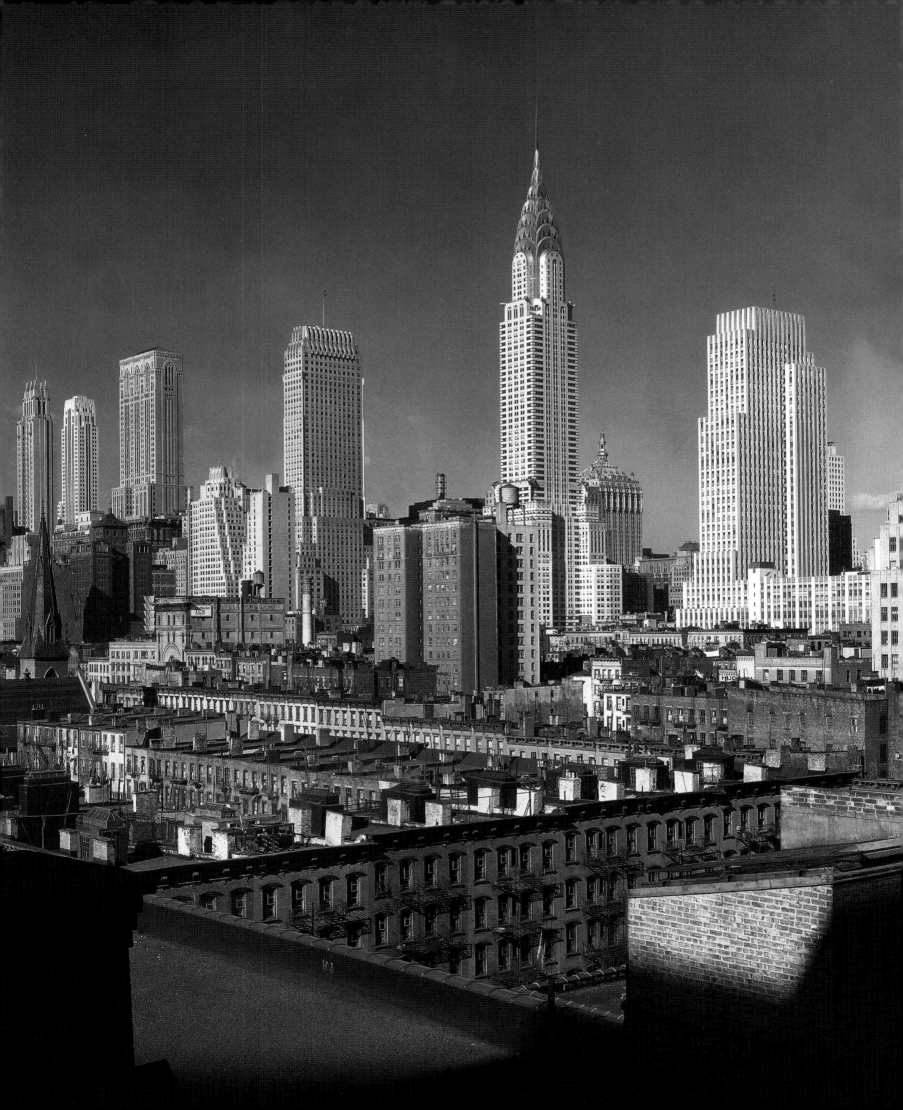

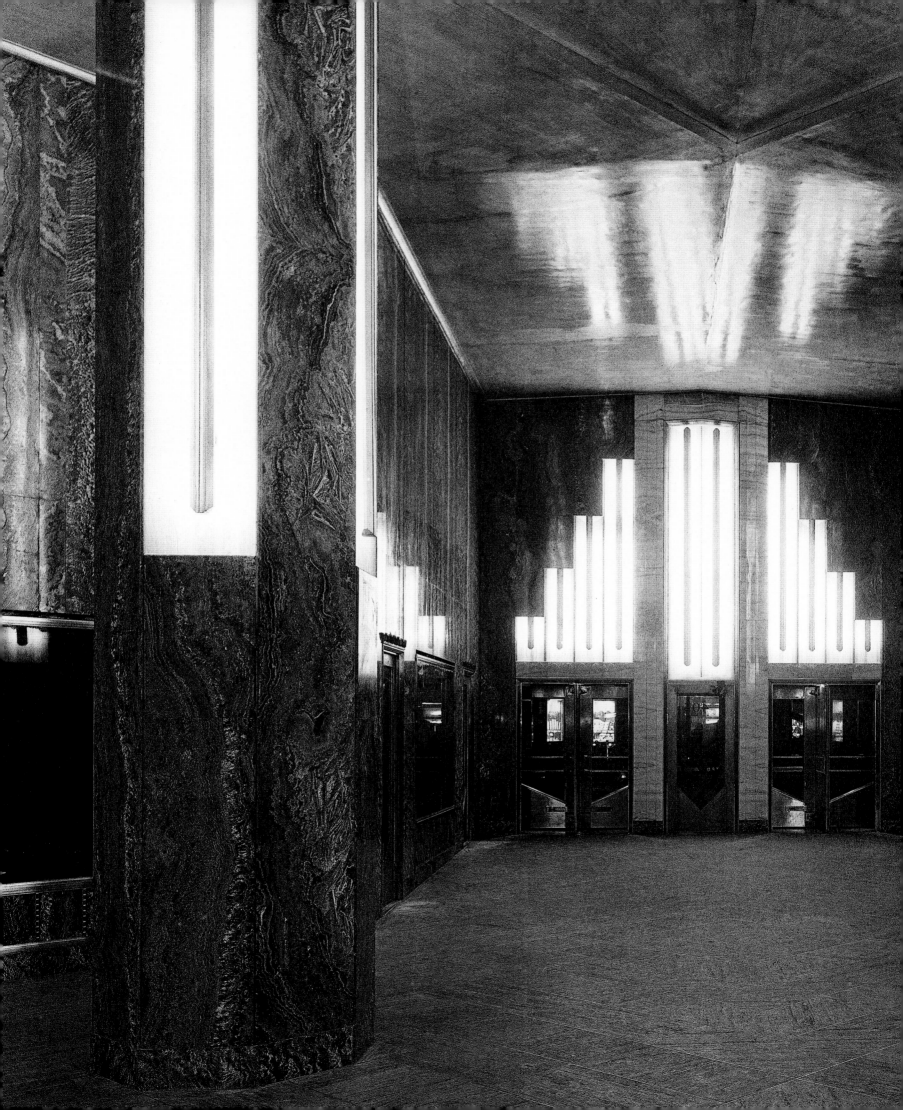

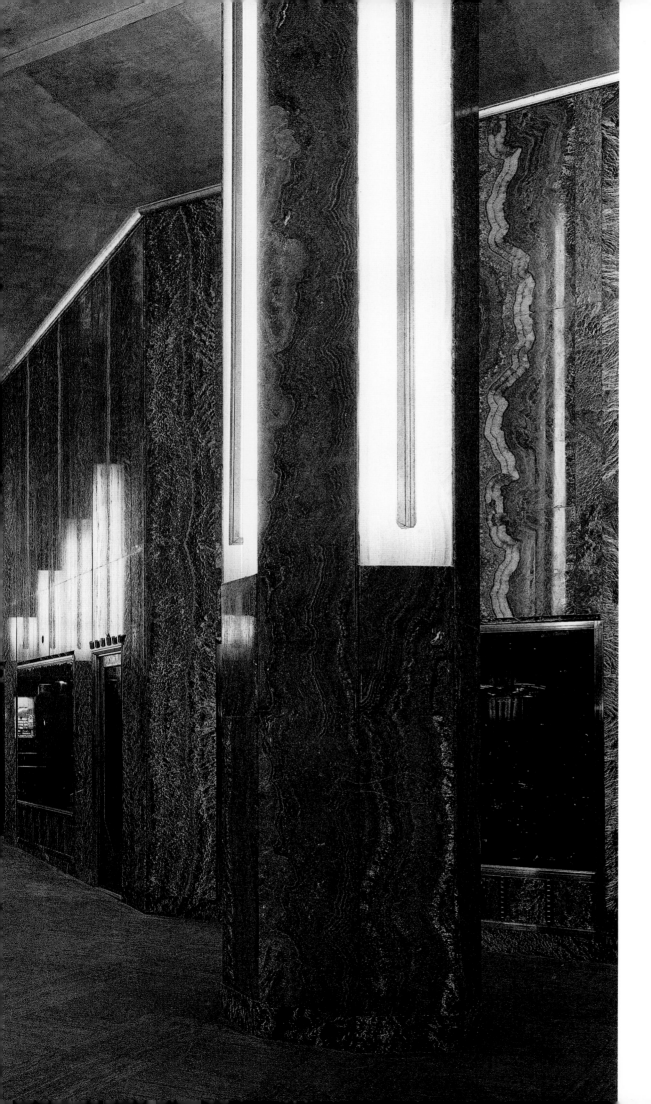

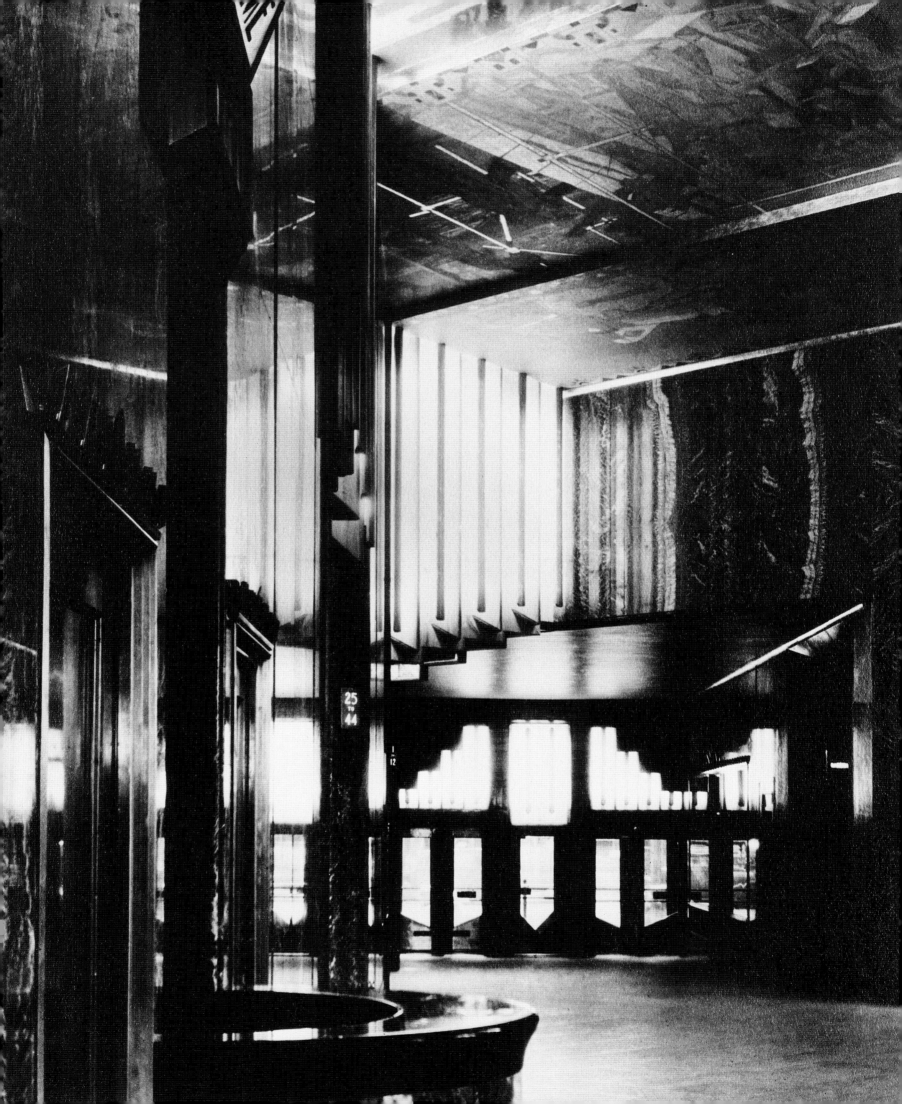

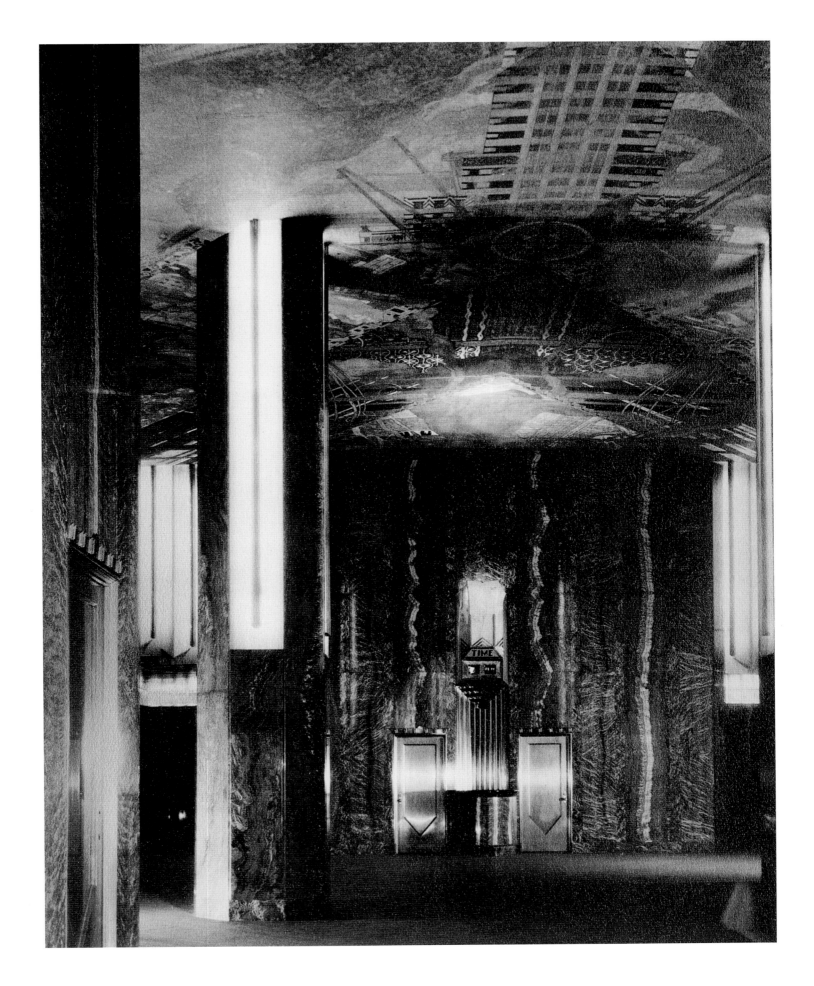

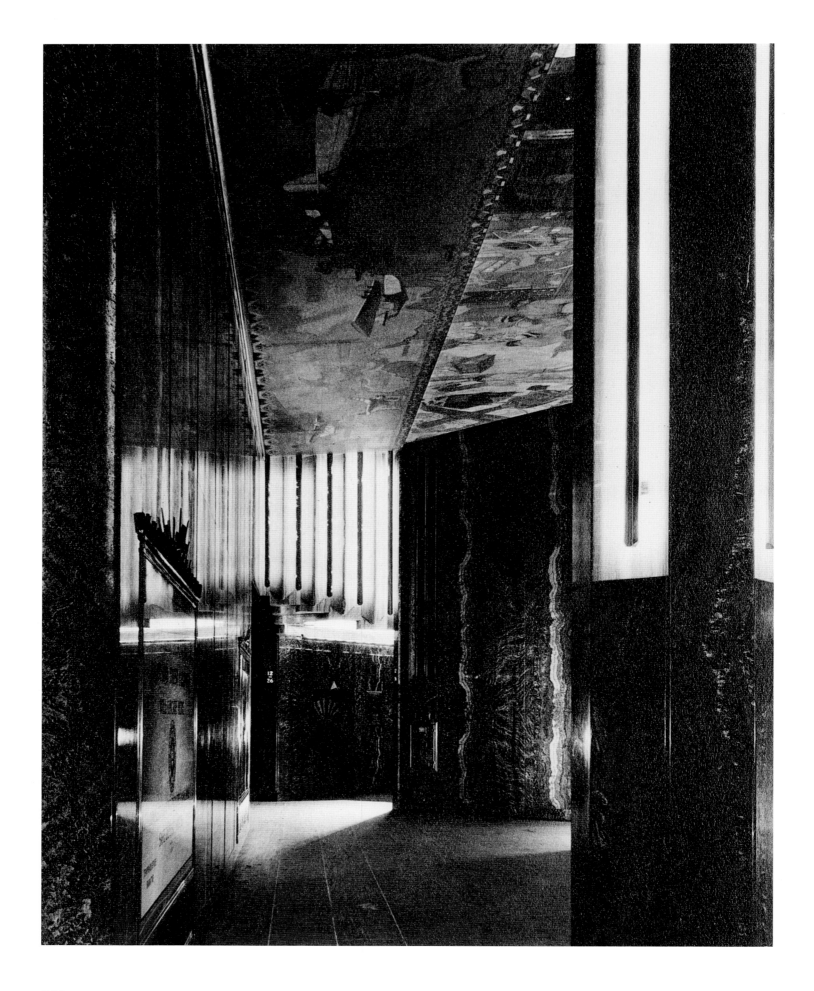

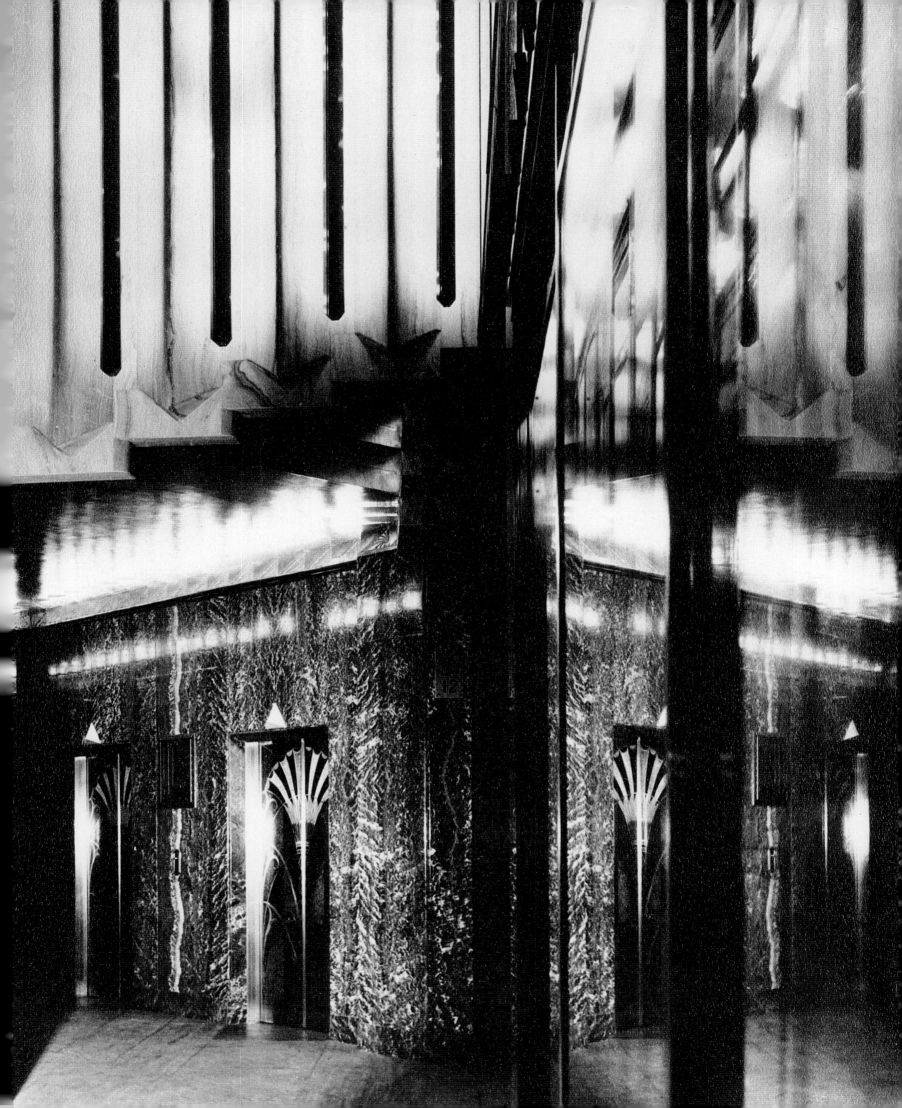

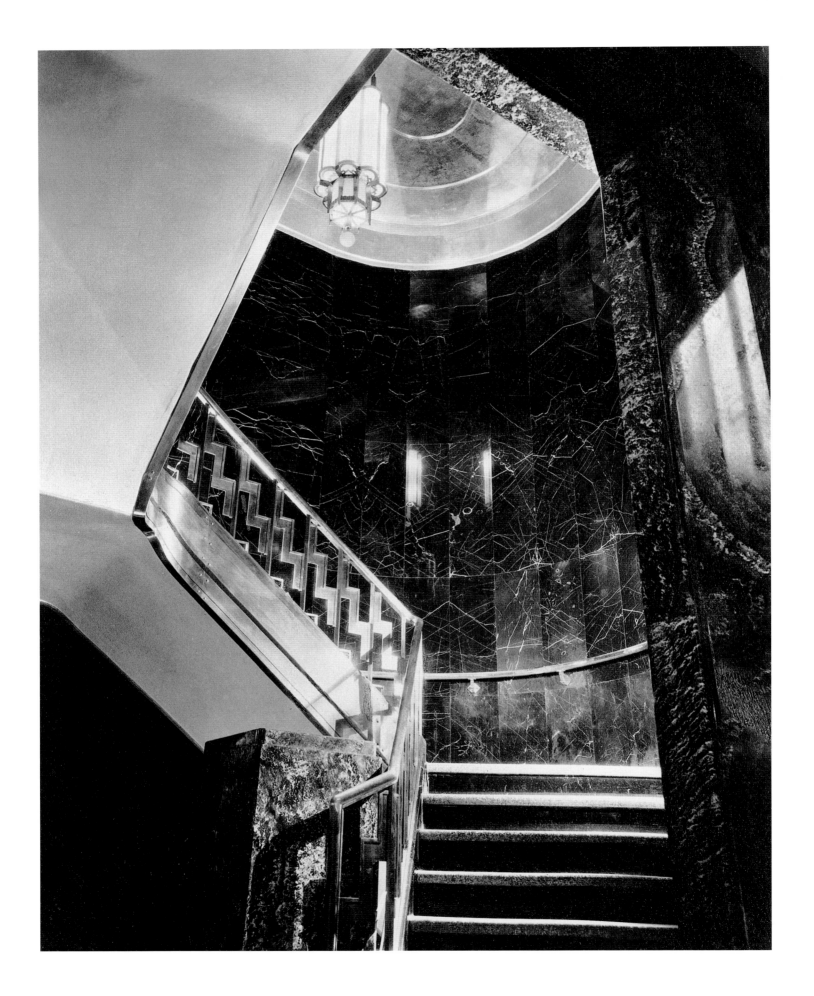

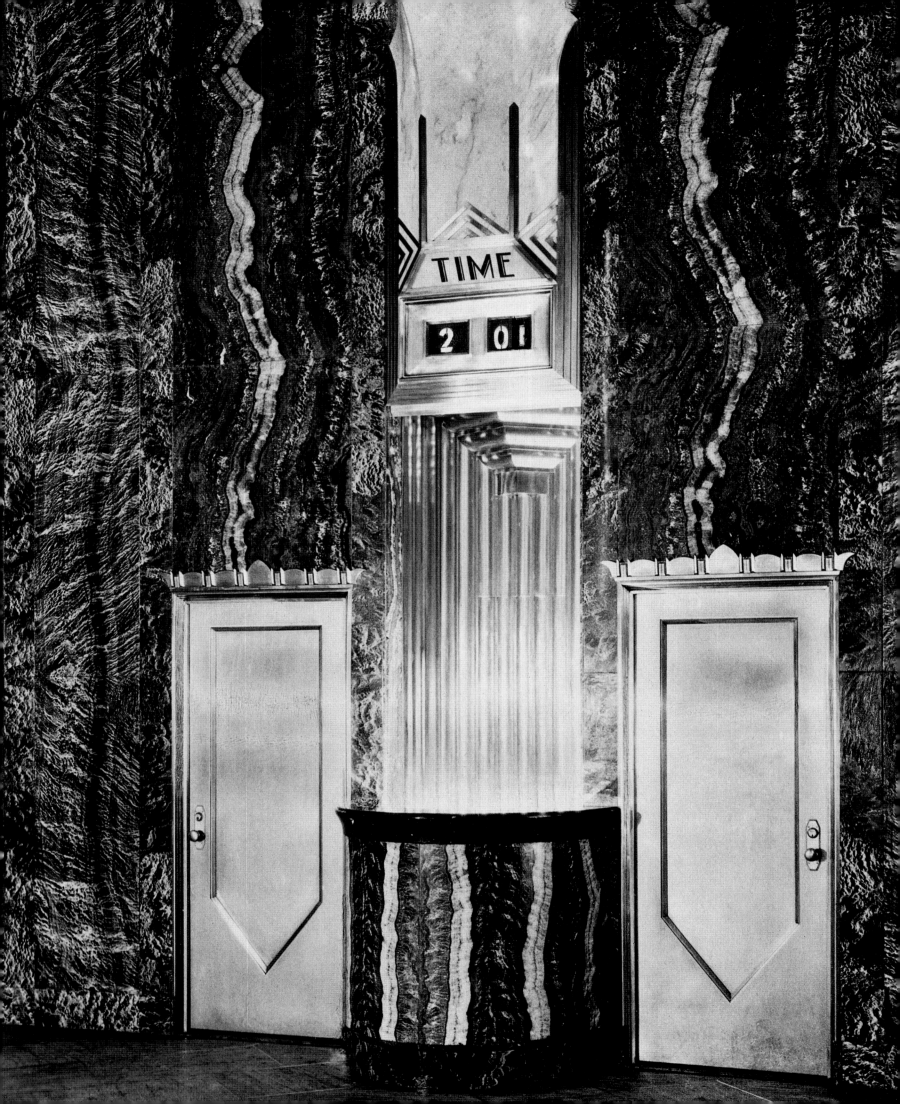

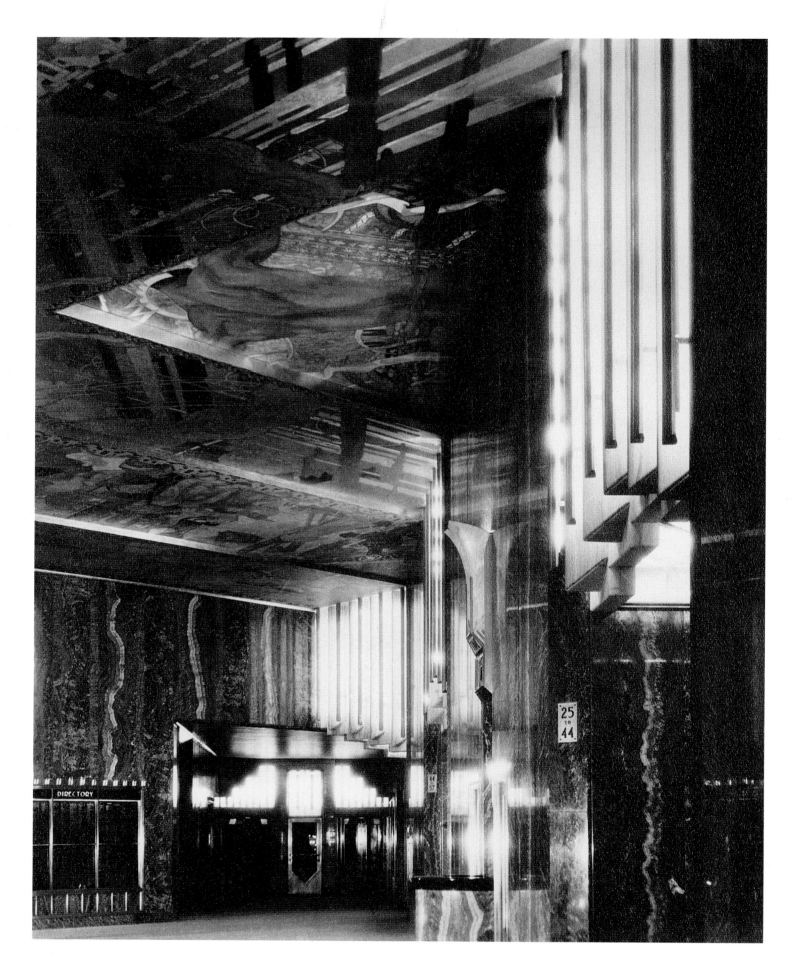

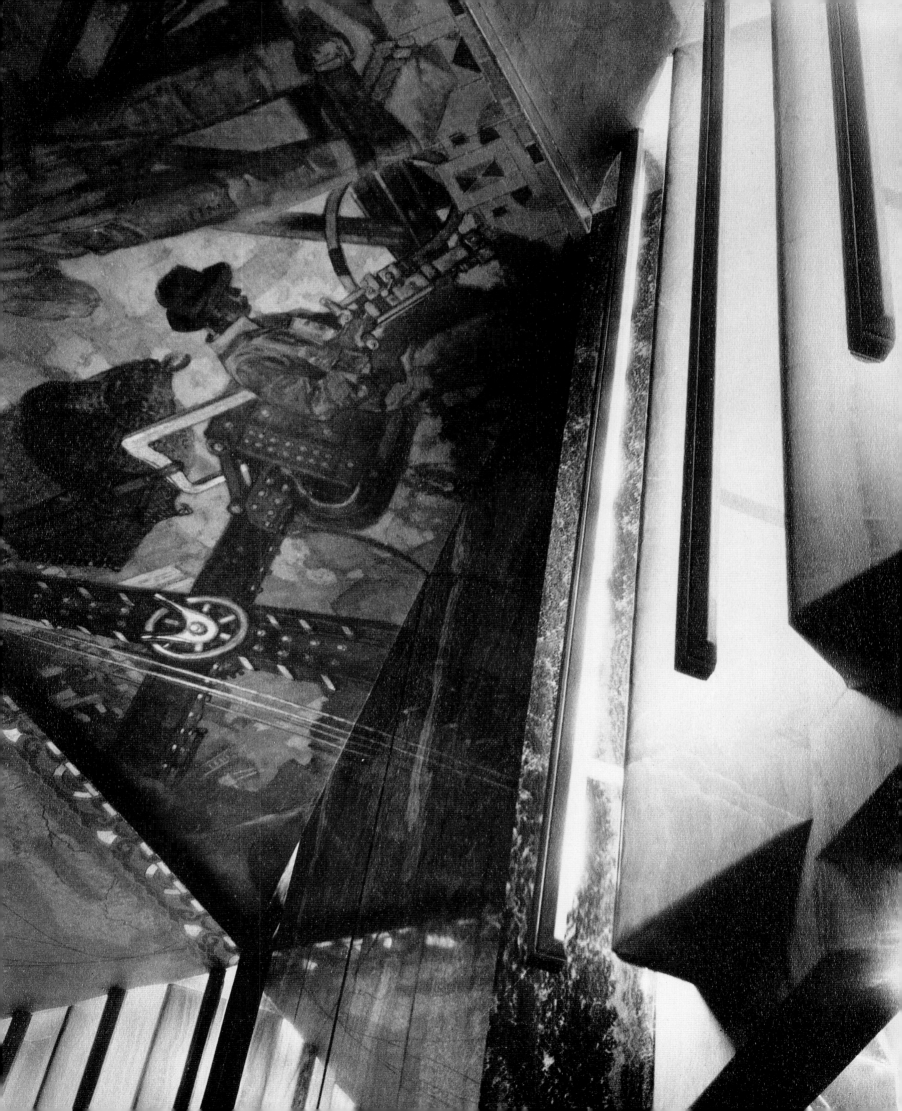

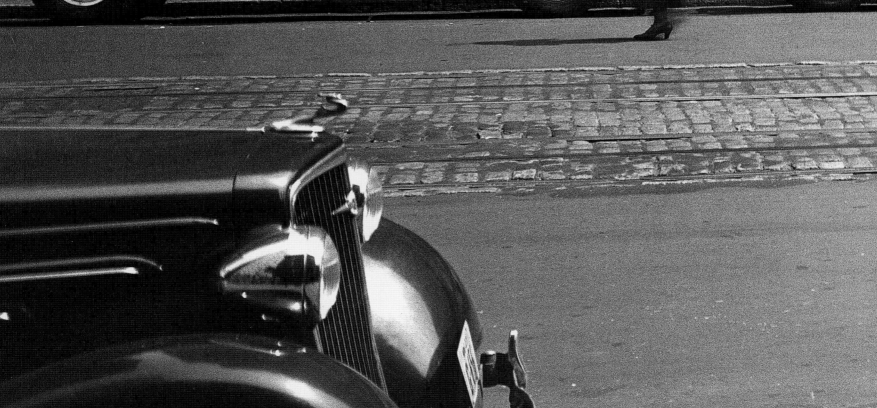

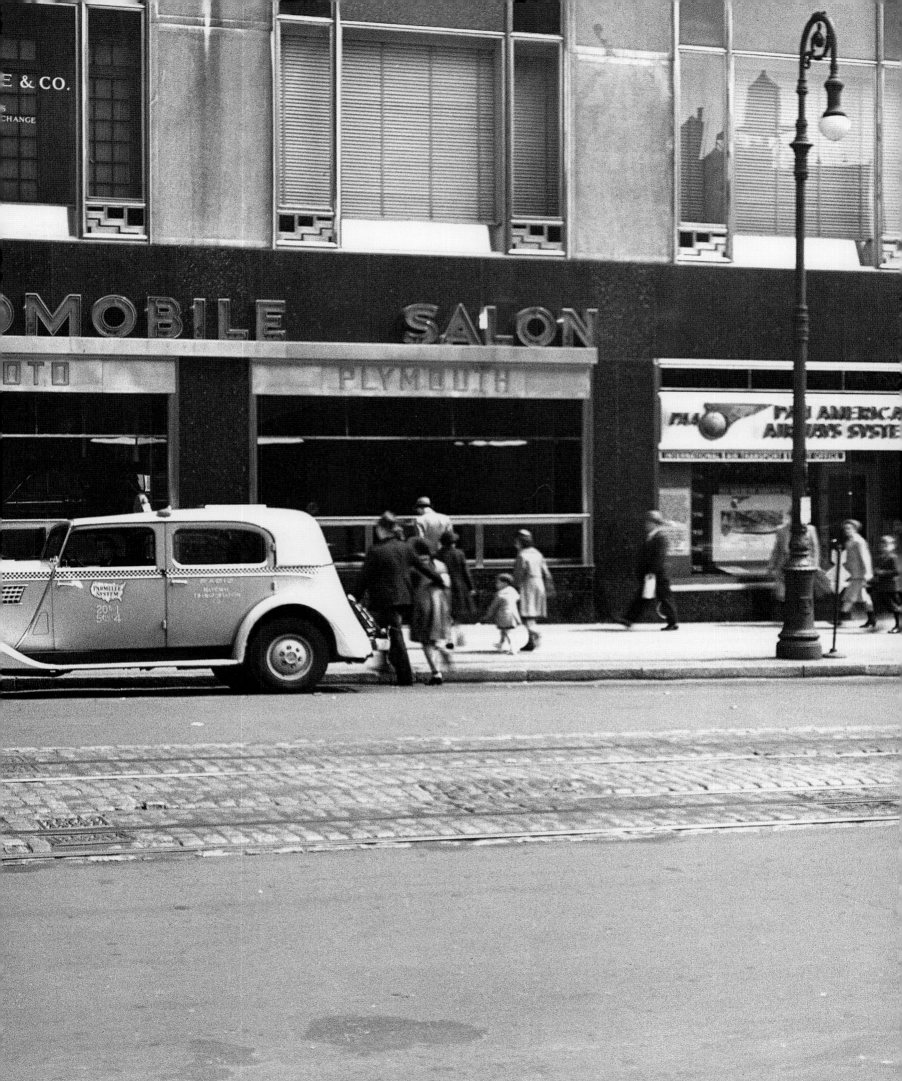

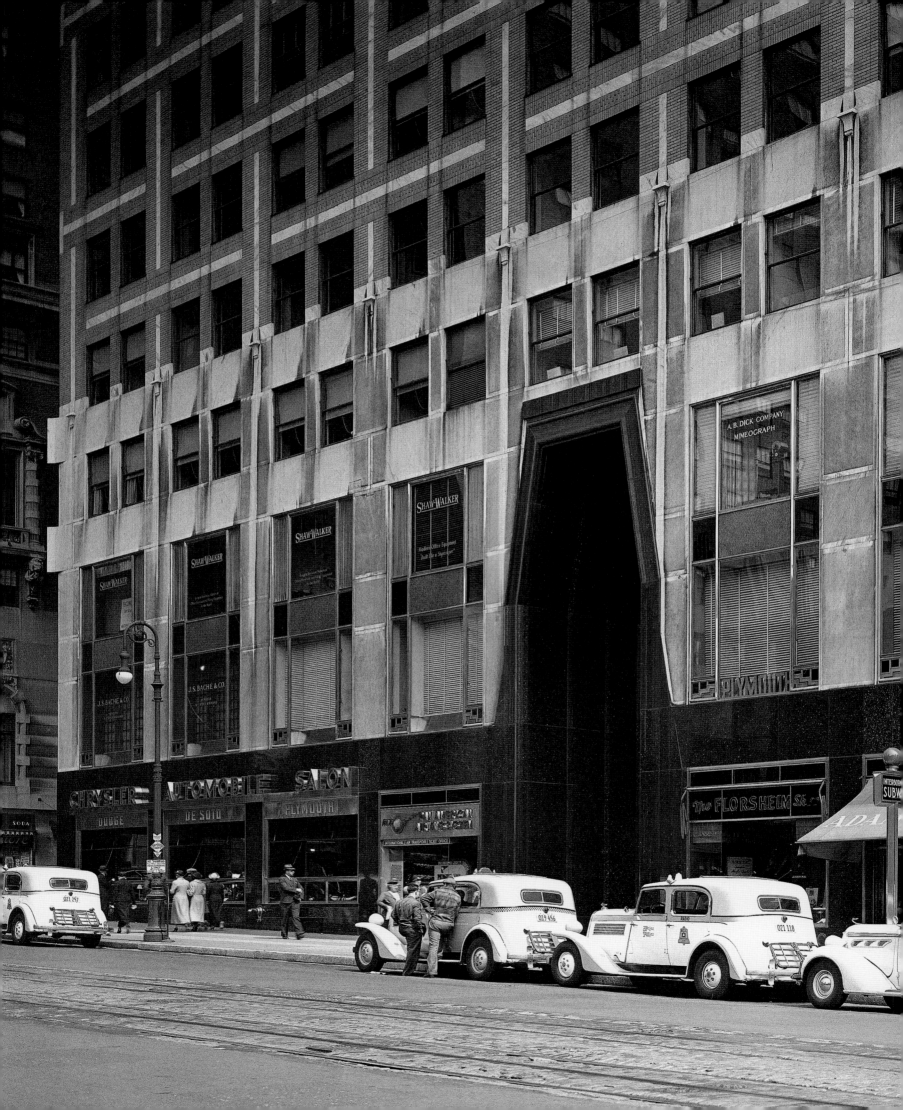

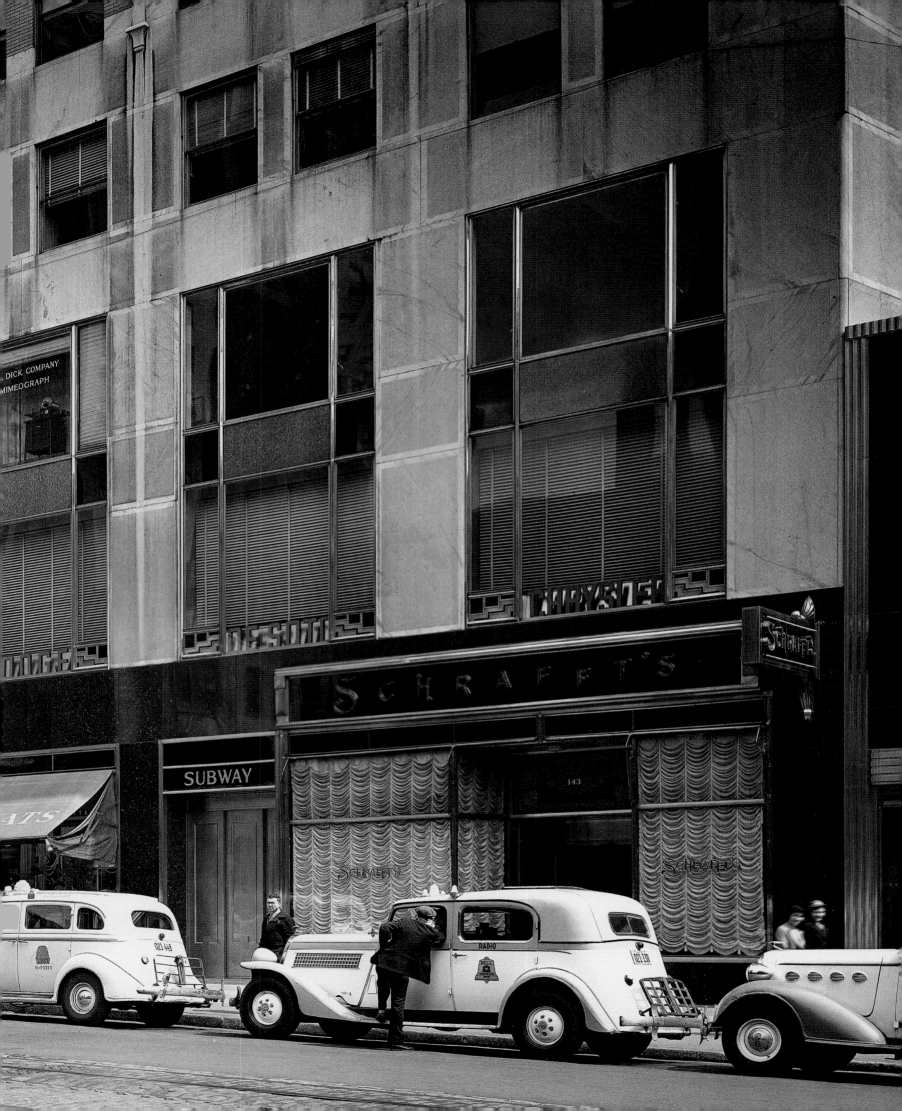

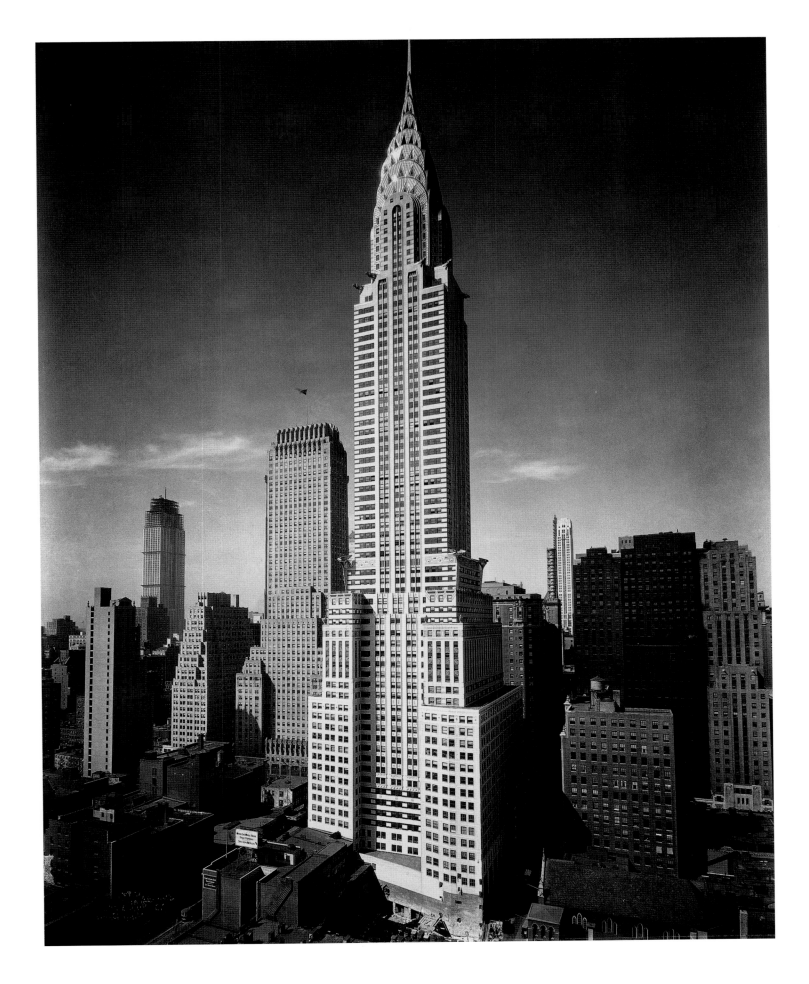

CATALOG

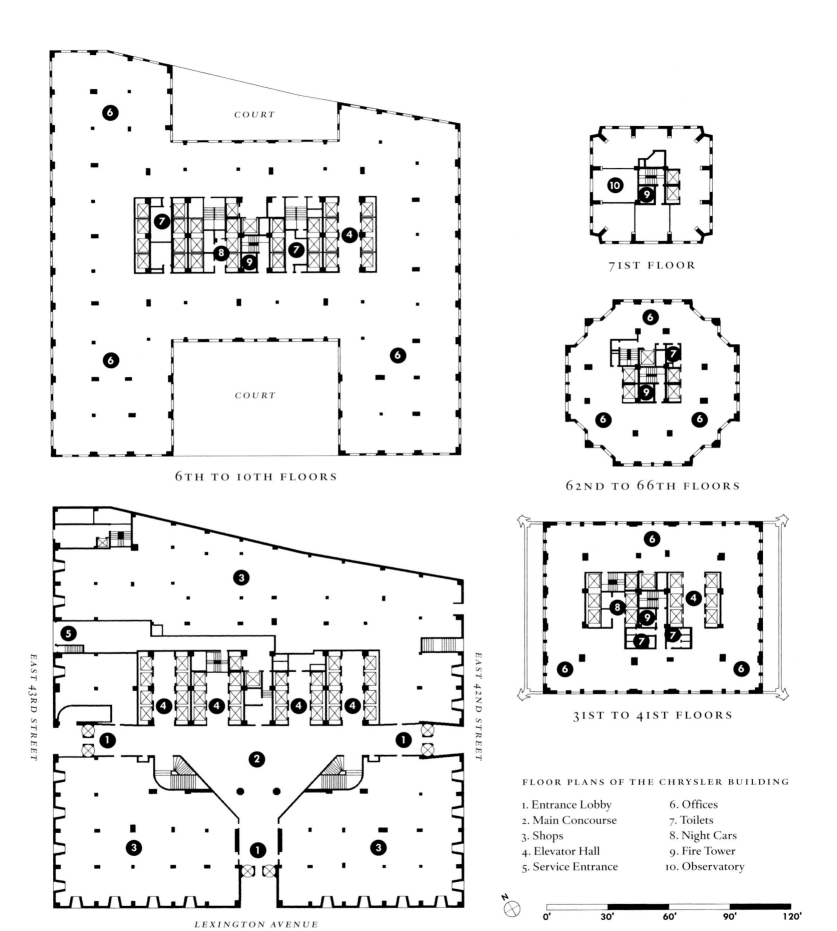

COURT

6

COURT

6 **6**

7 **8** **9** **7** **4**

6TH TO 10TH FLOORS

10 **9**

71ST FLOOR

6

7

9

6 **6**

62ND TO 66TH FLOORS

6

8 **9** **4**

7 **7**

6 **6**

31ST TO 41ST FLOORS

EAST 43RD STREET

3

5

4 **4** **4** **4**

1 **1**

2

3 **3**

1

EAST 42ND STREET

LEXINGTON AVENUE

1ST FLOOR

FLOOR PLANS OF THE CHRYSLER BUILDING

1. Entrance Lobby 6. Offices
2. Main Concourse 7. Toilets
3. Shops 8. Night Cars
4. Elevator Hall 9. Fire Tower
5. Service Entrance 10. Observatory

N

0' 30' 60' 90' 120'

Many of the negatives contained in this collection are annotated with a brief description of their subject matter and the date of their creation. Those annotations are transcribed here and in some cases are followed by more detailed information. Images without annotations are briefly described and, to the extent that it could be determined, appear in chronological order. All of the images are assumed to be the work of the firm Peyser & Patzig, except where otherwise noted.

PAGE II

CHRYSLER B'LDG/42ND ST & LEX AVE/ 1-23-1930

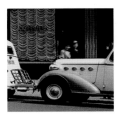

PAGE IV

Two women pass by the Chrysler Salon, located on the ground floor of the Chrysler Building.

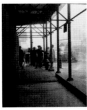

PAGE VI

A workman poses for the photographer outside the Chrysler Building.

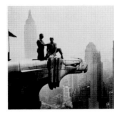

PAGE VIII-IX

Two workmen take a break atop one of the eight steel-clad eagles that adorn the sixty-first floor of the building.

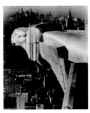

PAGE X

This image of the Chrysler Building's eagle was taken by Margaret Bourke-White in the winter of 1929–30. The photographer—whose studio was in the skyscraper, adjacent to the eagles—was asked by Walter P. Chrysler to document the completion of the building. How her now famous image wound up in this collection of relatively unknown images is a mystery.

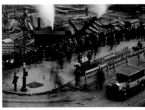

PAGE XII

CHRYSLER B'LDG/11-17-1928

This detail of the site documents its excavation.

PAGE XV

Frank B. Rogers, vice president of the W. P. Chrysler Building Corporation in charge of supervising construction, touches the tip of the skyscraper's spire—the tallest man-made structure in the world at the time.

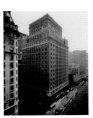

PAGE 3

Chrysler would build his speculative office tower on 42nd Street, one block east of Grand Central Terminal (shown here on the right). The building would contain a suite of offices for the automobile manufacturer's personal use.

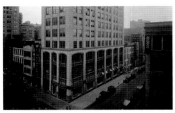

PAGES 4-5

The building on the far right, at the intersection of 43rd Street and Lexington Avenue, occupies the future site of the Chrysler Building.

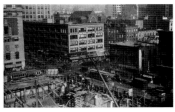

PAGES 6-7

This 1880s building on the northeast corner of 42nd Street and Lexington Avenue was owned by Brooklyn politician and developer William H. Reynolds. An advertisement for Lido Beach, a beachfront community with which Reynolds was also connected, decorates the façade. On the southwest corner of the intersection, work on the Chanin Building is under way.

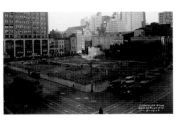

PAGES 8-9

CHRYSLER B'LDG/42ND ST & LEX AVE/ 11-9-1928

After paying Reynolds a reported two million dollars for the speculative office project he developed with the architect William Van Alen, Chrysler begins readying the site. Demolition of the existing structure began on October 15, and by November 9 is almost complete.

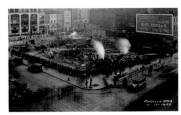

PAGES 10-11

CHRYSLER B'LDG/11-17-1928

Steam shovels strip the site down to bedrock. The wall of a building adjacent to the site is snatched up by Rival Shoes, which paints over earlier signs with an advertisement for their $5 shoes.

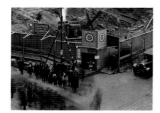

PAGES 12-13
CHRYSLER B'LDG/12-1-1928
General contractor Fred T. Ley hangs his sign above the barriers erected to protect passersby from heavy machinery, flying debris, and the deafening noise of steam shovels, pumps, drills, dynamite, and pneumatic hammers, all used in clearing the site.

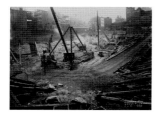

PAGES 14-15
CHRYSLER B'LDG/42ND ST & LEX AVE/1-21-1929
In an era before movable cranes, pivoting booms are assembled on the construction site and used to move large equipment and materials.

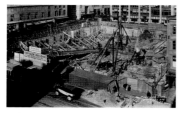

PAGES 16-17
CHRYSLER B'LDG/42ND & LEX AVE/1-29-1929
Temporary sheeting and large wooden tiebacks are set in place to hold back the earth on the excavated site, shoring up the foundations of adjacent buildings and protecting area water mains, trolleys, and subway lines.

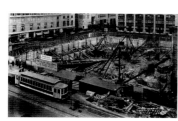

PAGES 18-19
CHRYSLER B'LDG/42ND ST & LEX AVE/2-12-1929
A crosstown trolley heads west on 42nd Street.

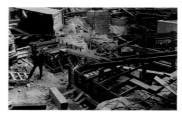

PAGES 20-21
CHRYSLER BUILDING/42ND ST & LEX AVE/ GULLAGES UNDER TOWER/STEEL COLUMNS/3-13-1929
Wooden shafts direct concrete into the form-work for footings and piers. A mesh of heavy steel supports is used beneath the footings to spread the load of the building.

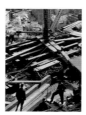

PAGE 21, FLAP
CHRYSLER BUILDING/42ND ST & LEX AVE/ GENERAL VIEW/3-13-1929
A hoist worker operates the stationary boom while other tradesmen look on.

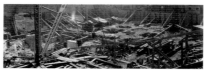

PAGES 22-23
CHRYSLER BUILDING/42ND ST & LEX AVE/ GENERAL VIEW/3-13-1929
Holes for the skyscraper's enormous concrete footings and piers are dug and filled.

PAGE 24, FLAP
CHRYSLER BUILDING/42ND ST & LEX AVE/ CONCRETE COLUMNS/FITTINGS UNDER TOWER/STEEL/3-13-1929
The wooden formwork for the footings and piers is assembled on the site. After the concrete has been poured and is set, it is dismantled and reused in other places on the site.

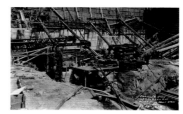

PAGES 24-25
CHRYSLER B'LDG/42ND ST & LEX AVE/ BOILER ROOM VAULT WALL/ON 43RD ST/3-22-1929
Structural steel members are stacked on the site. They will be hoisted into place by derricks, one of which is visible (laying on its side) on the left.

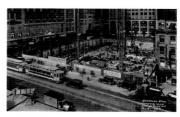

PAGES 26-27
CHRYSLER B'LDG/GENERAL VIEW/42ND ST & LEX AVE/4-9-1929
The site takes on the rational order of gridiron construction as the first columns are set in place.

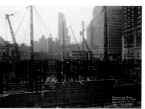

PAGES 28-29
CHRYSLER B'LDG/42ND ST & LEX AVE/ GENERAL VIEW/4-17-1929
Fittings placed atop the vertical columns are designed to form a rigid connection with horizontal beams. Together these elements create the moment frame of the building, which—free of the need for load-bearing masonry walls characteristic of earlier tall buildings—allows the skyscraper to soar to great heights.

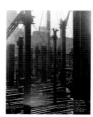

PAGE 31
CHRYSLER B'LDG/42ND ST & LEX AVE/ COLUMN NO. 63 UNDER/TOWER/WEIGHT 35 TONS/CARRYING 3700 TONS/4-17-1929

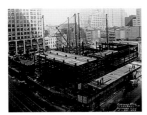

PAGE 32
CHRYSLER B'LDG/42ND ST & LEX AVE/ GENERAL VIEW/4-24-1929

The steel frame of the building begins to emerge. The wooden decking, brought to the site by horse-drawn carriage and placed on the frame, will be exchanged for poured-in-place concrete floor slabs.

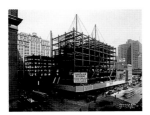

PAGE 33
CHRYSLER B'LDG/42ND ST & LEX AVE/ 5-17-1929

With no storage facilities on the site, trucks must unload their cargo quickly; materials are built into the structure at once. The paired derricks that hoist these materials also hoist each other higher up into the building as the work advances.

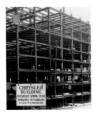

PAGE 35
CHRYSLER B'LDG/42ND ST & LEX AVE/ 5-17-1929

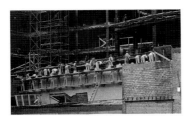

PAGES 36-37
CHRYSLER B'LDG/42ND ST & LEX AVE/ 5-25-1929

Bricklayers join steel and concrete workers on the job site. Here they set rows of brick on the eastern façade.

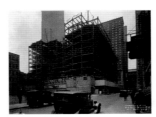

PAGES 38-39
CHRYSLER B'LDG/42ND ST & LEX AVE/ 5-25-1929

The light court and first setback of the building begin to materialize. City zoning laws require that the upper stories occupy only one-quarter of the total area of the lot to ensure that sunlight and fresh air reach the occupants of both this skyscraper and its neighbors.

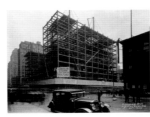

PAGES 40-41
CHRYSLER B'LDG/42ND ST & LEX AVE/ 5-25-1929

This photograph together with the image on the preceding pages document all four sides of the building on a single day. The many pairs of images taken by the photographers create a complete record of construction for the client.

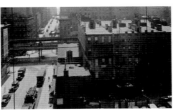

PAGES 42-43
Looking east from the Chrysler Building, the Third Avenue Elevated Railroad (El) hurdles 43rd Street. In the distance are the Second Avenue El and the East River beyond.

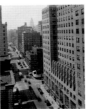

PAGE 44
Looking south from the Chrysler Building, the recently completed Chanin Building lines Lexington Avenue.

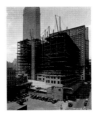

PAGE 46
CHRYSLER B'LDG/42ND ST & LEX AVE/ 6-3-1929

Rails attached to the eastern façade of the building and enclosed within a shaft are used to ferry men and materials to the upper floors.

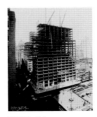

PAGE 47
CHRYSLER B'LDG/42ND ST & LEX AVE/ 6-14-1929

"Speed," Van Alen wrote, "is controlled by the rapidity of the steel erection." The architect did everything possible to maximize the speed of construction. Steel is hoisted in relays to avoid excessively high lifts; smaller lifts permit higher rope speeds and faster construction. By using some derricks exclusively for hoisting and others for setting steel into place, the material remains in constant motion until it is finally placed.

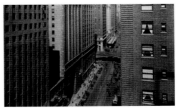

PAGES 48-49
Looking west on 42nd Street from the Chrysler Building, traffic passes beneath the Park Avenue Viaduct.

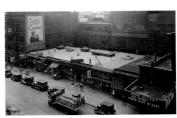

PAGES 50-51
The small low-rise buildings that line 43rd Street between Lexington and Third avenues are remnants of previous decades. Advertisers use the blank walls of adjacent four-story buildings to their advantage.

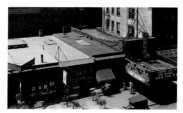

PAGE 52-53

The marquee of the Loews movie palace announces upcoming performances by the "man of a thousand faces," Lon Chaney, and by Stan Laurel (here without his partner Oliver Hardy). The introduction of sound is still recent enough to warrant a banner of its own.

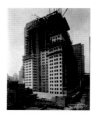

PAGE 54

CHRYSLER B'LDG/42ND ST & LEX AVE/ 7-5-1929

As construction proceeded, tradesmen with a variety of specialized skills converged on the site. Architects and engineers were joined by heating and ventilation experts, elevator manufacturers, boilermakers, machinists, painters, plasterers, sheet-metal workers, riveters, and pipe fitters. General contractors, subcontractors, and foremen coordinated their efforts via a telephone system installed on all floors.

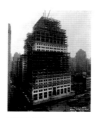

PAGE 55

CHRYSLER B'LDG/42ND ST & LEX AVE/ 7-5-1929

A basket-weave pattern of glazed gray, white, and black brick, trimmed with white Georgia marble and black Swedish Shastone granite decorates the lower portion of the building from the fifth to the sixteenth floor.

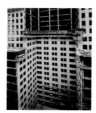

PAGE 57

CHRYSLER B'LDG/42ND ST & LEX AVE/ 7-10-1929

Approximately 3,826,000 bricks—each laid by hand—were used to create the light non-load-bearing walls of the Chrysler Building.

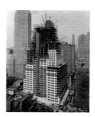

PAGE 58

CHRYSLER B'LDG/42ND ST & LEX AVE/ 7-12-1929

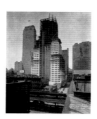

PAGE 59

CHRYSLER B'LDG / 42ND ST & LEX AVE/ 7-20-1929

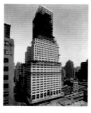

PAGE 61

CHRYSLER B'LDG / 42ND ST & LEX AVE/ 7-26-1929

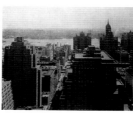

PAGE 62

Looking east from approximately the forty-fifth floor of the Chrysler Building, the rooftops of neighboring buildings are visible.

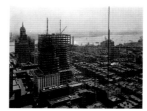

PAGE 63

Farther east on 42nd Street, the construction of Hood & Howells' Daily News Building proceeds. Together with the Chrysler, Chanin, Lincoln, and Empire State buildings, it helped create a highly concentrated business area around Grand Central Station and to shift the visual center of the Manhattan skyline northward.

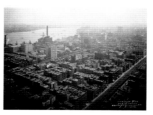

PAGES 64-65

CHRYSLER B'LDG/WORLD'S TALLEST/ 42ND & 43RD STS AND LEX AVE/8-2-1929

More significant than the view southwest from the Chrysler Building is perhaps the claim made in the lower right corner of this photograph. "World's tallest" was technically a misnomer, in that at fifty-odd stories it had yet to overtake either Cass Gilbert's 792-foot Woolworth Building or Gustave Eiffel's 984-foot exposition tower; but the phrase no doubt communicates Chrysler's intent to surpass them both.

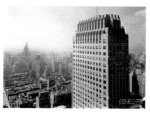

PAGES 66-67

LOOKING S.W. FROM/42ND ST & LEX AVE/ 51ST FLOOR

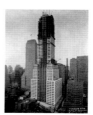

PAGE 68

CHRYSLER B'LDG/42ND ST & LEX AVE/ 8-30-1929

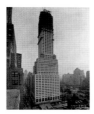

PAGE 69
**CHRYSLER B'LDG/42ND ST & LEX AVE./
8-30-1929**

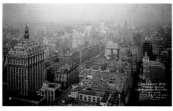

PAGES 70-71
**CHRYSLER B'LDG/WORLD'S TALLEST/
42ND & 43RD & LEX AVE/9-10-1929/
LOOKING N.W. FROM 43RD ST & LEX AVE/
57TH FLOOR**

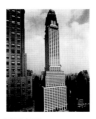

PAGE 73
CHRYSLER BLDG/10-7-29.
Above the sixty-sixth floor, construction was complicated by the curvature of the building's dome. Angled pieces of steel were fabricated on the floor of the Federal Shipbuilding and Dry Dock Company and transported to the site. The last of the 20,961 tons of structural steel used in constructing the building was installed on September 28.

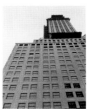

PAGE 75
Glaziers inserted some 3,862 windows into the Chrysler Building's façade. Here each window is temporarily emblazoned with the owner's name.

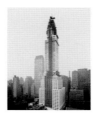

PAGE 76
**CHRYSLER B'LDG/42ND ST & LEX AVE/
10-14-1929**
With the completion of the seventy-seventh floor at the top of the dome, workmen set about installing the needlelike spire. As Van Alen described in the October 1930 edition of the Architectural Forum, a derrick was placed on one of four outrigger platforms at the top of the tower. The 185-foot spire was delivered to the site in five sections. The bottom section was hoisted to the top of the dome and lowered into the building's fire shaft to the level of the sixty-fifth floor. The remaining sections were hoisted and joined to the first in sequence.

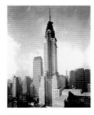

PAGE 77
**CHRYSLER B'LDG/42ND ST & LEX AVE/
10-23-1929**
"When the spire was finally assembled and riveted up securely," Van Alen wrote, "the signal was given and the spire gradually emerged from the top of the dome like a butterfly from its cocoon." As the twenty-seven-ton ornament was hoisted into place, the architect and his engineers looked on from Fifth Avenue and 42nd Street, three blocks away.

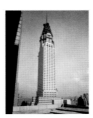

PAGE 78
**CHRYSLER B'LDG/42ND ST & LEX AVE/
10-23-1929**
This photograph was taken on October 23, 1929, the day before Black Thursday—that fateful day when the New York Stock Exchange crashed, heralding the end of the Roaring Twenties and the beginning of the Great Depression.

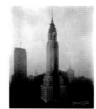

PAGE 79
**CHRYSLER B'LDG/42ND ST & LEX AVE/
11-1-1929**
A week after the stock-market crash, construction proceeds at the summit of the Chrysler Building.

PAGES 79 AND 82 FLAPS
**TAKEN FROM TOWER/CHRYSLER
B'LDG/42ND ST & LEX AVE/11-20-1929**
To the south, the rapidly emerging Empire State Building looms large on the horizon.

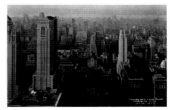

PAGES 80 AND FLAP
**LOOKING WEST FROM TOWER/CHRYSLER
B'LDG/11-16-1929**
To the west, the character of Midtown Manhattan as we know it today begins to take form.

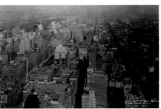

PAGES 81 AND FLAP
**LOOKING NORTH FROM TOWER/ CHRYSLER
B'LDG/11-16-1929**
To the north, Central Park provides a pastoral refuge within the dense urban area.

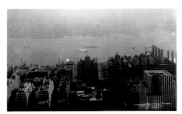

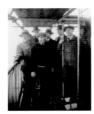

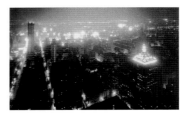

PAGES 82-83

LOOKING EAST FROM TOWER/CHRYSLER B'LDG/11-16-1929

To the east, Tudor City, the Daily News Building, and the Consolidated Edison Power Station rise above the river.

PAGE 88

Tradesmen and corporate executives pose on the tower's scaffolding, high above the city. Ley completed the structural work on the building without a single fatal injury to any workman—a remarkable achievement for the time.

PAGES 94-95

Looking west from the tower at night, the city below glows with light. The earliest scheme for the Chrysler Building included four floodlights at the corners of the fifty-sixth-floor terrace and another on top of the dome trained on the spire. The radiating tube lighting that decorates the crown today was also allegedly part of this scheme but was not installed until 1981.

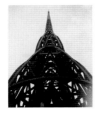

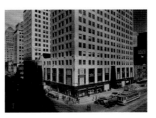

PAGE 85

The latticed-steel framework of the spire and needle is riveted together. Its installation marks the completion of the steel contractors' and consulting engineers' work.

PAGE 89

The material used to clad the building's distinctive crown and spire was developed by the German firm Krupps during World War I for use in its "Big Bertha" howitzer. The rust-resistant, noncorrosive chromium-nickel steel known as Nirosta or Enduro—the precursor to stainless steel—was also used on the ornamental gargoyles, storefronts, and doors of the building, greatly enhancing the skyscraper's modern machine-age appeal.

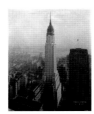

PAGES 96-97

As workmen finish out the interior space of the building, leasing agents look for potential renters. With more than seventy acres of new office space created in Midtown Manhattan through the completion of several skyscraper projects, the competition was intense. Agents emphasized the comfort, flexibility, and efficiency of the Chrysler Building's offices—which came complete with central vacuum cleaning and "manufactured weather"—in addition to its prestige as the world's tallest skyscraper.

PAGE 86

CHRYSLER BLDG/11-19-29.

A scaffolding of steel pipe draped with heavy wire netting was erected around the dome (and eventually the spire) to protect sheet-metal installers working on the building's ornamental terminus. Because of the curving shape of the dome's form, measurements for the sheet steel needed to be verified in the field. The bulk of the work was thus carried out in metalworking shops located on the sixty-seventh and seventy-fifth floors of the building.

PAGE 91

Rogers grips the peak of the shiny steel spire as he tips his hat to the world 1,046 feet, 4 3/4 inches below.

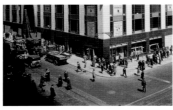

PAGES 98-99

A police officer directs traffic at the busy intersection of 42nd Street and Lexington Avenue. An underground passageway connecting the Chrysler Building to Grand Central Terminal was designed to alleviate some of the projected pedestrian traffic caused by the eleven thousand occupants of the completed building.

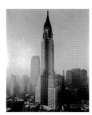

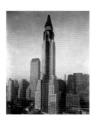

PAGE 87

CHRYSLER B'LDG/42ND ST & LEX AVE/ 12-24-1929

A light dusting of snow covers the Chrysler Building and its environs on Christmas Eve, 1929.

PAGE 93

CHRYSLER BLDG/1-29-30.

The radiating lines of polished steel that give the crown its shimmering quality are revealed as the scaffolding is removed from the top of the building.

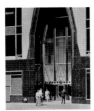

PAGE 101
Black granite and chromium-nickel steel adorn the 42nd Street entrance to the Chrysler Building's main concourse. (Photographer: Sigurd Fischer)

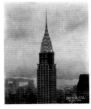

PAGES 102-103
CHRYSLER B'LDG/FIRST TENANT/42ND ST & LEX AVE/2-28-1930.

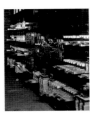

PAGE 105
The switch gear for the electrical panel that controls the flow of energy into the building is located in the basement.

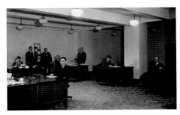

PAGE 106
CHRYSLER B'LDG/42ND ST & LEX AVE/ 6-17-1930
On the day this photograph was taken, with the roofing complete and the last of the scaffolding almost removed, Van Alen filed a $725,000 lien on the Chrysler Building for the balance of his fee. Although no contract had been signed between architect and client (Chrysler had taken over the leasehold on the project from a previous owner), the courts prevailed in Van Alen's favor, handing down its largest judgment to that date. The fee for preparing plans, drawings, and specifications for the building and for closely supervising its construction was calculated at six percent of the total $14 million building cost—a bargain compared to the ten percent demanded by other architects of the period.

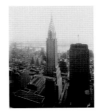

PAGE 107
As finishing touches are added to the exterior, workmen turn to the interior of the exclusive Cloud Club. Located on the sixty-sixth through sixty-eighth floors, the club is designed to cater to the discriminating tastes of its members— New York's most influential advertising, aviation, steel, and railroad executives. Its lounge, executive dining hall, private dining rooms, oyster bar, grill room, coffee rooms, ticker room, barbershop, shower, dressing rooms, and servants' quarters were all served by a special express elevator.

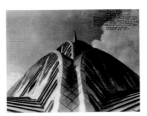

PAGE 108
FRED T. LEY & CO., INC./BUILDERS/ CHRYSLER BUILDING/SHOWING DOME CONSTRUCTION OF/ENDURO-KA-2- STAINLESS AND/RUSTLESS STEEL LOOK- ING UP/FROM THE 67TH FLOOR, SHOWING/ EXTREME PEAK 1046 FEET/4¾" ABOVE LEXINGTON AVE/STREET LEVEL/JUNE 20, 1930

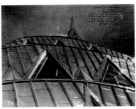

PAGES 109
FRED T. LEY & CO., INC/BUILDERS/ CHRYSLER BUILDING/SHOWING DOME CONSTRUCTION OF/ENDURO-KA-2-AND REZISTAL/STAINLESS AND RUSTLESS STEEL,/LOOKING UP FROM THE 67TH FLOOR/SHOWING EXTREME PEAK 1046 FEET/4¾" ABOVE LEXINGTON AVENUE/ STREET LEVEL/JUNE 20TH, 1930
Sheet metal is fastened to wooden nailing strips placed atop a thin layer of nailing concrete that coats the spire's structural-steel frame. To avoid contact between dissimilar metals, Nirosta steel nails, screws, bolts, nuts, and rivets are used to fix the sheet metal in place.

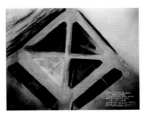

PAGE 111
FRED T. LEY CO., INC/BUILDERS/ CHRYSLER BUILDING/42ND ST & LEX AVE/ 6-10-1930/ LOOKING UP INTO SPIRE FROM THE 77TH FLOOR/THE CHRYSLER BUILDING

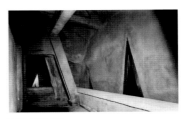

PAGE 112-113
FRED T. LEY CO, INC,/BUILDERS/ CHRYSLER BUILDING/ 42ND ST & LEX AVE.,/6-10-1930/ PHOTOGRAPHED FROM 76TH FLOOR/SHOWING INTERIOR CONST.
Inside the spire, the steel armature is encased in gunite, a type of concrete used for fireproofing.

PAGE 114
CHRYSLER B'LDG/70TH FLOOR/7-31-1930
The photographer documents the installation of ductwork on the seventieth floor.

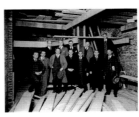

PAGE 115
A team of tradesmen pose for a photograph.

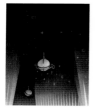 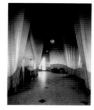 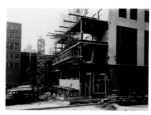 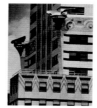

PAGE 116, 117

(*left*) A detail of the image on the adjacent page reveals the delicate astrological designs of the Observatory ceiling. Located on the seventy-first floor, the Observatory provided the public with an unprecedented and otherworldly vantage point on the city below. (*right*) In the Observatory of the Chrysler Building, the Michigan mechanic-turned-automotive-giant exhibited the tools with which he began his career.

PAGES 124-25

W. P. CHRYSLER B'LDG CORP/ANNEX/ 10-27-1930

Work proceeded on the annex as it had with the tower, only on a smaller scale. Here the steel is set in place.

PAGE 131

Like most of the ornaments on the Chrysler Building, those located on the exterior of the thirty-first floor are based on the automobile. Grey-and-white brickwork wheels, complete with mud-guards, ring the building. Just above, gargoyles modeled after the familiar Chrysler radiator cap project from the building's four corners. The winged cap resembles that of Mercury, the Roman god of travelers and protector of merchants and thieves. (Photographer: Sigurd Fischer)

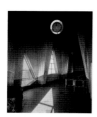

PAGE 119, 120

(*left*) The starburst that radiates from the dome on the Chrysler's exterior is suggested in the painted decoration on the interior walls of the Observatory. (*right*) A detail of the image on the previous page highlights the unique shape of the windows that pierce the surface of the building's dome.

PAGE 127

CHRYSLER B'LDG ANNEX./1-7-1931

The Annex exterior appears to be complete after little more than four months of construction—a far cry from the eighteen months required to complete its prodigious neighbor.

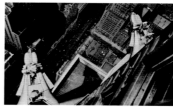

PAGES 132-33

Workmen put the finishing touches on two pairs of steel-clad eagles located sixty-one stories above Lexington Avenue. The depression behind the eagles' heads is designed to house floodlights that would illuminate the building's dome.

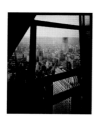 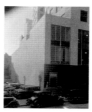

PAGE 121

Progress on the Empire State Building is recorded through an Observatory window of the Chrysler Building. The rival structure would snatch the title of world's tallest skyscraper in spring 1931, as it surpassed the height of the Chrysler by more than 200 feet.

PAGE 128

The Chrysler Building, as experienced at street level. (Photographer: Sigurd Fischer)

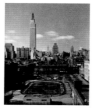

PAGE 134

Looking west from First Avenue between 35th and 36th streets, the Empire State Building nears completion.

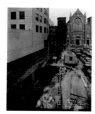 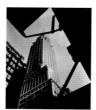 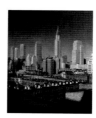

PAGE 123

POURING FIRST/CONCRETE FOOTINGS/ON "ANNEX" CHRYSLER/BUILDING--43RD ST SIDE/9-11-1930

In late summer 1930, work began on the Chrysler Annex, a small office building located adjacent to the northeast corner of the skyscraper.

PAGE 129

An aerial perspective on the completed Chrysler Building.

PAGE 135

Looking northwest from the same vantage point as the previous image, the Lincoln, Chanin, Chrysler, and Daily News buildings dominate the skyline. Old-time Manhattanites recalled at the opening of the Chrysler Building that only fifty years earlier the site had been a goat pasture.

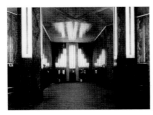

PAGES 136-37
Frank Lloyd Wright wrote in the New York Herald Tribune, "The city is centralization to the Nth degree, and the skyscraper is its peak." The main concourse of the Chrysler Building is designed to eliminate the congestion such centralization can cause. Its simple triangular plan funneled visitors and occupants from the entrance to waiting elevators, which whisked them to the desired floor.

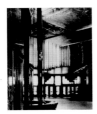

PAGE 138
Immense slabs of Moroccan rouge flammé marble streamed with white and other colors are used to line the walls of the main concourse. The elevator lobbies are framed in amber Mexican onyx; the floor is tiled in Sienna travertine.

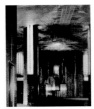

PAGE 139
Edward Trumbull was entrusted with the task of decorating the Chrysler Building's main concourse. Most notable among the artist's contributions is the 100-by-76-foot mural he painted and applied to the ceiling of the double-height space. The canvas depicts "Energy and Man's application of it to the solution of his problems" and expresses the spirit of the Machine Age. The tower of the Chrysler Building is featured amid symbols of Energy and Transportation.

PAGE 140
Vertical coves of Mexican onyx contain lights encased in steel. The overall effect is of warm ambient light.

PAGE 141
Inlays of rare woods fashioned into abstracted designs adorn the elevator cabs, inside and out. Thirty elevators are organized in five banks, each serving a different group of floors. Although engineered to run at 1,000 feet per minute, the cabs were originally run at a more modest 700 hundred feet per minute—a concession to local building code.

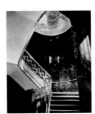

PAGE 142
One of two, this staircase leads from the main concourse to the second floor and basement of the Chrysler Building. With its polished black marble walls veined with white and its aluminum-leafed ceiling, it provides an elegant transition from the shop-lined passageway from Grand Central Terminal to the lobby space. (Photographer: Sigurd Fischer)

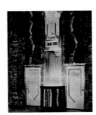

PAGE 143
Set within a polished steel niche, the clock in the Chrysler Building's main concourse helps keep business running on schedule. (Photographer: Sigurd Fischer)

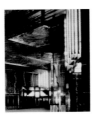

PAGE 144
The New York Landmarks Preservation Commission landmarked the main concourse and exterior of the Chrysler Building in 1978. Having fallen into disrepair, the lobby and storefronts were renovated in the 1990s. Although some original features have been lost over time, the renovation returned the building to its former glory.

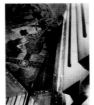

PAGE 145
Trumbull's mural—a detail of which is shown here—was conserved in the 1990s.

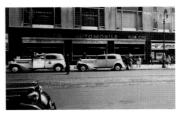

PAGES 146-47
In 1936 the Chrysler Automobile Salon by Reinhard & Hofmeister replaced a more conventional salesroom designed originally for the ground-floor space. The new exhibition hall, with its neon signs, invisible glass windows, and revolving turntable displaying Chrysler's latest models—drew record crowds, as much as eight thousand visitors in a single day.

PAGES 148-49
According to figures published in Fortune, the Chrysler Corporation's net income shrank from a profit of more than thirty million dollars in 1928 to a deficit of some eleven million dollars in 1932. By 1936, when the salon was renovated, things had begun to look up. In August of the previous year, Chrysler became the first automaker to raise its rate of production above the figures for the great boom year of 1929. Here new models lined the street.

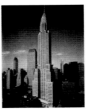

PAGE 151
The completed Chrysler Building marks the New York skyline.

PUBLISHED BY

Princeton Architectural Press
37 East Seventh Street
New York, New York 10003

For a free catalog of
books, call 1.800.722.6657.
Visit our web site at
www.papress.com.

© 2002 David Stravitz
Introduction © 2002 Christopher Gray
All rights reserved
Printed and bound in China
05 04 03 02 5 4 3 2 1 FIRST EDITION

Every reasonable attempt has been made to
identify owners of copyright. Errors or omissions
will be corrected in subsequent editions.

EDITOR: Nancy Eklund Later
DESIGNER: Sara E. Stemen

SPECIAL THANKS TO: Nettie Aljian, Ann Alter,
Nicola Bednarek, Janet Behning, Megan Carey,
Penny Chu, Russell Fernandez, Clare Jacobson,
Mark Lamster, Linda Lee, Jane Sheinman,
Katharine Smalley, Scott Tennent, Jennifer
Thompson, and Deb Wood of Princeton
Architectural Press
　　　　　　　—Kevin C. Lippert, publisher

**LIBRARY OF CONGRESS
CATALOGING-IN-PUBLICATION DATA**
Stravitz, David, 1940–
　　The Chrysler Building : creating a New York
　　icon, day by day / David Stravitz ; introduction by
　　Christopher Gray.—1st ed.
　　　　p. cm.
　　ISBN 1–56898–354–9
　　1. Chrysler Building (New York, N.Y.)—History.
　　2. Van Alen, William, 1883–1954. 3. Skyscrap-
　　ers—New York (State)—New York. 4. Art deco
　　(Architecture)—New York (State)—New York.
　　5. New York (N.Y.)—Buildings, structures, etc.
　　I. Title.
　　NA6233.N5 C3785 2002
　　725'.2'097471—DC21　　　　2002007057

THE EDITOR WOULD LIKE TO THANK Valerie Peltier
of Tishman Speyer Properties; Nat Oppenheimer,
Liviu Schwartz, and Edmund P. Meade of Robert
Silman Associates; Richard Metsky of Beyer,
Blinder, Belle Architects & Planners; and Lori
Dunning and Brant Rosenberg of the Daimler
Chrysler Corporation Archives for their valuable
input in preparing the catalog text. The plans,
which were drawn by David Later, are based on
versions that appeared in the September 1930
edition of the *American Architect*.

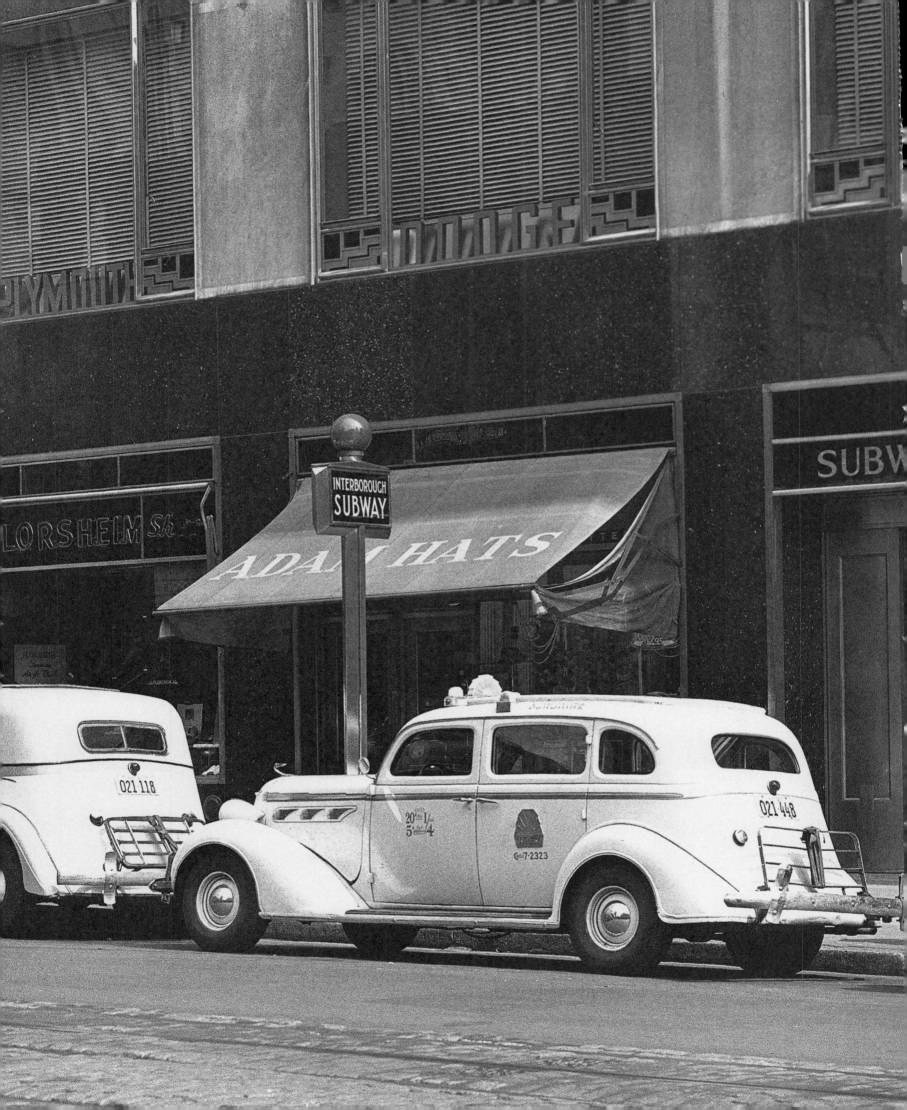